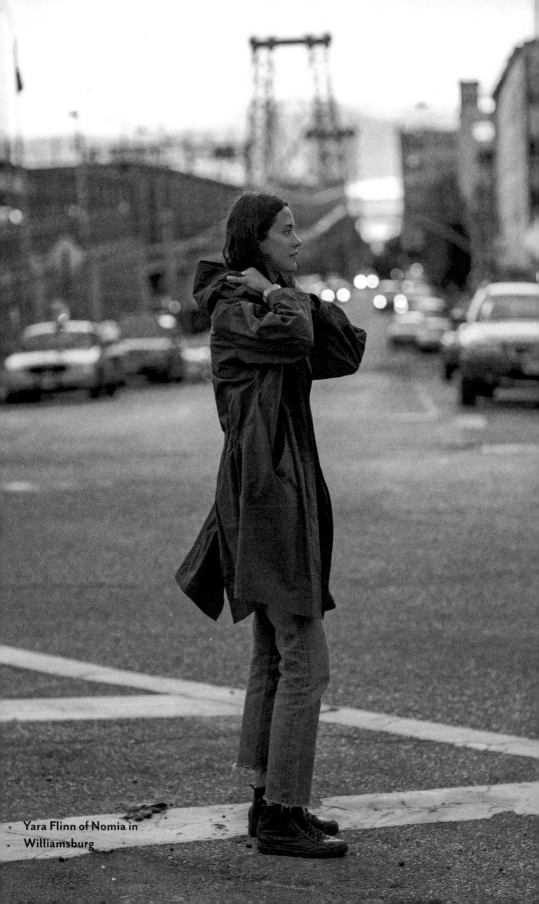

Yara Flinn of Nomia in
Williamsburg

BROOKLYN STREET STYLE

THE NO-RULES GUIDE TO FASHION

WITHDRAWN

BY ANYA SACHAROW & SHAWN DAHL
PHOTOGRAPHS BY SIOUX NESI

ABRAMS IMAGE
NEW YORK

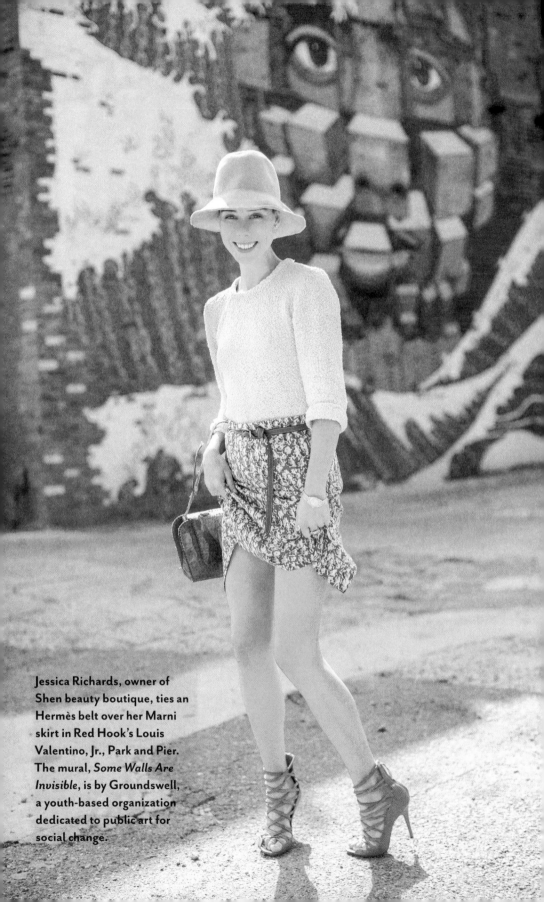

Jessica Richards, owner of Shen beauty boutique, ties an Hermès belt over her Marni skirt in Red Hook's Louis Valentino, Jr., Park and Pier. The mural, *Some Walls Are Invisible*, is by Groundswell, a youth-based organization dedicated to public art for social change.

Contents

Introduction...**What Is Brooklyn Style?** 6

1. Make Your Own Rules 14

Interlude...**Mixing Prints** 26

2. Mix It Up 30

3. Dress for Life 46

Interlude...**Shoes** 66

4. Wear Your Tribe 70

Interlude...**Hats** 88

5. Wear Your Conscience 92

6. Make It Yourself 116

7. Don't Fuss 134

Interlude...**Beauty** 148

8. Embrace the World 152

Interlude...**Accessories** 168

9. Have Some Fun 172

Interlude...**Headwear** 192

10. Love the Street 196

Postscript...**Style Knows No Age** 214

Brooklyn Guide 218

Thank-Yous 238

WHAT IS BROOKLYN STYLE?

Introduction

• • • • • •

In 1990 there were rumblings about Brooklyn's ascension to global style capital. The media were buzzing about the nascent art and music scenes in Williamsburg. Dank warehouse parties and dark makeshift bars warranted frequent visits to the neighborhood.

Still, if anyone had said, "In the twenty-first century, women will pay one hundred dollars for yoga pants with 'lemon' in the name, and a store dedicated to such yoga pants will sell them on Brooklyn's Smith Street," it would have seemed absurd. Back then, Smith Street was to be avoided for its dodgy storefronts and illicit activities happening on corners and in back rooms on behalf of drug lords or the mob.

By 2000, Smith Street was coined Brooklyn's Restaurant Row, and you'd happily go there for a good

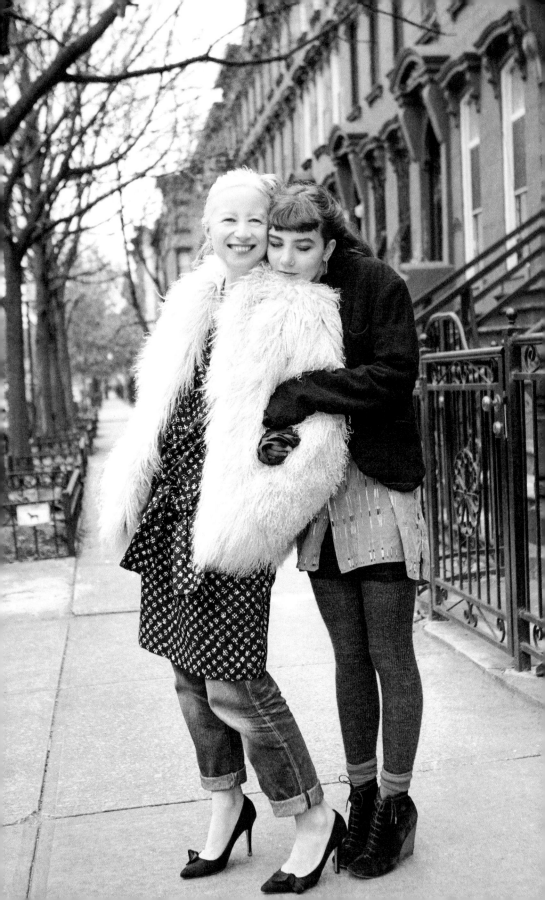

Who knew that so many of us reside, in our mind's eye, in some hipper-than-hip outpost of Brooklyn?
—**Anna Wintour,** Vogue

A Détacher designer Mona Kowalska and her daughter, Claire Linn, share a moment on their Clinton Hill block. Kowalska, a master of the layered look, wears a vintage fur coat over an A Détacher front-tie cotton dress, RRL jeans, and Isabel Marant suede heels. Linn, a student at the Art Institute of Chicago, wears her own vintage finds with A Détacher leggings.

French meal at the pioneer restaurant Patois. Even devoted Manhattanites started to brave the F or L subway lines to the outer borough for dinner out in Brooklyn—something that was still all a new adventure, with maybe the exception of a historic visit to Williamsburg's Peter Luger Steakhouse or Lundy's seafood restaurant in Sheepshead Bay.

Brooklyn's food revolution had yet to catch fire. Once it did, the borough's gastronomic fanaticism captured the attention of trendsetters who hadn't already converted to the church/synagogue of Brooklyn via Spike Lee, Erykah Badu, Paul Auster, or the Beastie Boys. Ultimately, some combination of art, music, food, and cheap rent (the siren song for artists, musicians, and chefs) propelled Brooklyn to the center of the fashionable world, at least in the "mind's eye," as Anna Wintour declared.

Based on the astronomical coffee and real estate prices, new boutiques and boutique hotels, the sound of jackhammers ricocheting across the borough, and the three-Michelin-starred Chef's Table at Brooklyn Fare, we can say that the borough's star is still rising. People the world over look to Brooklyn as a beacon of design, art, pop culture, and fashion. This is not your

grandmother's Brooklyn, however, or even the dustier, more economical Brooklyn of a decade ago.

We say this as lifelong New Yorkers. Our writer, Anya, a third-generation Brooklynite and cultural reporter, has watched the Brooklyn phenomenon happen from Brooklyn itself. During the 1980s, her mother owned two vintage clothing stores on Park Slope's Seventh Avenue. Our designer and project editor, Shawn, has been working on photography, fashion, and style books for almost as long as the twenty-five years she has lived in New York. An excellent seamstress, she often makes her own clothes. Fashion, beauty, and portrait photographer Sioux Nesi lives on Brooklyn's Smith Street and has photographed many iconic women, including Oprah Winfrey, Marianne Faithfull, and Tracee Ellis Ross. Sioux's work appears in magazines and advertising campaigns worldwide.

In creating *Brooklyn Street Style*, we wanted to explore how Brooklyn came to be so influential to fashion and style and portray it with authenticity. The center of alternative-youth culture is no longer Williamsburg, which instead is now Brooklyn's version of a

Fearless dressing is a sign of Brooklyn pride. Everyday People events organizer Saada Ahmed perfects a vivid yellow Zara suit that she had tailored. Ahmed was photographed at the South African restaurant Madiba, which has been a Fort Greene mainstay for nearly twenty years.

 A sense of confidence grows on a person when they're living in Brooklyn. It just happens, because you see other people wearing what they want to wear boldly, just blatantly expressing themselves. And you think to yourself, 'Why not? Why can't I dress in my own version of that boldness?'
—**Eniola Dawodu**, designer

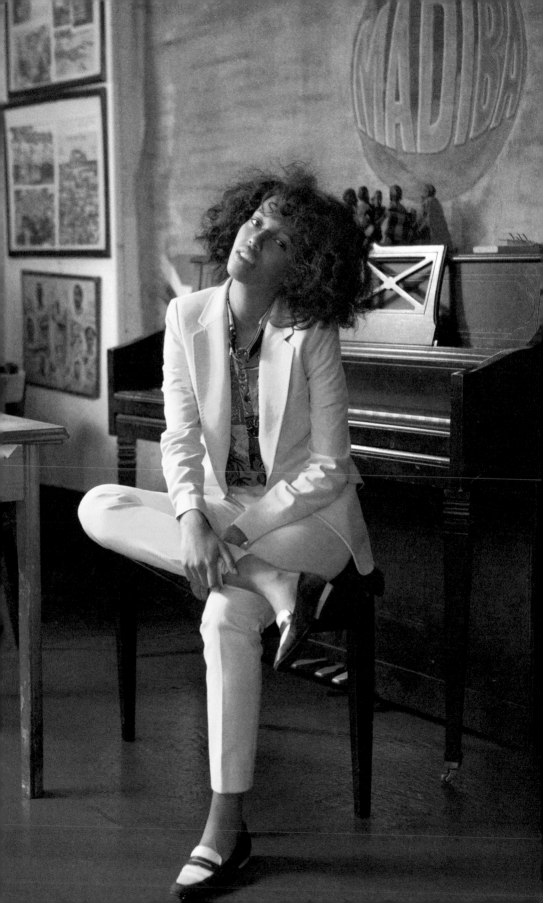

> *Brooklyn is a great canvas for self-expression.*
> **—April Hughes,** stylist

luxury district with swanky shops, restaurants, and the boutique Wythe Hotel. That energy and edgy fashion have pushed their nexus south and east to Bushwick, Bedford-Stuyvesant, and Crown Heights. At the same time, the adjacent neighborhoods of Brownsville and East New York are still among the poorest areas of the city, despite the influx of capital just a few miles away. Brooklyn is a complex living place.

The layered, eclectic, and cultural nature of Brooklyn is what makes it interesting and nurtures innovation. We chose the women in these pages—among them a boxer, butcher, DJ, designer, florist, and boutique owner—for how they embody Brooklyn. We looked to them to explain what Brooklyn style is about. And guess what? These chicest, hippest, coolest of women say that anyone can create their own Brooklyn style from any zip code. Brooklyn style is an acceptance of yourself and the daring to be and wear whatever that may be, independent of what is currently considered fashionable. The most stylish women of Brooklyn are from different countries and neighborhoods. They don't wear the same thing or look the same way. Their most common trait is that they are individualistic, comfortable in their own shoes (or sneakers, or boots, or wedges…). With that in mind, who doesn't want to be very Brooklyn, regardless of where you're at?

Dossier Journal creative director and photographer Skye Parrott wears mid-waist flared Marc Jacobs jeans. The low-rise skinny cut was fashion's favorite for several years, but in true Brooklyn spirit Parrott mixes it up.

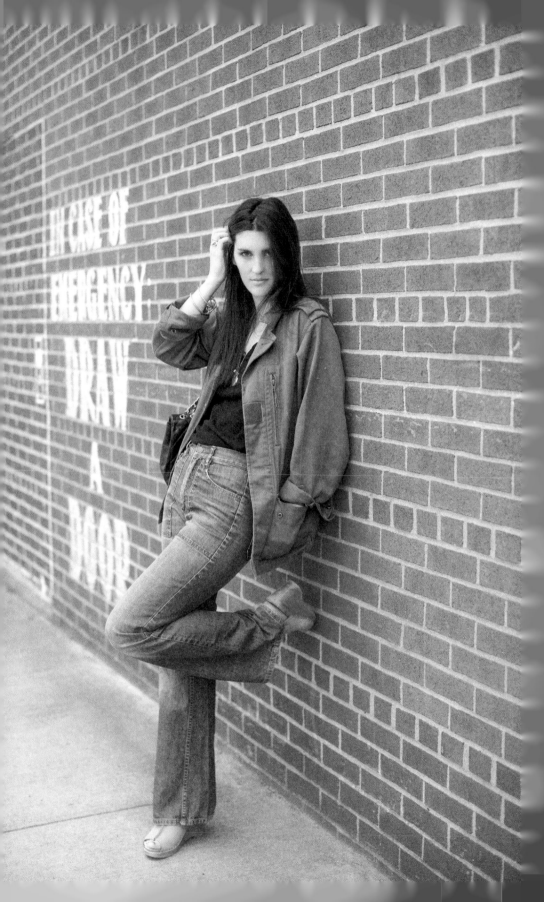

MAKE
YOUR
OWN
RULES

1

In this borough of 2.6 million people from all over the globe, there is no singular Brooklyn style. One woman in black skinny jeans and a Rag & Bone T-shirt crosses paths with someone sporting offbeat thrift-store threads. The woman standing next to her wears loose layers in neutral tones. And next to *her* is someone in a vibrant head-to-toe mix of prints. You are as likely to see one style as the other, all within the same city block.

Particular style absolutes that are true elsewhere do not hold up in Brooklyn. White jeans and white dresses in winter are chic. Black and navy pair beautifully. Clogs and sneakers go with everything. Yet, this is not eccentricity for the sake of it. It is well considered, by design. The doyenne of this Brooklyn style is Jennifer Mankins, owner of the borough's small boutique chain Bird. A native of Texas and a Brooklynite since 1999, Mankins has a signature smile that projects her warm Southern vibe. Her bespectacled beauty—she's always found in round Selima Optique blue or red frames—comes off rather Annie Hall, but if Annie had loosened up on a trip to Rajasthan, come back dressed

in layers of colorful patterns, and then thrown one of her vests over it all.

"I love color, print, textiles, patterns," Mankins says. "So I'm not your typical stylist wearing black and navy and taking herself and her fashion too seriously. My stores were born out of that, too."

In New York City fashion circles, Mankins (now a Ditmas Park, Brooklyn, dweller) is revered for elevating her arty look and helping to define the Brooklyn aesthetic in the process. She favors all kinds of dresses, peasant-style blouses or tunics, and something she calls "the soft pant," which often has an elastic waist and is made of a forgiving fabric, perhaps something in a silk crepe.

Jennifer Mankins layers on New York designers: Selima Optique glasses, Lizzie Fortunato necklaces, a Rachel Comey jean jacket, and a Zero + Maria Cornejo dress.

At Bird, you will not find anything too tailored, too girlie, or intentionally coordinated. Instead, clothes drape on a woman's form. Colors and patterns reign. Caftans, capes, jumpsuits, and vests are in heavy rotation on the racks. Mankins' choice of designers leans toward a look that is cool: the masculine appeal of Rachel Comey, the exquisite simplicity of Maria Cornejo, or anything from bohemian-spirited Isabel Marant. But, above all, pieces must be comfortable and fit with your life.

There are no dos or don'ts. Enjoy everything. Love wearing sequins during the day or wearing things that aren't typical. Why have beautiful, special things and only wear them one time? Just wear them. Nothing is going to happen to them. It's OK. **—Jennifer Mankins,** boutique owner, Bird

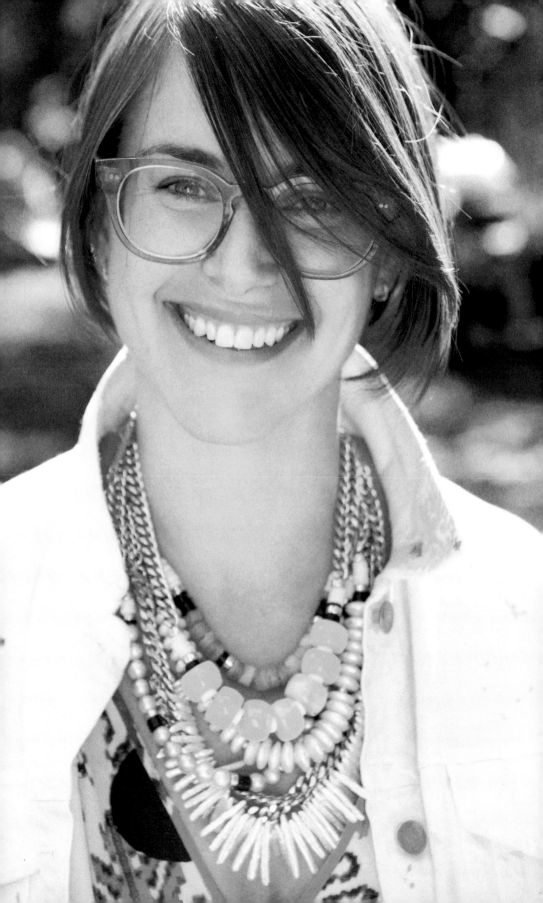

If we talk about the ideal in this neighborhood, maybe it's more important to have a nice bike than a high-fashion item. Or, you can have a designer handbag on your bike. Or, you can have a crappy bike and a fancy dress. Or, you can have the opposite. There are no rules here.

—Sofia Hedström, fashion director, *Women's Health* (Sweden)

"The word 'pragmatic' is not a sexy fashion word," Mankins says. "But there is something about living in Brooklyn—your style has to work and function. In Brooklyn, we're running around. We're jumping on the subway. We're constantly on the go. Until recently, it wasn't like you could put on your heels, walk out the door, and hail a taxi."

Brooklyn women do not feel beholden to wear something just because it is expected of them. Swedish fashion writer Sofia Hedström, who has lived in Williamsburg for more than a decade, often contrasts Europe with Brooklyn. When she attends Paris Fashion Week, she feels it's necessary to dress up, wear heels, and carry a good-looking bag.

"There are more expectations that I have to be a certain way," she explains. "Here, your life is always on the go. You never know if you're going from work to a dinner, to a party, or for a run. Everything blends together, and it doesn't really matter. That's why you have these beautiful combinations of high and low—like a T-shirt with diamond jewelry. Also, the influence of hip-hop culture and underdog culture is key to Brooklyn style. If you like diamonds, you'll wear diamonds, and that's allowed. It adds humor to Brooklyn style. In Paris or

Journalist Sofia Hedström throws her Marc Jacobs bag in the basket of her old fixed-gear ride, which she found at B's Bikes in Greenpoint.

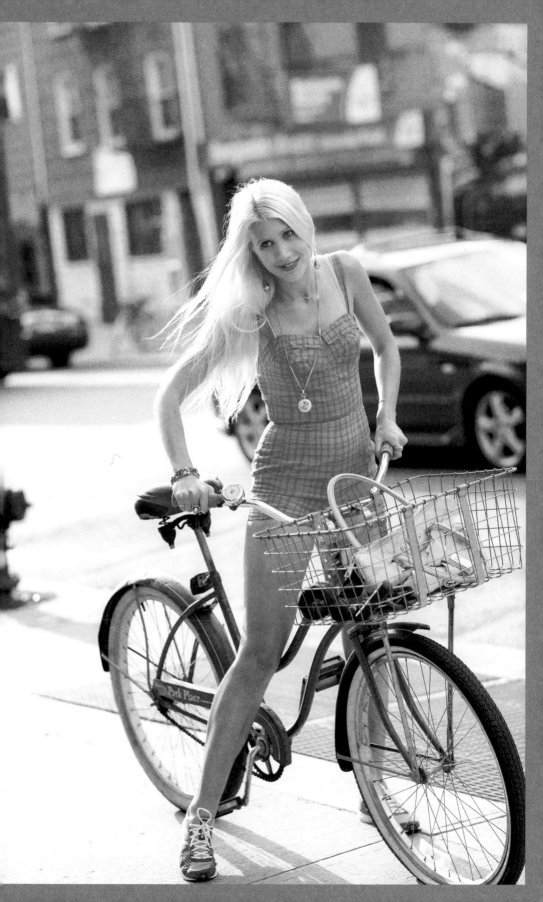

Stockholm, you should be more reserved and know the rules, whereas every day in New York City can be a fashion show."

Hedström considers herself somewhat of an underdog, as she is not from the urban center of Stockholm, but rather from a small town called Skara in southern Sweden. The area, "a very unsophisticated farmland," she says, is called Slätta (short for Västgötaslätten). Her Swedish friends in New York loved to tease her about it, and, because of this, Hedström's nickname became Slätta. She designed and made a gold cursive-script ring featuring the name of her home rapper-style, as a shout-out to say, "Slätta in the house!"

"When I go back to Sweden, I feel proud about wearing this ring," she says. "Every time people see it, I laugh, but they get confused about me being so loud about where I'm from when it should be something I hide because it's not so sophisticated."

In many ways, it's the melting-pot ideal that forms the basis of Brooklyn style. More than half of the borough's residents speak a language other than English at home. According to the U.S. census, the racial breakdown is roughly equal between whites and blacks at a little more than one-third of the overall Brooklyn population for each. Nearly twenty percent are Latino; and almost twelve percent are Asian.

"Here you can look different because people come from different cultures," Hedström says. "People speak different languages. It's a very free subculture."

These Are
Not
Rules

If you're searching for inspiration, look no further than these women who take liberties with their fashion. A sense of freedom is what Brooklyn style is about.

Comfort is chic, but slovenly is not.
ICON: *Lauren Hutton*

Too matchy-matchy is too matchy-matchy.
ICON: *Solange Knowles*

Something unexpected keeps an outfit interesting.
ICON: *Chloë Sevigny*

You can never go wrong by keeping it simple.
ICON: *Sofia Coppola*

The ultimate style accessory is your own self-confidence.
ICON: *Angela Davis*

It's not very New York, very American, or very Brooklyn to tell people what to do. We all come here so we don't have to be told what to do.

—*Karyn Starr*, cofounder, White-Starr Aesthetic Consulting

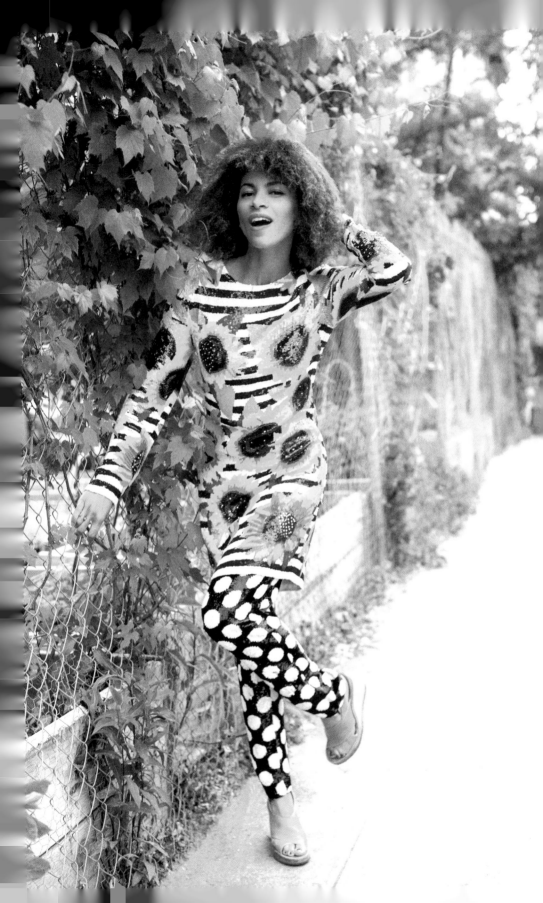

Though Hedström's roots are in rural Sweden, her take on Brooklyn is the same as that of Parisian-born singer Adeline Michèle, who fronts a disco/funk band and lives in Crown Heights. Michèle grew up in the suburbs northeast of Paris, an area associated with violence and crime and very far from Paris Fashion Week. Her biracial parents moved to the area while the projects deteriorated around them. As a mixed-race girl, Michèle says she was a minority in her community. She moved to New York City at age eighteen to work and play music, and fell in love with Fort Greene, Brooklyn.

"All these people were black, white, Asian," Michèle says. "I was standing in this neighborhood where everybody was either mixed or some sort of mix or mixed together. You didn't have to be black. It was just being with people who were 'other.' And they were all stylish."

Growing up in suburban Paris, Michèle was used to seeing African influences everywhere—those in her parents' generation often wore traditional dress. But the way Fort Greene women carried the earthy, Erykah Badu–inspired style of long earrings and African patterns was completely new to her. Michèle had never seen her Parisian peers mix colorful prints in an outfit or combine the look with something as casual as jeans or sneakers.

In Brooklyn, Michèle began shopping vintage, finding unique pieces that no one else had. She started wearing more patterns as part of her look. She decided

Adeline Michèle, lead singer of Escort, declares: "I'm in a disco band—I'm not going to wear bell bottoms, I'm going to wear sequins!" She favors pieces from the king of sequins, Delhi-born and London-based designer Ashish Gupta. His sparkling sunflowers blend with Michèle's Crown Heights community garden.

to embrace her naturally curly hair and wear it out or tie up her curls in a turban or a headpiece. Today, she feels free to dress how she likes, and will always try to incorporate a pop of color. For the everyday trip to the grocery store, she might throw on, say, tight black jeans, an orange tiger sweater, a black-and-white head scarf, and sunglasses.

"What I take from American fashion and American culture is, be as loud as possible, be as colorful as possible. Nobody will talk shit about you. The crazier you are, the more we love you. That's not something we can do in France."

There is something of the original American spirit still in Brooklyn today. We don't have cowboys, per se, but plenty of artists, techies, and otherwise creative freelancers dress like them in jeans, boots, and plaid shirts. Urban pioneers set up boutiques, restaurants, cafés, and galleries in neighborhoods where there were few of these spaces before. People predominantly from Latin America, Asia, and the Caribbean continue to migrate to Brooklyn, following the European waves from a century ago. All these factors help create a place where pretty much anything goes. People who thrive here wear their freedom of expression, which is the one unifying element of the Brooklyn look. It's in the essence of your approach. You can interpret these Brooklynites' varying philosophies, then put them together to create the style that is you.

An Anna Sui jacket over a dress from Anthropologie brightens up chef Leslie Parks' rainy day at the Brooklyn Borough Hall Greenmarket. Michael Kors heels.

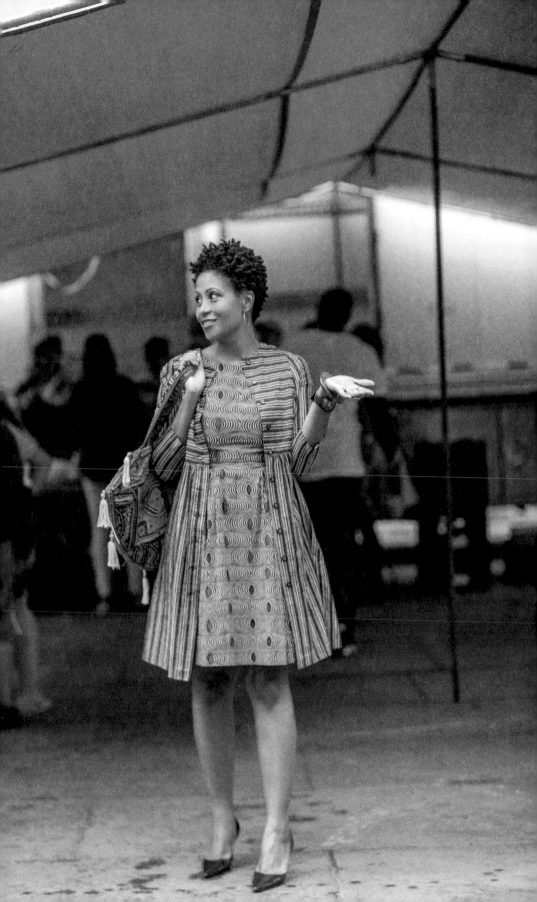

Interlude...
MIXING PRINTS

The maximalist knows how to combine stripes, dots, paisley, and plaid in one outfit. For these women, more is more. Here's how they do it.

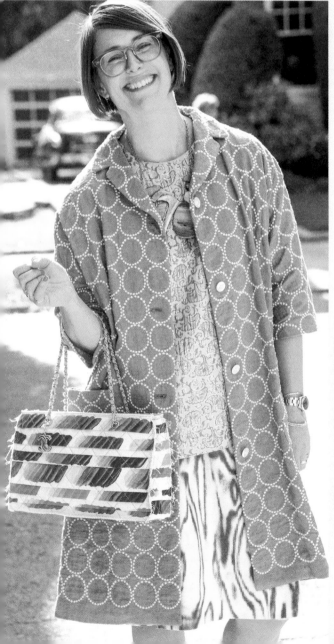

Bird boutique owner Jennifer Mankins (left) has a closet of stunning prints and colors from top designers around the world. Here, she wears a circle-motif Minä Perhonen coat by Japanese designer Akira Minagawa with a Dries Van Noten brocade top, 3.1 Phillip Lim skirt, Chanel bag, and Melissa Joy Manning necklace. From Mankins we can see how to vary the density and shapes of patterns in an outfit to play against one another, which can be done on any budget.

A mood board like the one in designer Ulla Johnson's studio (below) helps to visualize how different fabrics can be combined and contrasted.

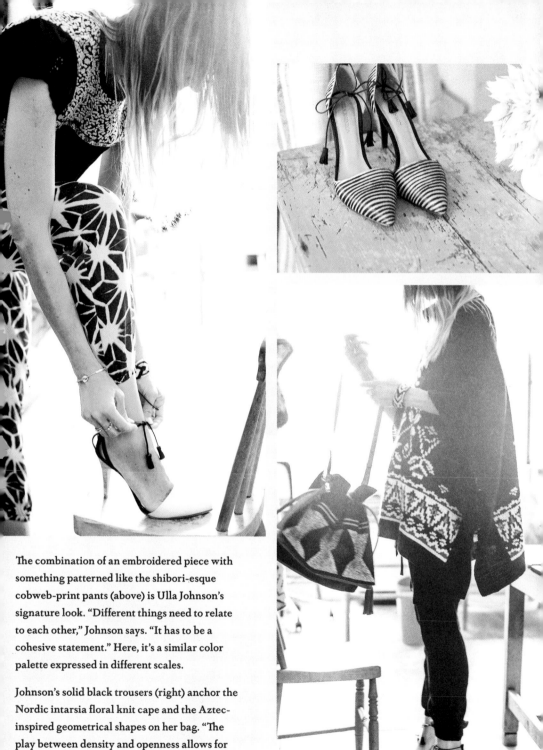

The combination of an embroidered piece with something patterned like the shibori-esque cobweb-print pants (above) is Ulla Johnson's signature look. "Different things need to relate to each other," Johnson says. "It has to be a cohesive statement." Here, it's a similar color palette expressed in different scales.

Johnson's solid black trousers (right) anchor the Nordic intarsia floral knit cape and the Aztec-inspired geometrical shapes on her bag. "The play between density and openness allows for a quietness," she says. Unifying a color palette such as black and white, including the stripes on Johnson's heels (right and above right), creates an ensemble that works.

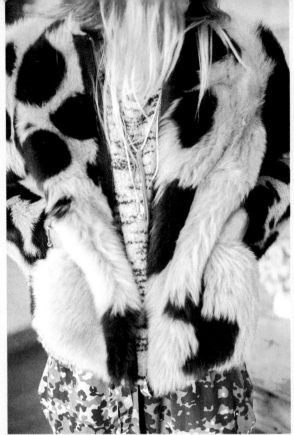

The blurred edges on details in patterns like shibori, ikat, and batik have an organic quality that allow them to mix together. Similarly, the shearling jacket (top left), pixelated camouflage pants, and muted sweater all have a softness that relates. Extreme contrasts in scale pair well in the tiny dotted top and large multistriped pants (below).

Designer Eniola Dawodu (below left and right) pairs quiet stripes with a tote of multi-colored shapes and mirrors.

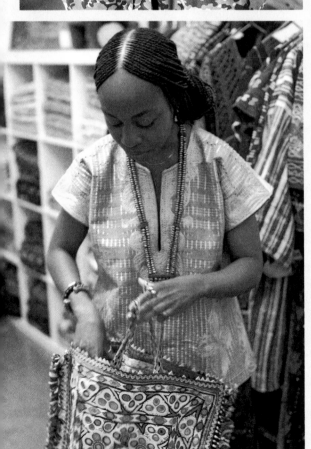

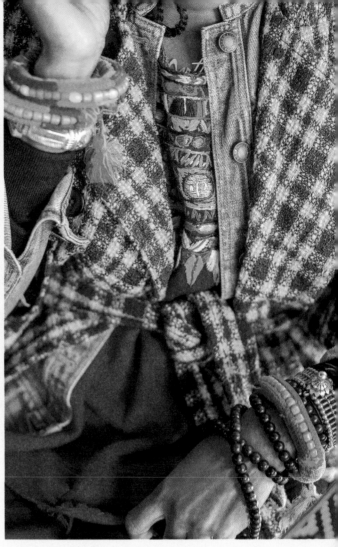

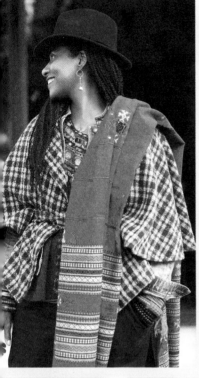

A wool plaid belted cape, denim jacket, embroidered blouse, and blanket scarf up the ante on mixing prints for stylist and designer Debbie Hardy (above left and right), yet they all relate in color. The dominant turquoise in the scarf highlights the bit of teal in the plaid; the bright blouse mirrors the pink in the scarf.

If you are hesitant to wear a variety of patterns on your body, consider what Leslie Parks (near left) achieves to eye-catching effect by carrying a large purse with a graphic design. Or mix prints in smaller doses, broken up with a solid piece. Try a scarf or bag in a beautiful flower print with a striped shirt and a solid-color jacket.

MIX
IT
UP
2

A green plaid UNIQLO shirt on Mona Kowalska, the designer of A Détacher, looks fitted and sexy. She wears it braless, with the collar folded under, and unbuttoned several inches, like a 1970s deep V-neck. The shirt is tucked into a pair of A Détacher layered black mesh pants, which are cut like long basketball shorts over skinny sweats (and retail for several times the price of the shirt). Her hair is swept up in an elegant loose knot, and she also wears a combination of statement jewelry—several rings, a necklace, and a daith ear piercing (*da'at* means "knowledge" in Hebrew). Aside from lipstick, the fair-skinned, white-blond Kowalska wears no makeup.

The outfit defies categorization. The plaid shirt has no connotation of grunge, country, or anything rugged. The pants are from Kowalska's collection called Sports Injury, but they don't look sporty at all. Her messy updo is perfectly disheveled in the way French women wear it. The daith piercing and snake ring are iconoclastic. Somehow, Kowalska looks polished and edgy, seductive and sensible. It's difficult to picture the same outfit on anyone else.

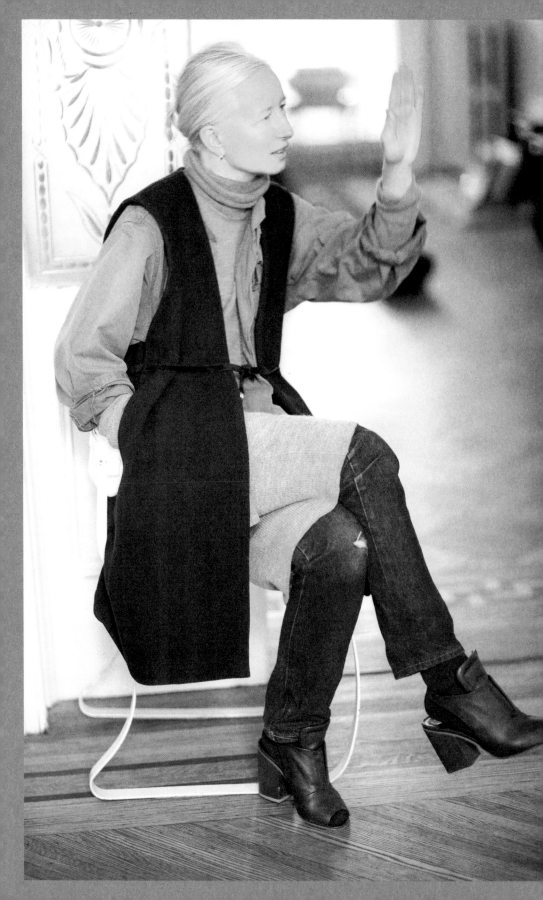

We haven't progressed beyond sexy librarian. That's as complicated as it gets.

—*Mona Kowalska,*
founder/designer,
A Détacher

By combining her own A Détacher piece with the more basic, affordable UNIQLO shirt, Kowalska demonstrates what many women do these days—mix high and low. It's the rare fashionable subject who dresses all in designer wear because, really, who can afford it? But Kowalska adds another element to her fusion. She doesn't dress as a type. We love her look, and there's no easy way to define it, except to say she is unique. "There are just too few stylistic roles for women," Kowalska says. "You're either the vixen or the librarian. You look smart or you look stupid. In the twenty-first century, how is that even possible?"

The Polish-born designer, who has also lived in Paris and is now a Clinton Hill resident, has a modern approach to women and fashion. Women are many things at once: modest and sexy, athletic and arty, mothers and careerists, and so on. Combining varied elements of the day-to-day calls for a multidimensional way of dressing. Indeed, Brooklyn is the kind of place where women do diverse things: pursue families, jobs, creativity, and athleticism or start up a business, label, or studio. Many of the women in this book acknowledge one another as strong, inspiring influences in their personal and professional endeavors.

Kowalska also admires a handful of European women designers who successfully embrace these

The sophisticated, layered look of Mona Kowalska combines an A Détacher black wool tunic vest with attached leather belt, a cashmere sweater dress, and a vintage army jacket. Kowalska cut the collar off the jacket.

Mix *This* with *That*

"The trick is taking a runway trend and incorporating it into your wardrobe in a way that doesn't break the bank. Blend them with your own personal style." —Olivia Palermo, socialite and resident of Dumbo

Vintage items that may be faded, frayed, or otherwise loved and lived in
ICON: *Kate Moss*

\+

New items with contemporary tailoring and fit, modern fabrics and details

Sporty, comfortable athletic gear
ICONS: *Rihanna, Gwen Stefani*

\+

Formal, dressier garments

Masculine shirts, trousers, blazers, shoes, and coats
ICONS: *Audrey Hepburn, Diane Keaton*

\+

Feminine skirts, dresses, blouses, and heels

Global goods from your travels
ICON: *Erykah Badu*

\+

Beloved favorites already in your closet

Affordable basics
ICON: *Olivia Palermo*

\+

Investment pieces made with exceptional materials and construction

Interior stylist and author Kathleen Hackett at her Boerum Hill home. She loves statement pieces, such as the vintage Sonia Rykiel gray feather shrug she wears with Nili Lotan genie pants and J.Crew lace-up wedges. "I would claim that I love a uniform, in theory, but my closet says otherwise," Hackett admits.

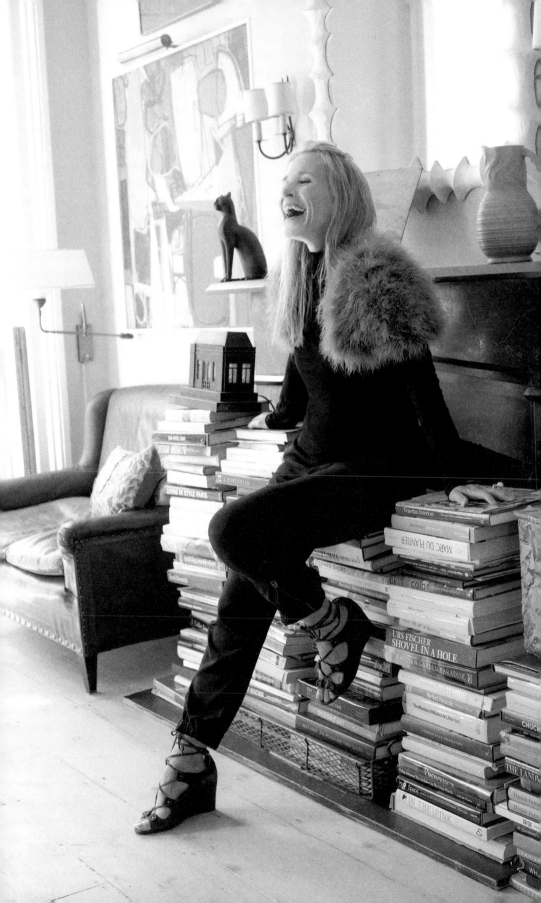

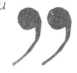

> *The way you dress can give you an extra boost of happiness.*
> —*Cary Vaughan,*
> designer, Ace & Jig

multifaceted identities in their work. She cites the masculine-toned simplicity of Phoebe Philo's Céline and Miuccia Prada's chaste, buttoned-up version of granny-sexy. "Maybe you're sporty and not sporty at the same time," Kowalska adds. "Maybe we're always the thing and then its opposite. That's where it gets interesting, because otherwise there's a flatness to it."

These tastemakers set the contemporary tone of style by mixing genres, eras, and types of pieces. Philo, who is British and runs a French fashion house, launched a mad craze for white Adidas Stan Smith sneakers when she was spotted wearing them after a Céline show in 2010. Four years later, the Parisian boutique Colette displayed its limited-edition version at the center of its window display, surrounded only by the store's signature blue dots. The sneaker clash effect—wearing kicks with something dressier than jeans or sports gear—has not typically been part of the French woman's repertoire. However, it has long been au courant for Brooklyn.

Saada Ahmed, cofounder of a New York City brunch party called Everyday People, always wears sneakers with something more refined, like a suit or a dress. Born in Kenya, Ahmed grew up in Atlanta before moving to Brooklyn and eventually settling in

Designer Cary Vaughan, in her Ace & Jig buffalo check top and maxi skirt, adds a pop of yellow with a Reed Krakoff bag.

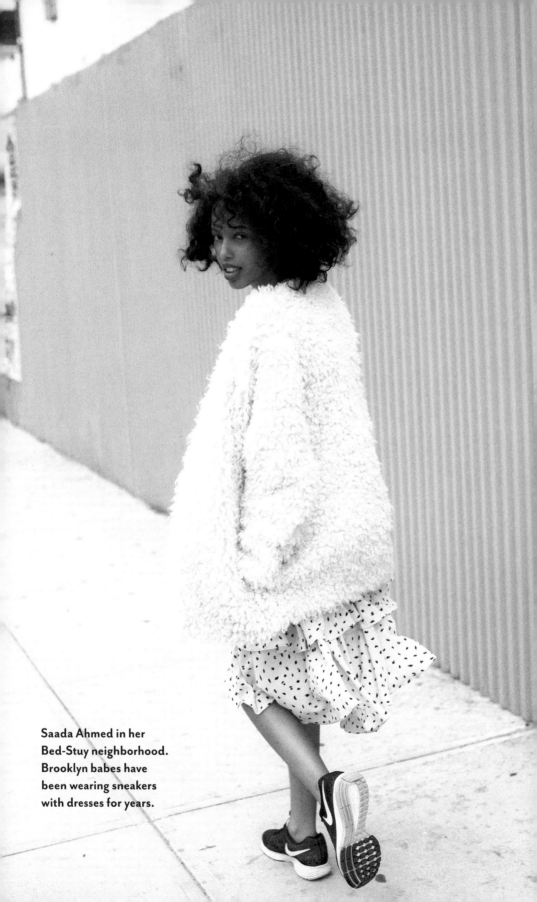

Saada Ahmed in her
Bed-Stuy neighborhood.
Brooklyn babes have
been wearing sneakers
with dresses for years.

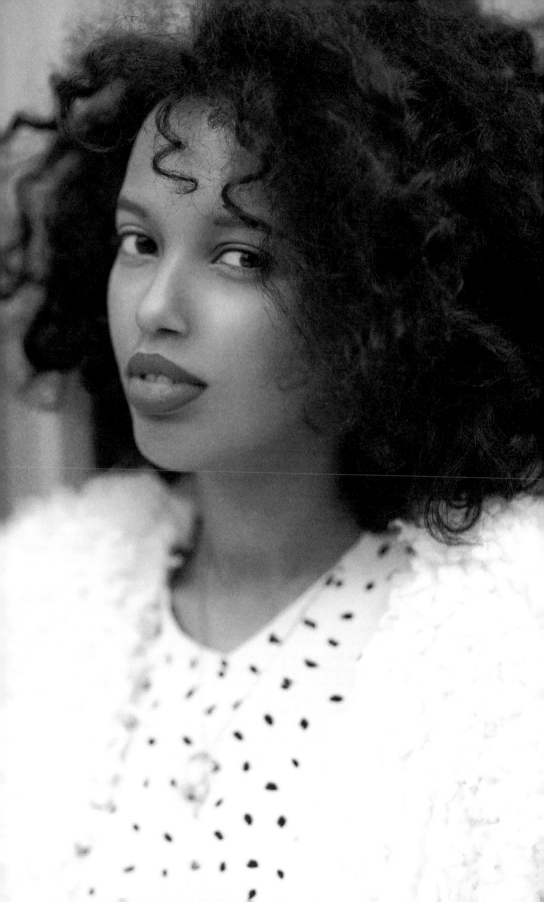

Bedford-Stuyvesant (Bed-Stuy). Style blogs, including J.Crew's *Girls We Know*, feature Ahmed for her tailored, global-eclectic look. She likes contrast in what she wears. If she puts on bold lipstick, she wants her clothes to be a subdued color. Or something tight always goes with something baggy. "I mix, in terms of comfort," Ahmed says. "I like to look feminine, but I wear sneakers."

Like Ahmed, playwright, actor, and singer Eisa Davis says her own sense of style is contrarian. She loves vintage pumps, but might wear them with ripped-up jeans or a pair of Rag & Bone sweatpants. The ever-thoughtful performer, whose play *Bulrusher* was nominated for a Pulitzer Prize, points out that wearing casually styled pumps in Brooklyn carries a different association than wearing the same shoes on Manhattan's dressier, moneyed Upper East Side. "A certain item will connote something," Davis says. "Then you can play with the meaning of it, depending on what you pair it with or who you are and what people expect of you. If you wear a piece that's unexpected, that's interesting to me."

Davis, who grew up in the San Francisco Bay Area and now lives in Fort Greene, adds that the meaning attributed to clothes and brands is in the eye of the beholder. "If I see someone wearing a Polo shirt, does that mean they're a golfer or playing tennis?" she says. "Not in this neighborhood." Polo Ralph Lauren, originally created as an aspirational label of the wealthy,

Eisa Davis in a vintage flower-print jumpsuit, red Madewell sweater, H&M denim jacket, and a wool plaid-and-striped Suno poncho. Brooklyn-based Suno does production work in East Africa and takes inspiration from Kenyan kanga fabric, which joins two different patterns like a bandanna. "A reversible poncho is another way of creating print-on-print energy," Davis says.

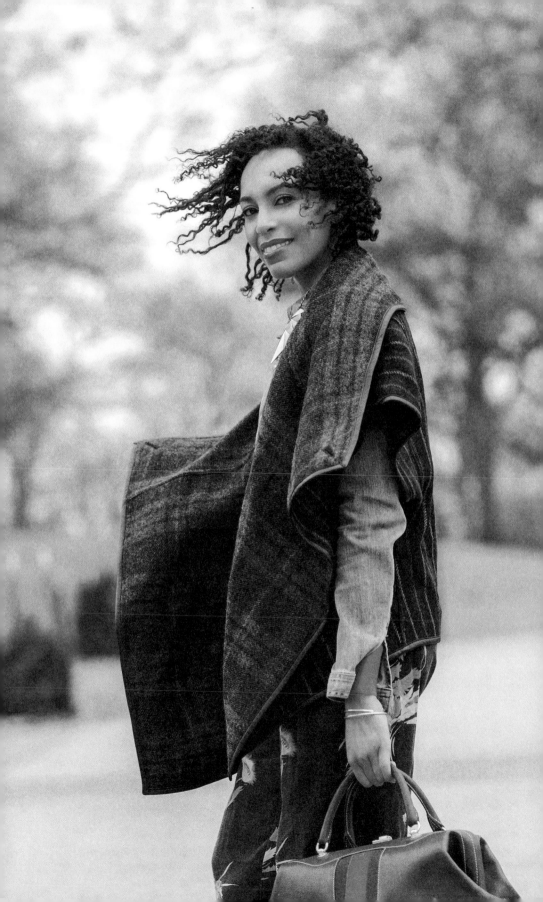

underwent an unintentional rebranding when a 1980s Brooklyn gang called the Lo-Lifes adopted it as their uniform. Throughout the nineties, gang members in Crown Heights, Brownsville, and East New York wore their "Lo" head to toe, across the borough.

"So much of what is happening in style and fashion is about irony, appropriation, and using old meanings, then placing them in a new context of mixing one thing with another," Davis says. "That provides a fresh permutation on an old way of seeing things." These days, Davis notices people in her neighborhood rocking their prep gear with looks that are punk, skate, hip-hop, or high-end, and every kind of combination in between. No one, it seems, wants to be typecast, especially in Brooklyn. The Lo-Lifes adopting Polo as inner-city street chic way predates Philo elevating Adidas to fashion it-shoe status. But it's the same thing: wearing something in an unexpected way that gives it a new context. This helps us personalize the image of our own complicated identities as people. Because we're never just one thing or the other. Philo has some street in her. And the Lo-Lifes have style.

I like the idea of wearing something super tough with something super pretty. . . . Opposites always attract in fashion. Something usually comes to life when you put it with something completely unexpected.
—Chioma Nnadi,
fashion news director, Vogue.com

Q&A

with Jenn Rogien, costume designer, **Girls**

In 2012, along came writer/actor/director Lena Dunham's HBO series *Girls,* which captures the great struggle that is our post-college twenties. Set mostly in Brooklyn along the borders of Bushwick, Williamsburg, and Greenpoint, the show follows four friends: the ever-burdened aspiring writer Hannah; type A Marnie; lackadaisical British bohemian Jessa; and her spunky cousin, Shoshanna.

Girls' costume designer Jenn Rogien captured the zeitgeist with the show's Brooklyn style. A longtime Clinton Hill resident, vintage devotee, and Yale graduate who studied art and psychology, Rogien has an astute sense of her characters. Here, she speaks to us about creating her vision of the Brooklyn look.

How do you define Brooklyn style? It's not hipster style.

I have tried to leave the word "hipster" out of the vocabulary. At this point, it is so unspecific that it needs a qualifier in order to recognize what kind of look I'm talking about. We also have stopped referring to Williamsburg as the neighborhood look that represents what we're trying to do. Williamsburg has changed entirely since we started shooting the show. It's not the same since the high-rise buildings over the water opened. When I lived in Williamsburg nine years ago, I was the only one walking to the subway at seven o'clock in the morning. Now at seven o'clock in the morning, there is a stream of people crossing Kent Avenue to go to work.

I think it's hard to distill Brooklyn style to just one definition. Brooklyn is such a large area. Each neighborhood tends to have its own sensibility, and the look or the style tends to go with that.

How do the *Girls* characters represent Brooklyn?

They are evolving every time we see them. I think that directly reflects Brooklyn. You look once and it's

one thing. You look again, and it's moved on to something else. People who choose to live in Brooklyn are always exploring the next thing that's interesting.

It was always said that fashion was the fifth character in *Sex and the City*. We see that in *Girls*, but in a totally different way.
The clothes have taken on a life of their own. And now I'm seeing so much reality on-screen, that genre of very realistic portrayals of complicated characters. That's what we started with *Girls*. In retrospect, it was quite surprising that all the clothing wasn't new. It wasn't in season. A lot of it was from the thrift store, maybe a vintage store. And some of it had been altered to intentionally look more realistic and worse in order to achieve the character's effect. We stripped away the Spanx. We took out all the belts. With Hannah, we wanted hemlines in the wrong place, too long, too short—just the wrong spot on Lena's body in order to achieve the character's look.

What's the role of vintage on the show?
Vintage is part of my toolbox as a designer. Vintage things are truly unique and can tell your story in such a specific way. And there's a distinction between thrifted clothing and vintage. Vintage has a specific set of qualifications and a date range. If you're going through something that's been curated and you can approximately date the item, then you might be in the vintage world. If it's a massive warehouse, you're likely thrifting.

How do you see Brooklyn women wearing vintage?
Oftentimes, you can't tell, and that's the best use of vintage. And when it's just a great vintage dress, it's like, "Wow, that's a great dress. Oh, it's probably vintage."

It has become popular in the last few years to incorporate vintage pieces into your look. But, there is a world where it goes too far. We did a fitting where it was all thrifted pieces. I looked at the photos and said, "She looks like she's wearing a costume." That's the challenge of using vintage in your life or as a costume design tool. There is a line that can get tricky.

What style lessons do you think women gain from the show?
There are so few rules at all in fashion anymore. I mean, sweatpants are an acceptable item to wear anywhere these days. There are some

very cool and chic sweatpants in the world, so don't get me wrong. There's a way to do it.

We put on costumes every day to make ourselves feel a certain way. There's emotion in our clothing. How do you portray that?
There's a whole psychology of fashion. It's about how we feel and how we express that. I try to tie that into whatever I can.

That's what attracted me to clothing in the first place. It is all self-expression. Humans are visual animals. And, oftentimes, the thing that you will experience about another person is what they look like and what they're wearing, before you ever hear their voice or have any other way of assessing their character.

So, in character design, I have a split second to try to convey their emotional state, their socioeconomic state, potentially their occupation, maybe their orientation, any religious affiliation. I have to tell all of that through their clothing. Sometimes it's very succinct. Sometimes it's the typical lab coat. It's scrubs. It's a uniform: inmate, correctional officer, police, postal service.

On *Girls*, it's important to create a contrast between Hannah and Marnie specifically. Hannah's wardrobe was never ironed and barely steamed. I have a whole wardrobe team that takes incredibly good care of the clothing. I would come in and say, "Please steam that dress and drop it at the bottom of the garment bag to stay there overnight until tomorrow morning." And they had such a hard time doing it at first because it intentionally looks like you picked up a thing off your floor.

Which is, of course, what Hannah would do. What about Marnie?
Marnie is laundered, dry-cleaned, pressed, ironed, steamed—very much meticulously cared for in terms of her wardrobe. She always had earrings, a necklace, a ring, and a bracelet for every scene. Hannah sometimes had earrings and one ring she wears with everything. Sometimes it was very free-spirited. I had to express those two characters very distinctly. It was the preparation of the clothing, not just the clothing choices themselves.

What do you see in Brooklyn style that inspires you?
It's hard to describe Brooklyn style because as soon as you come up with a way of describing it, it's moved on to something else. It's constantly evolving.

DRESS FOR LIFE

3

here is a certain woman who looks good no matter what she is doing. You see her all over Brooklyn: standing on a subway platform, riding a bike, dropping her kids off at school, walking the dog. She will wear a vintage leopard coat over baggy jeans to do the school run. Or, she may shop the farmers' market in a simple Mexican-inspired embroidered dress with gladiator sandals. Perhaps she combines prints—ikat, batik, and stripes—that look pulled together in the mix.

It's easy to sigh and toss it off as effortless chic. However, few of us can throw ourselves together without much thought. Those forever-fashionable icons such as Jane Birkin make it look like it all just happened, when, in fact, creating personal style takes work. We can envy someone like rocker Patti Smith, who could put on a tank top, a black felt bowler hat, and, with no makeup, look tousled, sexy, and cool. But for most of us, style is a more studied affair.

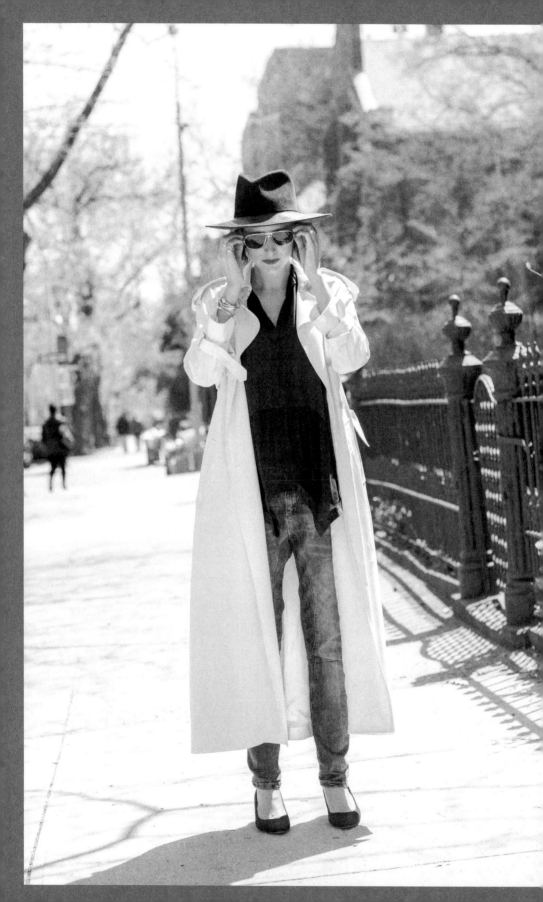

Style is important because what we wear can make us feel good in our own skin. Everyday style carries us through everything we do, enabling us to best face the world. It's your life; why not get dressed for it?

Thankfully, there are women who possess the gift of garb and inspire those of us who are more challenged. Karyn Starr, a petite, fast-talking mother of two who lives in Clinton Hill, makes her living as an aesthetic consultant. She is a stylist for the everywoman and will descend on your closet and help transform you into the best-looking version of yourself.

"I know that people feel better when they put care into finding clothing that fits their spirit," she says.

Starr is interested in what women do every day and what they wear to do it. She also helps women develop a style for who they are. To offer an example, Starr talks about an architect who worked mostly for clients in the fashion world. The architect resorted to wearing all black because she felt it worked.

"When I saw her house, it was amazing," Starr says. "It was preppy, how you'd envision Kate Spade's house would be, with pink and green and vintage wallpaper. I said, 'What's going on?' There was such a disconnect. But when it comes to the body, things go back to how your mother treated you and to all your psychological-political body stuff." After her Starr sessions, the architect developed an offbeat preppy look that incorporated more color and pattern, but also retained a classic silhouette, very iconic à la Audrey Hepburn.

Karyn Starr raises the style quotient every day. For a walk in her Clinton Hill neighborhood, Starr wears impeccable classic pieces: a Steven Alan trench, Givenchy blouse, Cotélac jeans, and Donald J Pliner pumps. The vintage Cartier shades belonged to Starr's father. Her quilted-leather-and-tweed fedora, by British milliner Noel Stewart, is from the collection Date with the Night.

Fashion fades, only style remains the same.
—*Coco Chanel*

Starr wants a woman's style to fit her personality and life. To this end, she helps women create what she calls a "working wardrobe," meaning a closet where the clothes all work together and can be relied on to get you out the door in five minutes.

"You're putting in great effort," she says. "But then once your clothes are on, you don't feel fussy. I can't stand clothes that require too much attention. I don't want to think about it again, except to think, 'I feel great.'"

Even with a streamlined working wardrobe to draw from, Brooklyn women face another style challenge due to geography. We leave our homes in the morning and don't return until late. In the course of a day, we may breakfast with the boss, teach a class, take children to the park, head to yoga, and maybe meet friends for dinner or go to a play (this is, after all, the city that never sleeps). We never just pop home to change. "Brooklyn lights a fire under your ass to be more organized," Starr says. "If you work in Manhattan and go out in Manhattan, you're not going home [to Brooklyn] in between. Brooklyn women are naturally super utilitarian dressers."

Some women master this with a bag-within-a-bag strategy. Everything gets thrown into a large bag, like a classic tote, including a small clutch or purse. The smaller bag can function for an evening event while the tote stays behind. Wearing layers also keeps an outfit

Kerry Diamond, editor in chief of the food and fashion magazine *Cherry Bombe*, in a navy silk print dress from Tucker by Gaby Basora. Near her Carroll Gardens home, Diamond poses at the Smith–9th Street elevated subway platform, which was built to tower over tall-masted ships navigating the Gowanus Canal below.

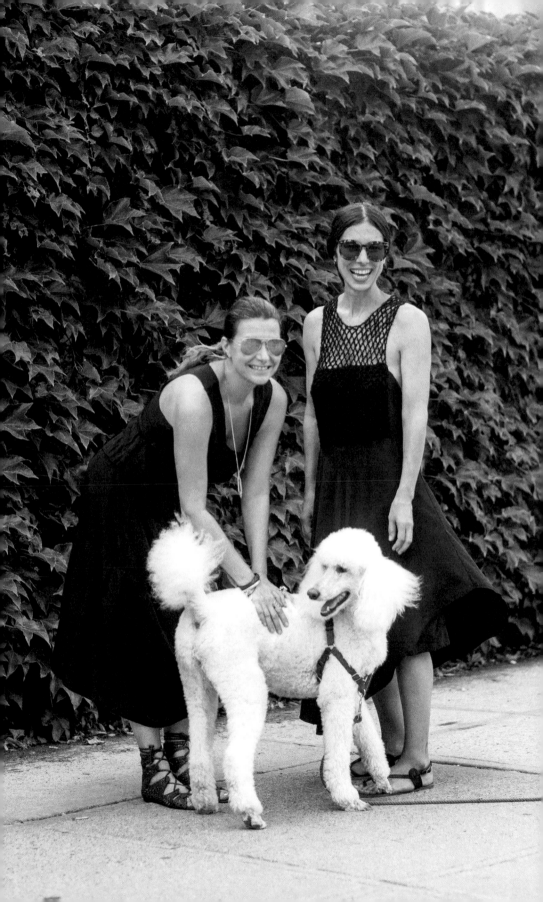

versatile. A dress or beautiful pair of trousers and a shell under a blazer or sweater are perfect workwear. Take off the top layer, add dramatic earrings and, perhaps, some fancy footwear, and voilà. Or, create a bag of things to keep on hand so you always have options: a dramatic lipstick, a skinny belt, one kerchief-size silk scarf (for your hair or your neck), and either a pair of heels or sneakers (depending on how you like to switch it up).

Still, even with forethought, there is ongoing effort in putting it together. We find this reassuring. Unlike the concept of effortless chic, style is not elusive magic that only the select few can conjure. Some of the chicest women in fashion are continually working it out.

Stylist April Hughes and experience designer Marina Burini, the original cofounders of an influential Williamsburg-based boutique called Beautiful Dreamers (now named Oroboro), each went through different phases before settling into their understated bohemian cool. "It does take a while to find this formula that works with your body, your lifestyle, and the picture that you want to paint," says Hughes.

Originally from Alabama and the daughter of a teacher and a preacher, Hughes says she didn't have access to pursuing fashion and style growing up. In college she began studying law before switching to fashion design, eventually moving to New York City and landing her first job at *Elle* magazine. She recalls wearing a yellow, checked, ill-fitting linen pantsuit to the interview: "How could they have hired me in the outfit that I was wearing?" She shrugs and laughs.

Williamsburg women in black: Marina Burini (left) and April Hughes greet their neighbor, standard poodle Milou. Both sundresses from Lower East Side label Correll Correll. On Burini: Ray-Ban shades and Sigerson Morrison sandals. Hughes' sunglasses are Karen Walker Eyewear and her sandals, Marlow Goods.

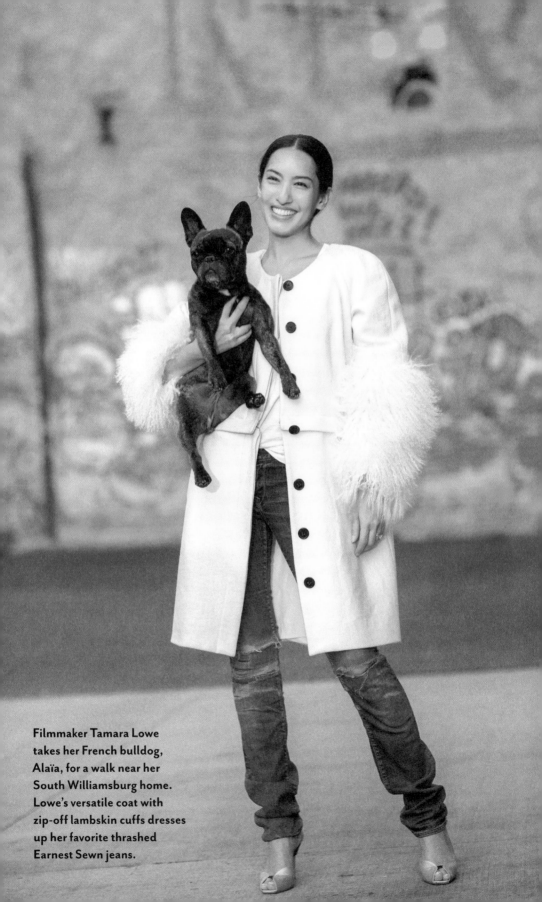

Filmmaker Tamara Lowe takes her French bulldog, Alaïa, for a walk near her South Williamsburg home. Lowe's versatile coat with zip-off lambskin cuffs dresses up her favorite thrashed Earnest Sewn jeans.

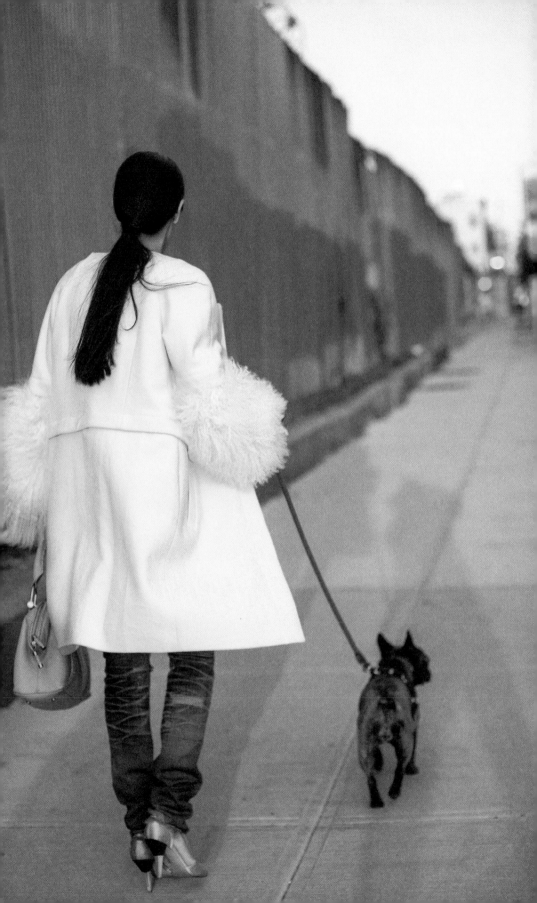

Hughes still works as a stylist for magazines, advertisers, and celebrities. She evolves her style by experimenting and by taking inspiration from the street and mixing things her own way. Hughes suggests working with classic pieces in your wardrobe, then adding items of adornment. For basics she prefers neutrals, vintage Levi's, and layering denim with denim. Then she'll add one unique element, such as a kimono, a jacket, or a strong piece of jewelry. "We all go through that 'What am I wearing? Ugh, I can't get it together' feeling. Then you go through those moments when you feel great, and you're working with the same palette of clothes and pieces. It's also feeling good about yourself, which adds to the way you feel in the clothes."

The dramatic collar detail on Texas-born actor/model Taylor LaShae's Cole Haan wool coat brings some intrigue to a wardrobe staple.

Marina Burini now runs her lifestyle website at beautifuldreamers.com. Half-French and half-Italian, she grew up in Monaco, the French Riviera city-state. When she was young, Burini and her friends skipped school lunch and headed to the big rocks by the Mediterranean to jump in the water. One afternoon, she turned around to see Helmut Newton taking pictures. Chanel, Christian Dior, and Gucci couture boutiques were part of the landscape. Burini says she was always aware of the brands, though she didn't have them in her closet. Instead, she was invested in figuring out a

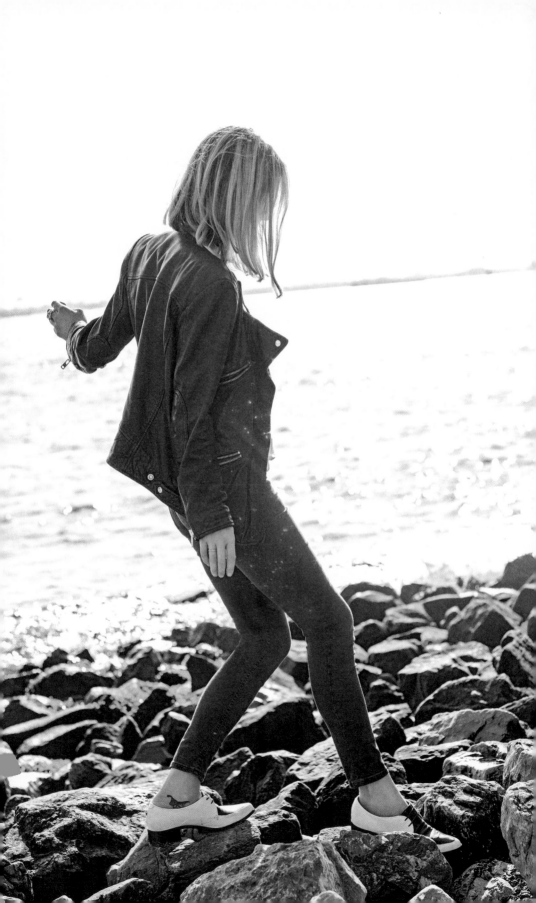

personal sense of style. Her mother taught her to sew, and the two would pursue an idea, buy materials, and have fun with it.

On her own as a young adult, Burini lived in Paris for several years. She studied business law and accounting. She also shopped the flea markets and, inspired by David Bowie's Berlin era, experimented with her look—dyeing her hair orange, wearing short skirts and high platform shoes. Burini remembers seeing a tall man decked out in Jean Paul Gaultier near the Place des Victoires, perhaps a sign of her future in fashion. She was so fascinated that she sought out the Gaultier boutique to see what it was about. "The meticulous choice of clothing is something that has always interested me," Burini says.

After moving to New York, Burini ended up as a stylist at the suggestion of a friend who thought she'd be a natural. She and Hughes were neighbors, and the two originally started Beautiful Dreamers as another dimension to their work. While Hughes still works as a stylist and owns Oroboro, Burini was ready for another phase, which was about curating a lifestyle aesthetic.

The Oroboro boutique has the feel of a tree house, albeit a luxurious one with clothing, jewelry, art, and

Casual and classic, beauty and style expert Jessica Richards wears an Isabel Marant moto jacket, Frame jeans, a Rag & Bone T-shirt, and Tabitha Simmons oxfords as she walks across the rocks by Red Hook's Valentino Park. A century ago, this part of Red Hook was a major shipping center for the country.

Looking effortless takes a lot of effort. When I get new Converse, I dedicate some time at home to shoving mud on them so they don't look squeaky clean.

—*Alexa Chung,* model, international It girl, and British *Vogue* contributing editor

organic beauty potions. The interior is nature inspired: plants, antiqued wood floors and shelving, with clothing racks made of tree branches. There's a sense of globalism in the hanging textiles on the walls. And the offerings, which are curated by Hughes, underscore a commitment to local designers.

"I really care about knowing where everything comes from, knowing the people who are making it and what goes into making it," says Hughes. "I know the people I buy my clothes from." During the winter, Hughes rarely takes off her Clyde felt Panama hat by milliner Dani Griffiths, who lives a few blocks away.

For each change of season, Burini and Hughes stick to their basics and then add their go-to items of the moment. They figure out what is essential for that time (considering weather or special events, then selecting an extraordinary thing they recently picked up or just a cherished old favorite), and build around that element of the wardrobe. Hughes starts with her vintage Levi's. Burini prefers leather pants for warmth in the winter. She also layers pieces that add color or texture and then might wear a statement jacket on top. "What I'm into becomes essential, everyday," Burini says. "If I'm in love with a piece, that's it. I have to wear it. And yes, I'll go back to my other loves, eventually. But there are always the things that you need every season to feel like you're in the moment, a more modern version of something that you've been doing, over and over."

Starr, Burini, and Hughes have an inspired approach for getting dressed every day. They look

Jewelry designer Jeanette Lai Thomas, in her live/work Williamsburg loft, wears her favorite designer, Rick Owens, with geometric pieces from her Moratorium line.

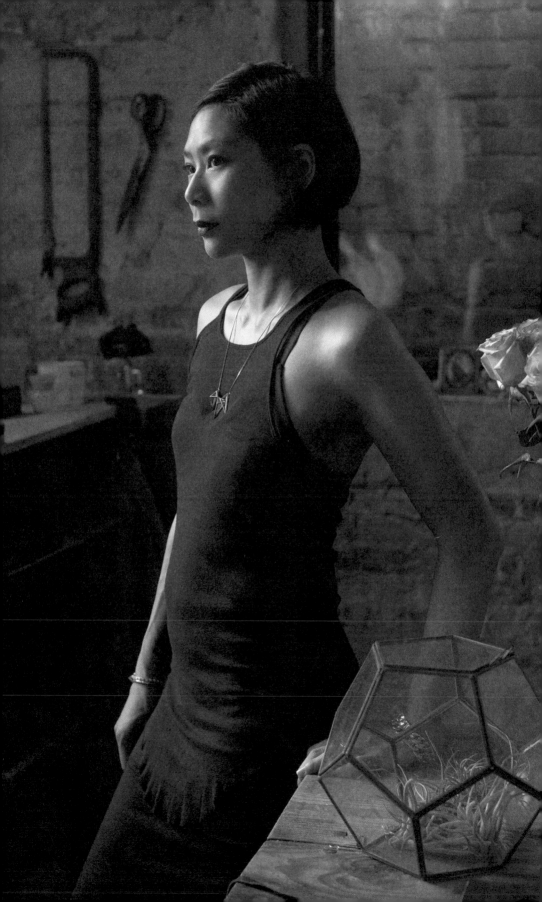

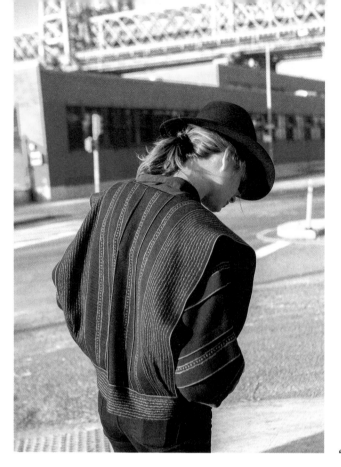

Stylist Marina Muñoz photographed near the Williamsburg Bridge. "My Issey Miyake jacket is vintage and from the early eighties—like me," she says. J.Crew jeans. Rag & Bone boots.

forward to it. From them we can learn to edit our own closets and build around essential items for each season (say, a favorite coat or pair of shoes). Then, Brooklyn living has its own lesson: Find the right comfort-chic that fits your lifestyle. It's a sensibility that can be self-taught and developed over time. "People talk about this Brooklyn way of dressing," Hughes says. "You used to go into Manhattan and feel like you had to dress a different way. But now you don't. And, for me, finding my style has come with finding my lifestyle as I've gotten older. Things that are comfortable work for me. But still, you can dress up, dress down, go from day to night. I'm pretty natural, but I love a bit of design and one big piece. That's pretty much it."

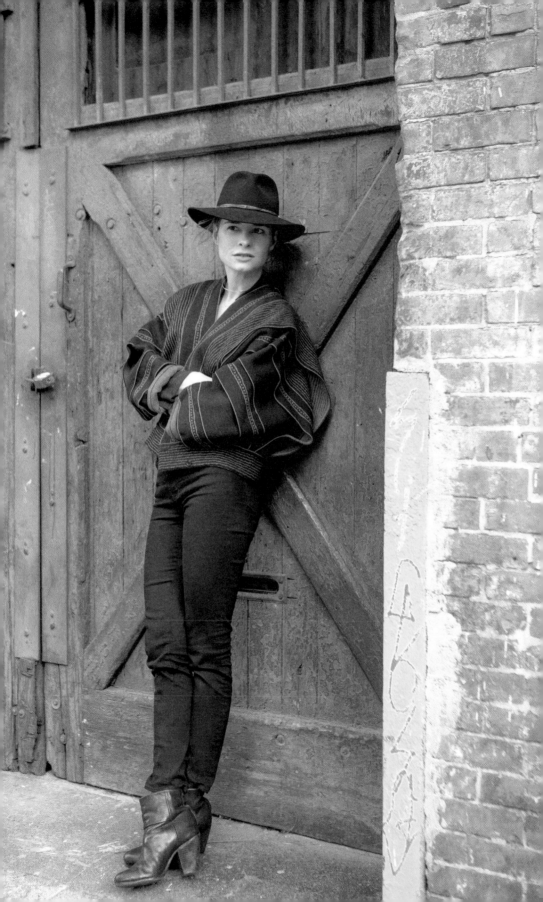

Build a Working Wardrobe

Karyn Starr, cofounder of White-Starr Aesthetic Consulting, is the person you'd want to be your fashion fairy godmother. More than a stylist, she will explore your psyche to help define what kind of style is the most *you*. Here Starr explains how to curate a wardrobe that allows you to get dressed quickly and put on something you love and feel great in—a wardrobe that works in every sense of the word.

The Goal

We want everyone to be able to get dressed in five minutes in the morning. If you have small children pulling on you, maybe that's all the time you have. So less is more. In your closet, have a couple of investment pieces and then your particular basics to mix and match. We want the wardrobe to vie for your attention so every piece is awesome and makes you happy. It should be a hot competition in there, instead of "These three things are great and the rest doesn't work."

If It Doesn't Work, Give It Away

First, try on your own clothes—and really be honest with yourself. If you've gained some weight, keep a couple of nice things that fit you before, put them away, and label them "attainable." In six months to a year, if you feel they may fit, try

them on again. But we're so hard on ourselves. I love fashion, but the imagery can be oppressive. Except for models, nobody looks like the people in magazines and on billboards.

If you haven't worn something for eighteen months, barring that it's sentimental or an amazing piece that you feel will come around again, get rid of it. That's fashion karma: letting go so something new can happen. You want to look at clothes that you actually wear.

Return the keepers to your closet and then make three piles from the rest. One is to give away to a local thrift store. Next, if there are expensive pieces that aren't working for you, take these to consignment. Last, have a pile for the tailor.

Look for Inspiration

Once you've done the closet cleanse, look at what is missing. Are there

pieces that you need to complete your wardrobe? Try finding inspiration images and create a map for your personal aesthetic.

Think about your life. Maybe think of someone's style that appeals to you. It could be a friend or someone in the public eye. Try to figure out what you like. See if it's attainable for you. Is your life at all comparable? If you're a corporate lawyer and you like the way that Kate Moss dresses, it may not work. But there may be a takeaway about the way that she puts her outfits together. People with incredible style—like Moss, Jane Birkin, and Lauren Hutton—never wear anything totally crazy. They just have pulled-together looks. It's how they assemble the whole outfit that makes them look so great.

Shop with a New Eye

When you are ready to go shopping, try on different shapes, even if in the past you might have said, "I don't look good in that." Maybe you haven't tried it on in five years. Try on what you haven't been wearing. If you've worn a wide leg, try on a slim pair of pants. If you've only been wearing dresses, try on pants. Also, patterns and fabrics have changed with innovation. Technology in clothing is amazing. There's a reason that jeans can fit so well. You need to experiment with

shape and silhouette more than anything else.

To really see a lot of different style and shape options, starting at a bigger store can be helpful. Then you can go to a smaller boutique. Also, if you find someone who is helpful, be super-honest with them. You know yourself. You know what you will and won't wear. And tell them your budget.

Make Your Style Work for You

Next is the hardest part: putting it together. Spend some time trying on the clothes in your closet. Stand in front of the mirror, snap pictures, and throw them on your desktop. Actually have some outfits planned so if you have an important meeting, you don't have to reinvent the wheel. Think, "What have I worn in the past few weeks that made me feel awesome?" Re-wear that outfit. Then go from there.

Reevaluate

Every three to five years, take time to reevaluate. People often need help when they're in transition—getting married, looking for a new job, having a baby, moving. Women's lives have so many transitions that can affect how we present ourselves to the world. Your clothes matter. You need to keep figuring it out.

Interlude...
SHOES

Wherever we're headed in Brooklyn, there will be walking to get there. We need to step out in comfort as much as style.

Even the most style-devoted Brooklynite will usually leave the stilettos in her closet so she can walk to the subway or ride her bike across the bridge. A sturdier platform heel, like the one on designer Cary Vaughan (right), is better suited for getting around the city. Photographer Skye Parrott (below) prefers the No.6 shearling-lined clog boot (also in brown, below right), which is a signature, laid-back Brooklyn look.

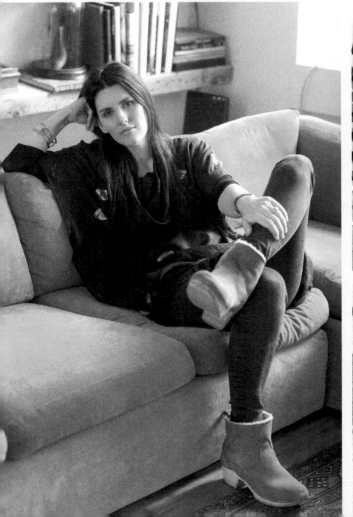

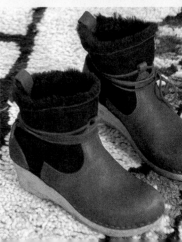

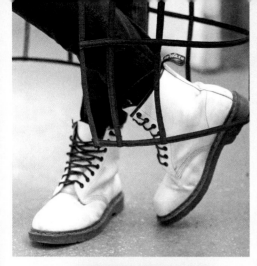

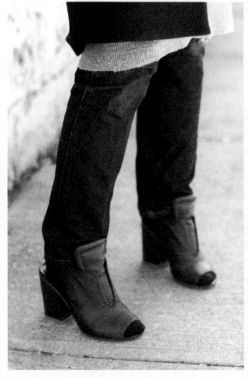

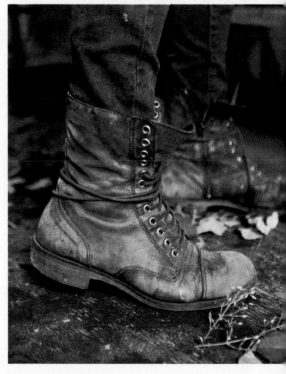

Designer Becca McCharen's white Dr. Martens (top left) keep getting better the more she wears them, like dancer Elle Erdman's brown ankle boots (top right). Similarly, the well-loved Nilson Shoes work boots on florist Ingrid Carozzi (right) wouldn't look right any other way. Mona Kowalska's A Détacher chunky-heeled mules (above) can be dressed up with a skirt or dressed down with jeans, and still keep you walking.

Finding footwear that is both elegant and comfortable is a challenge. Think about the shape of the shoe rather than the height of the heel. A bulkier design can weigh you down, add the appearance of heaviness, or draw too much attention away from your frame. Writer Kathleen Hackett's smoke ombré INK by Bernacchini oxfords (left) are slight enough to wear bare legged with a skirt and still look polished. The Tabitha Simmons two-toned pointed oxfords on beauty expert Jessica Richards (above) balance her skinny jeans.

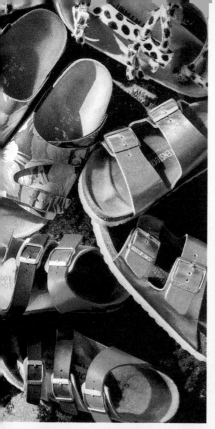

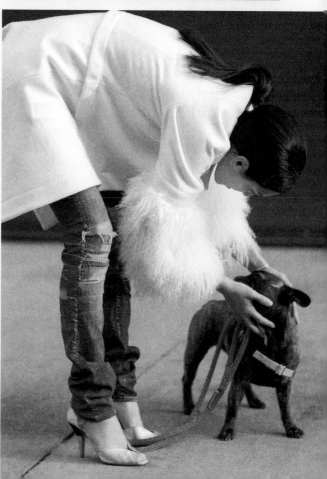

Clockwise, from top left: The cork-soled Birkenstock sandal, now quite chic, has been around for more than fifty years. Of course, many Brooklyn women still love their heels, like these Isabel Marant sandals. For walking the dog, a low heel works for filmmaker Tamara Lowe. Once considered a faux pas, socks with sandals hit the Burberry Prorsum runway several years ago, followed by Prada and Hermès, among others, which only confirms that there are no rules in fashion.

WEAR
YOUR
TRIBE

4

Here's one image of tribal style: a bright, long, wax-print cotton skirt worn with a dashiki. Add to this an armful of beaded bangles, some big earrings, and a fringed patterned scarf, artfully draped. Now, think more broadly. Tribal style is about the people who make sense to you—whether culturally, professionaly, ethnically, or religiously. Your tribe may be an essential foundation for your beliefs or it may be an aesthetic choice.

This latter tribal style thrives in Brooklyn, where one-third of all New Yorkers live, making it the city's most populous borough. (Less than a quarter of the city's residents live in Manhattan.) Moreover, Brooklynites represent nearly one hundred different ethnicities living within the borough's seventy-one square miles. Tattoo-sleeved rockers live next to white-bearded Hasidic men in long black coats, down the street from grill-clad B-boys and B-girls. Several blocks away, Italian *nonnas* in housecoats sit in folding chairs, surveying everyone on their block.

The fashion-conscious add another dimension to tribal style, making it their own. Russian American Ksenya Roz is the perfect muse. Born in Kiev, Roz grew

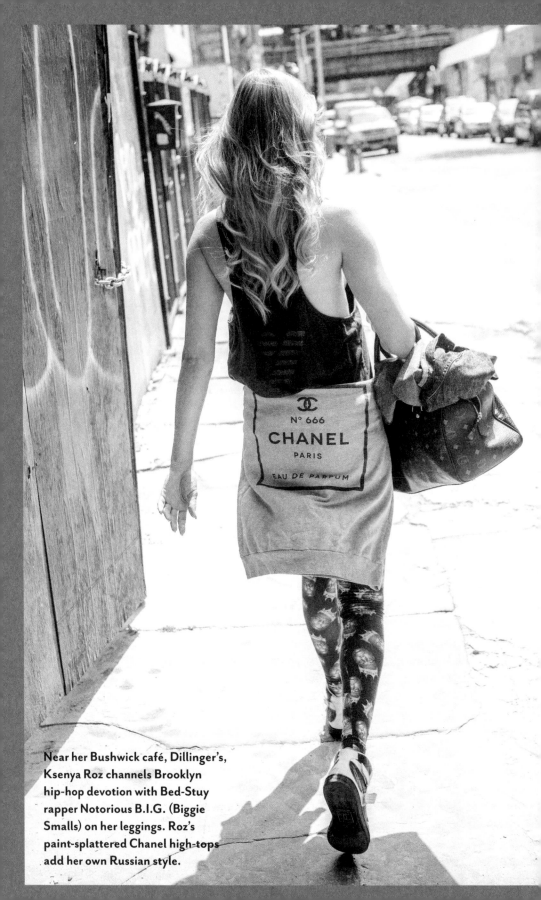

Near her Bushwick café, Dillinger's, Ksenya Roz channels Brooklyn hip-hop devotion with Bed-Stuy rapper Notorious B.I.G. (Biggie Smalls) on her leggings. Roz's paint-splattered Chanel high-tops add her own Russian style.

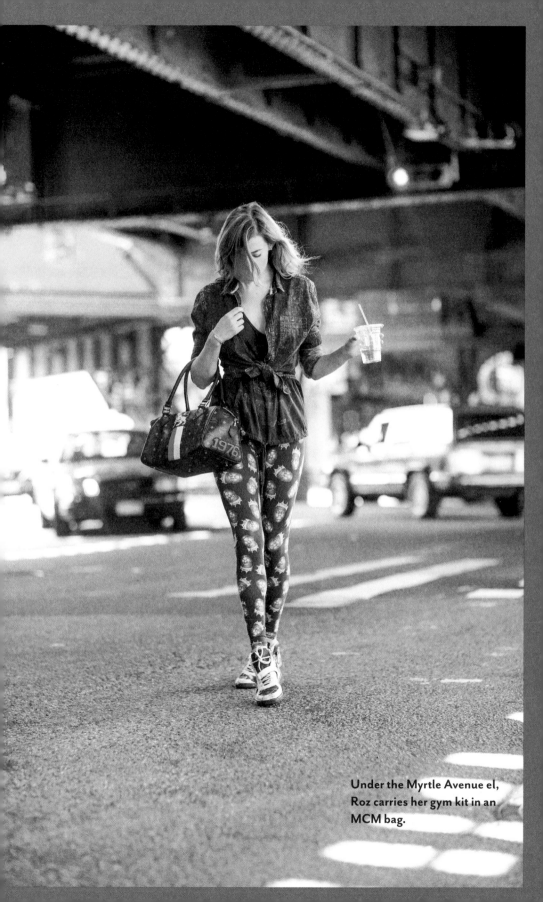

Under the Myrtle Avenue el, Roz carries her gym kit in an MCM bag.

up in Brighton Beach, Brooklyn, the Russian neighbor-hood also known as Little Odessa. Her mother is a for-mer Soviet prima ballerina. When the family moved to America, Roz's father started a shipping container busi-ness and for many years did well.

The extravagant Russian American style of Brigh-ton Beach would be equally suitable for the housewives of Beverly Hills. Women dress in luxury labels such as Chanel, Louis Vuitton, Versace, and Fendi; long furs and long nails; and high heels, heavy makeup, and big gems. "Russians can be on welfare and they'll still find a way to buy luxury," Roz says.

Roz is a painter and graffiti artist who now co-owns a small café called Dillinger's in Bushwick. She has a fair amount of couture in her rotation, but at work prefers paint-splattered Chanel sneakers and a ratty gray Chanel T-shirt with leggings—no makeup. She runs up and down stairs from the kitchen to her customers, serving excellent small *pelmeni* (dumplings) and espresso.

Roz's closet at her Fort Greene apartment, how-ever, tells the full story. She pulls out a full-skirted Vivienne Westwood dress, pointing to where she has safety-pinned up the hem; her mother's Versace gown from 1989; and a vintage-print Pucci sheath. "All these old vintage dresses are still relevant today," she says. "I don't wear them dressed up. I wear them dressed down." As in, with flip-flops, to the beach.

Digging farther into her closet, Roz spots several leopard-print numbers, including a Dolce & Gabbana

Electronic musician Vandana Jain creates her particular style mash-up, referencing her native Bangalore, India, with rocker flair. At her Williamsburg loft, Jain wears Ashton Michael harem pants, a vintage Indian top, and a sheer kimono from Dust & Drag. Call it sari-chic.

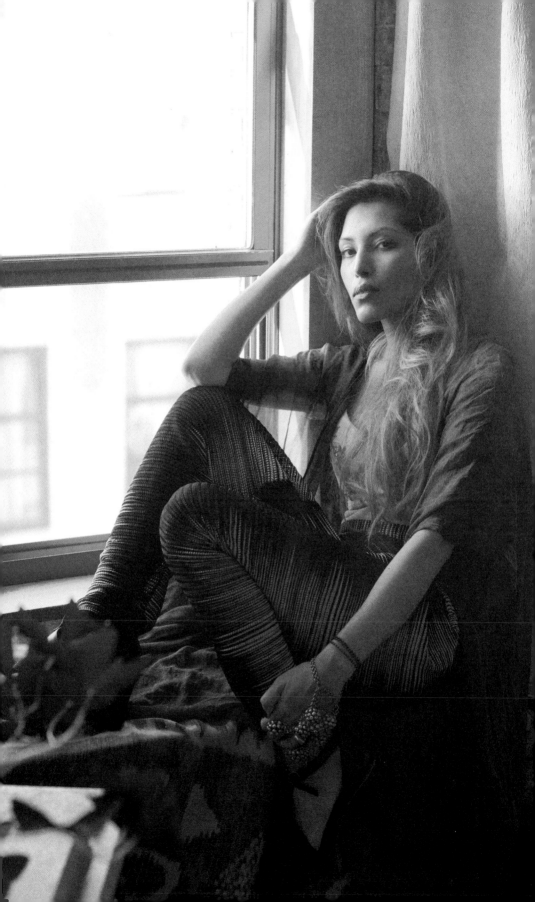

floor-length gown and a silk blouse. She holds up the dress in one hand and the blouse in the other. "This is very Russian. You can't have enough leopard. Ever. Here's one for day and one for night. How could you not?"

Next, Roz pulls out a basket of leggings—a Betsey Johnson pink pair printed with revolvers, a pair featuring galactic cats in space, and ne plus ultra burgundy ones dotted with Biggie Smalls' head in a gold crown (from H&M—not everything carries a high price tag). She often steals one of her husband's Lanvin shirts to put around her waist, and wraps a vintage Hermès or Dior silk scarf from her collection around her head.

Roz likes to mock her own closet, pointing out the Chanel evening bags that she never uses. At the same time, she cherishes these pieces. She just likes to wear them irreverently. Therein lies the difference between Roz and the more typical Russian American fashionista, such as blogger Helena Glazer, the Brooklyn Blonde. Glazer, like Roz, is Russian and a Brooklynite, but she always steps out in pulled-together outfits worthy of her Louboutins. Roz, on the other hand, would pair her Louboutins with ripped denim cutoffs, a black Helmut Lang tank top, and her grandmother's babushka as a head wrap. She has been known to add one of her mother's fur coats thrown on top. "This is how practical I am," Roz says. "My Chanel sneakers are covered in paint. But, you can't hold on to something and take it so seriously. It's a thing. You wear it. You enjoy it. If it gets

Longboard skaters Priscilla Bouillon and Emina Kadrich rock cutoffs and vintage tees at the Bushwick Collective outdoor street art gallery.

> The history of street style is a history of 'tribes.' Zooties, hipsters, beats, rockers, hippies, rude boys, punks . . .
>
> —*Ted Polhemus,* **anthropologist**

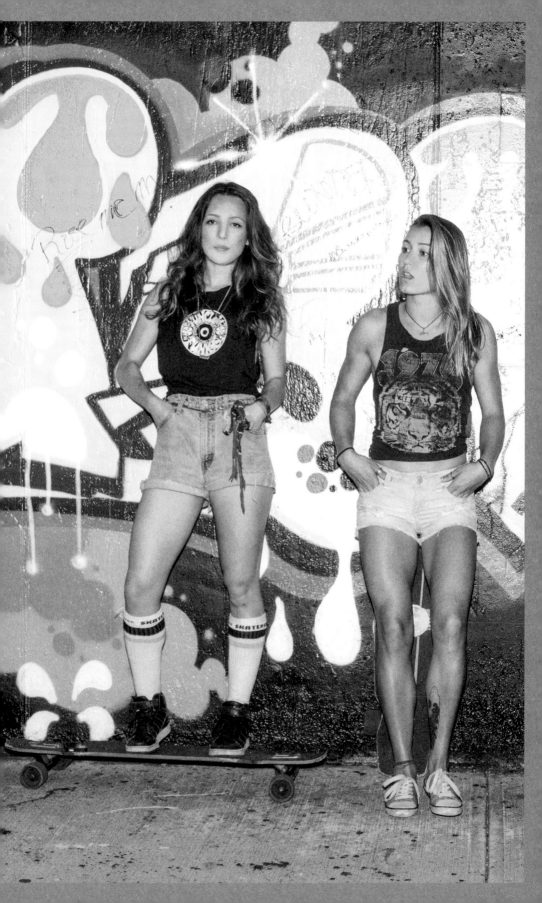

messed up, that's life. When you have something you like, you have to use it. What else did you get it for?"

After visiting with Roz, we came across a pair of Orthodox Jewish stylists—sisters Simi Polonsky and Chaya Chanin, who both have the eye and sensibility of any New York It girl. Polonsky and Chanin run a business in Crown Heights called the Frock Swap, a high-end consignment shop and consulting service. The two are both married with children, but do not dress in traditional long black skirts and shapeless long-sleeved black tops. Like Ksenya Roz, they follow the tribal style of their people, but at the same time they personalize their look.

Polonsky and Chanin are originally from Coogee Beach, a seaside suburb of Sydney, Australia. As daughters of a rabbi, they were raised in a traditional household with restrictions on how they dressed. Orthodox women are required to keep their elbows, knees, cleavage, and hair covered. In their beach town, where Sydney's weather is endless summer, the family would take walks on Saturday, the day of Shabbat. While women in bikinis sat at outdoor cafés, the girls wore modest dresses and walked beside their dark-bearded father clad in black trousers and a yarmulke. "Growing up, that was a huge challenge for us," Polonsky says. "And also a huge factor that inspired our style," adds Chanin, the older sister. "The challenge being, we can't just wear a bikini. We have a certain dress code that we had to adhere to."

Sisters Simi Polonsky (left) and Chaya Chanin near their Crown Heights homes. They bought the blue hexagon print robe at a vintage fair in Manhattan. "Simi thought it was hers," Chanin says. "And then I wore it most of the time." Polonsky wears a Stella McCartney jacket, Markus Lupfer tunic, and Diane von Furstenberg pants. Necklaces, SBNY Accessories.

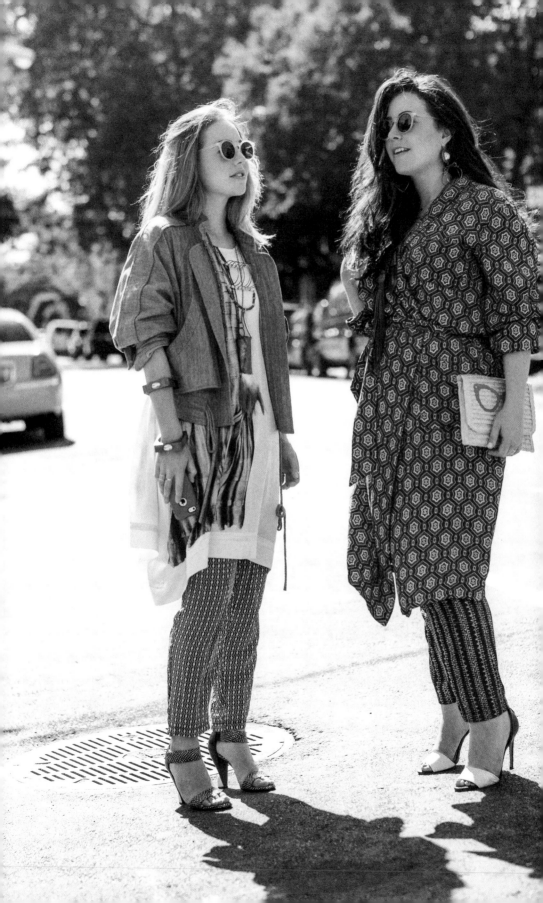

Polonsky, who is blond, today prefers a stylized schoolteacher look. She loves Prada, Miu Miu twinsets, cardigans, and mid-length skirts. The brunette Chanin favors bohemian chic, Dolce & Gabbana, floral ethnic dresses, big earrings, and lots of color. Depending on their mood, they both might choose to layer with androgynous pieces in black, selecting something from Yohji Yamamoto or Alexander Wang, perhaps. That look is also inspired by the Australian easy vibe and tendency to wear layered, angular pieces in neutral tones. Regardless of the garment or designer of choice, the sisters always dress in accordance with Orthodox standards. They also wear wigs, impeccably styled as swept-back hairdos and so well done that we never knew.

"A lot of people view Hasidic women as *Fiddler on the Roof*—dressing in long, black, baggy clothes and covered completely in shawls," says Chanin. Polonsky interrupts, "When we tell people that we're Orthodox, they're shocked. We're in the twenty-first century! We don't want people in New York City, which is the most advanced of places, to be shocked that Orthodox women look great. To us, that's terrible. We want people to look at us and say, 'Oh, wow, they look great!' And then do a double take and say, 'Oh my gosh, they're modest, they're Orthodox!' So that's our motto. You can look great and stylish and still maintain a modest appeal."

For many women, finding one's tribal style can feel like coming into your own. Cipriana Quann, cofounder of lifestyle website Urban Bush Babes, struggled to find

her style for years. When she did, she says, "the beast was unleashed." Cipriana and her twin sister, Takenya ("TK Wonder") Quann, grew up in Baltimore, Maryland, during the big-hair days of the eighties. The girls loved style icon Lisa Bonet on *The Cosby Show* and Holly Robinson Peete on *21 Jump Street*. But more than these fictional characters, the twins looked up to their mom. Sheila Quann was the CEO of a medical supplies company and, in her younger days, sang in a soul band. Her closet, says Cipriana, was worthy of Diana Ross. It held her work uniform of pencil skirts and high-waisted slacks, but also colorful, patterned pieces she wore on weekends and treasures from her performing days.

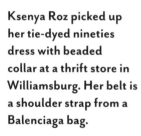

Ksenya Roz picked up her tie-dyed nineties dress with beaded collar at a thrift store in Williamsburg. Her belt is a shoulder strap from a Balenciaga bag.

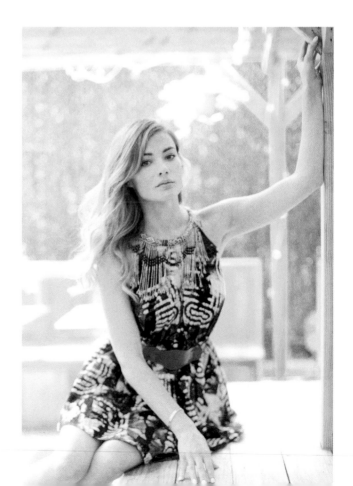

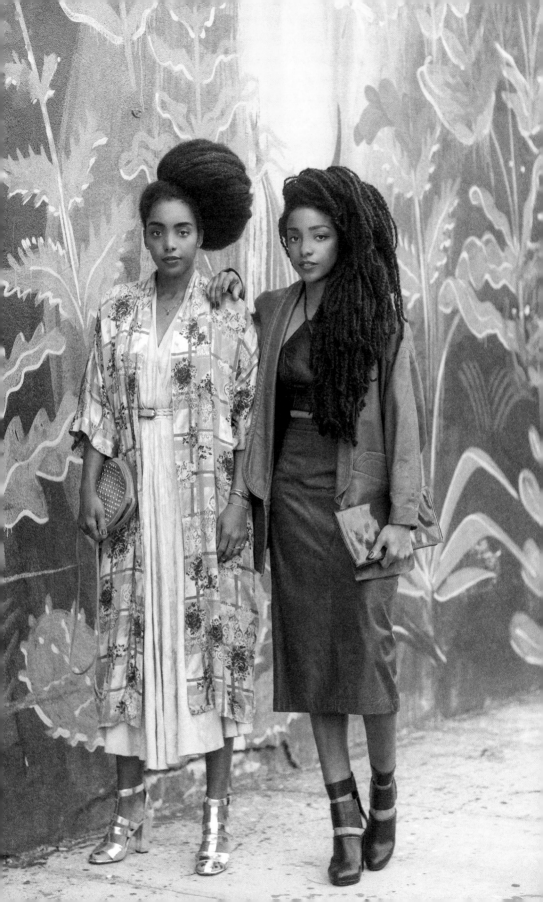

When the girls were thirteen years old, Sheila relaxed her hair to give herself long, wavy locks (similar to a Jheri curl). Looking up to their mom, Cipriana and TK did the same treatment and kept it up for several years until their dad decided, enough; it cost too much money. TK chopped her hair off. Cipriana transitioned into braids, combining processed hair with her natural hair while it grew out. TK liked her look. Cipriana had a more tormented relationship with her hair.

This lasted as the twins moved to New York. TK was a rising rapper/singer/songwriter. Cipriana modeled professionally for ten years, and, though grateful for the opportunity, she hated it. Her unruly hair remained an issue. "People said, 'You can go so far, but what are we going to do with that hair?'" she says. "Something about it never felt right. In the back of my mind there was always this other person saying, 'Well, what's wrong with my hair, really?' Maybe I didn't love it as I do today, but I didn't think it was ugly."

Misgivings aside, under the fashion industry's influence, Cipriana again decided to relax her hair. This time she had a bad reaction to the chemicals that stripped her hair from the roots. Both model and hair were traumatized. Cipriana got extensions and did not process her hair again. Back to her natural, kinky frizz, Cipriana lost jobs, but she was done changing herself and her hair. She quit modeling. "I didn't want to be that person anymore," she explains. "It was affecting who I was and wanted to be. It was changing my image,

Cipriana Quann (left) and TK Wonder wear vintage ensembles with gladiator heels near the L train's Jefferson Street stop in Bushwick.

my mother's image. We adore our mother and look up to her. If anyone told me I wasn't beautiful, they were saying my mother wasn't beautiful."

Then, an interesting thing happened. Natural hair transformed Cipriana's style. As her hair got bigger, she felt more free. She adopted her current approach to style, which she describes as "all over the place." Cipriana loves a seventies Woodstock vibe, and also nineties grunge. She loves her kimono, anything with fringe, and anything long, leather, lace, or suede.

As Cipriana got more creative, TK added more classic pieces into her rotation. TK now cringes at the outrageous looks of her younger days. She thought nothing of going to school in a pink sheer fishnet top with a zebra miniskirt and goth knee-high boots, as

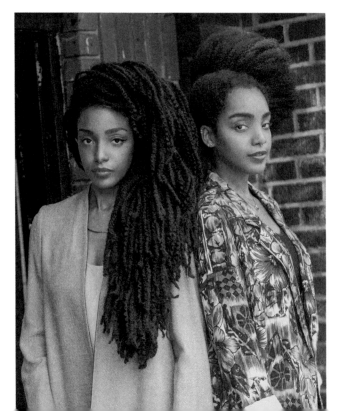

Natural-hair soul sisters TK Wonder (left) and Cipriana Quann.

comfortable as if they were jeans and a T-shirt. TK still likes her bright colors, but has since toned it down. "Now that I'm older, I adopted her fashion sense," she says, referring to her twin.

Both sisters love vintage and steal things from each other's closets. They both now live in Brooklyn, Cipriana in Bushwick and TK in Prospect Heights, and they always seek out projects to collaborate on, such as an ad campaign or coordinating outfits for fashion week. Having grown out their hair for the past decade or so, Cipriana and TK cut quite the image: Cipriana wears her hair piled high in a bun or two while TK's thick braids fall down her back.

"Short hair, long hair, however you decide to rock your hair is beautiful," says TK. "For me, hair was a lot more than just hair," adds Cipriana. "It was a transformation of me becoming who I was meant to be, which was just myself."

In 2013, *Vogue* named Cipriana one of the best-dressed bloggers of the year. Finding her natural-hair style tribe gave Cipriana the daring to be uniquely herself. With her website, Urban Bush Babes, she now also inspires other women to accept their natural hair. In an opposite approach, Roz, Polonsky, and Chanin work against their tribal types, stretching the traditional boundaries of what is expected. Both ways can inform personal style: finding a kinship with others or, like the punks, dressing to rebel—which, of course, is then a tribe in itself.

Q&A

with Michaela Angela Davis,
activist and CNN commentator

As an image activist, former fashion editor of *Essence* and *Vibe*, media commentator, and longtime Brooklyn resident, Michaela Angela Davis has a unique perspective on the progression of the borough's style. Davis first moved to New York in 1982 and got her break as an assistant stylist for photographer Richard Avedon. She witnessed the birth of hip-hop and still has her eye on urban culture.

What defines Brooklyn style?

There's an ease to it. It's creative. And it seems like it's a lifestyle versus someone who looks like they spent a lot of thought putting themselves together. Like Madison Avenue: a tight bun, crisp bag, and fitted suit. But, in Brooklyn, there's a swagger. You feel like people have a soundtrack with their look.

I go to things in Brooklyn just to see what people wear. I feel like what they're wearing in Brooklyn will determine what people are wearing in Atlanta and the rest of the country in the next couple of years.

What's an example?

A harem pant, but on men. And just skinny jeans in general. The hipsters were doing it, and the hip-hop version was with a drop crotch. And I'm seeing men with long beautiful hair. And women with natural hair.

Also, if you go to the West Indian Day Parade and community, there's that whole nail craze. Those girls had very elaborate nails years and years ago. I remember going to the West Indian Day Parade and looking at the nail art. I was like, "Oh, my God!" And now it's huge.

How has Brooklyn style changed over the years?

In the eighties, there was this modern take on Afrocentricity that I wasn't seeing anywhere else in the country. Fort Greene was the epicenter, literally—Erykah Badu was living there. People wore dreadlocks for fashion, not because they were Rastafarian. This whole idea of natural hair and clothes was inspired by Afrocentricity.

And now more style tribes have come: hipster and rockabilly and skater and nerd chic. And then there's the mash-up, like you will see "mipsterz," a Muslim community that's very hip.

Then there's this cross-cultural exchange. So you can see a woman with big, natural hair. But then she may have a couple of tats, so there's that tribal thing. She may be on a skateboard with a faded sundress like Lena Dunham. That's what's really interesting to me: this non-verbal style and cultural exchange.

How did hip-hop influence street style?

Hip-hop made me really look at people on the street for the first time. How they moved in their clothes was inspiring. A lot of the fashion was functional. Adidas and track pants gave you this ability to dance. Turning your baseball cap around was so you could see as a graffiti artist. But then there were name necklaces and door-knocker earrings. It just seemed fresh, right? They were taking everyday things and rearranging them in ways that we never thought of. They made us look at a tracksuit like fashion. Then hip-hop changed the jeans industry. They made diamonds good for the day and jeans appropriate for night. That had never happened before.

Street style is always telling you what's going on in the world. High fashion can tell you what people are thinking about maybe in the fine art world. But what's happening on the ground, you see through the street.

Interlude...
HATS

"A hat makes clothing identifiable, dramatic—and, most importantly, fashion," says British couture milliner Stephen Jones. It's the crowning touch.

To say you can't wear hats is like saying you can't wear shoes. Brooklyn's favorite milliner, Dani Griffiths (above), favors a simple silhouette in her outfit to play up her own Clyde wide-brimmed straw hat.

Clockwise from top right: Ace & Jig's Cary Vaughan adds a pop of red to her black-and-white checks. Longboard skater Nathalie Herring wears a Rag & Bone fedora. Jessica Richards of Shen beauty boutique loves her vintage Helen Kaminski felt hat. On the Ogun sisters, Dynasty's L'Enchanteur duckbill cap is her design; Soull dons a vintage leather garrison hat.

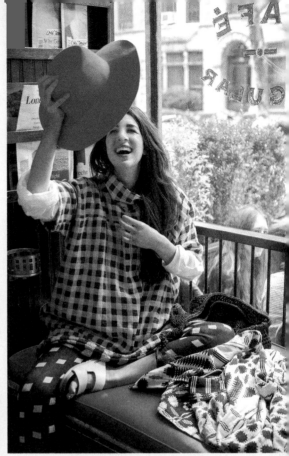

Pragmatic or dramatic, the hat that suits you will look and feel right. The vintage Norma Kamali for Stetson hat on stylist Marina Muñoz (left) is actually a size too big, but it works. "It seems to top off any of my outfits," she says. "Even my pajamas." A dash of Slavic flair in fur for painter Suzannah Wainhouse (below).

Actor Taylor LaShae (opposite), flirty and feminine in an oatmeal-hued beret and cable turtleneck.

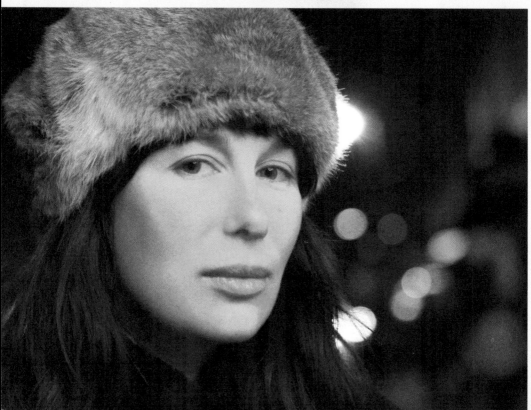

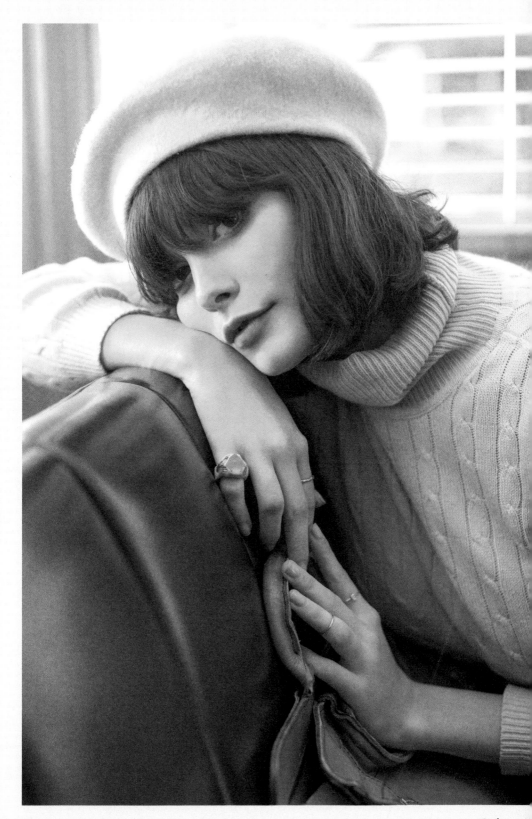

WEAR YOUR CONSCIENCE

5

By many accounts Brooklyn's reputation for sustainability started in 1998, when a painter named Andrew Tarlow opened a small Williamsburg restaurant called Diner. At the time, the neighborhood was an industrial, urban frontier of cavernous, raw loft spaces; cheap rents; and the creative types drawn to both. Tarlow created Diner in a 1920s Kullman dining car under the Williamsburg Bridge so the neighborhood could have a place to meet and eat. Driven by its locally minded chef, Caroline Fidanza, Diner served farmers' market goods and grass-fed burgers. It was exactly what people wanted. Even Manhattanites crossed the bridge to see what this new 718 outer-borough dining scene was about. Over the next several years, Tarlow built a Brooklyn epicurean empire of restaurants, bars, a food journal, and a boutique hotel—all with the same local/sustainable ethos.

Nearly two decades on, you can't do much in Brooklyn without tripping over the word "sustainable," especially in the borough's hyped food world. And what is now viewed as common sense by foodies is increasingly being adopted by fashionistas.

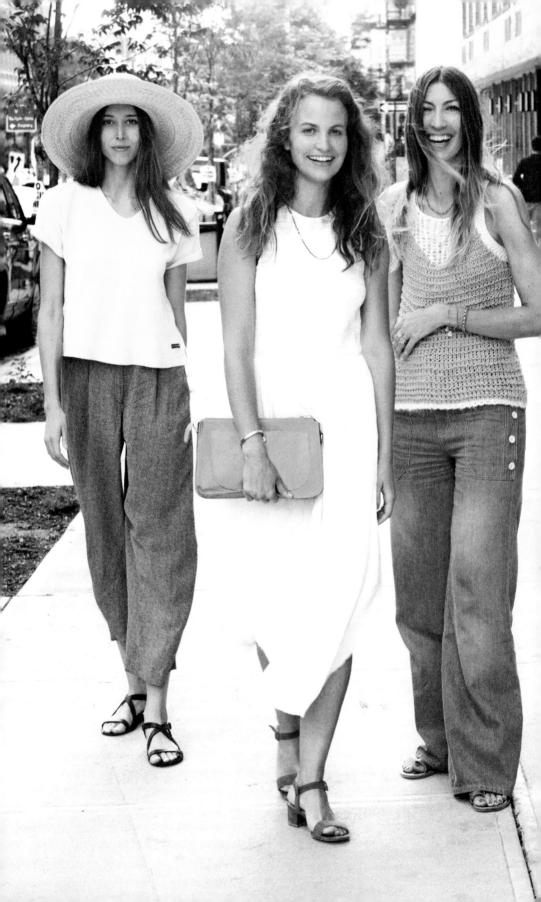

"The only way of communicating what's going on in the fashion world is through food," says Sofia Hedström, whose book, *Fashion Manifesto*, charts a detox regime from her shopping habit. "People have started to become aware of what they eat. Why not take the same step with fashion?"

Indeed, Brooklyn has become the backdrop to a growing conscientious mind-set toward fashion. Kate Huling, who lives in Fort Greene, created a line of leather handbags and used a nose-to-tail approach (meaning no part of the animal is wasted) for sourcing her materials. Huling is Andrew Tarlow's wife. The skins used for the bags (which are part of her clothing/accessories line, Marlow Goods) are a by-product of the meat served in her family's restaurants. So, you could eat a sirloin steak at Diner in June, and come back in December to purchase a cross-body satchel that came from the same cow. Huling herself remembers specific steers that became handbags in her shop. "It's about seeing the whole process through," she says.

A bag from Marlow Goods is a different beast from the luxury-brand products on department store displays. Huling's creations may have nicks, scars, and dark spots, and can appear rougher in some patches, smoother in others. This is because the leather is not cut specifically for bags; it is a by-product of the slaughter process. Holding up her own pale-green tote, which is textured with imperfections, Huling says many people might call it "disgusting." Most designers working with leather look for consistency and

Kate Huling (center), in a white cotton Ulla Johnson sundress, carries her own Marlow Goods purse. Friends Dani Griffiths (left) and Ulla Johnson herself (right) wear their own designs.

> *Buy less, choose well, make it last.*
> —*Vivienne Westwood*

Conscientious Consumption

- ➔ Shop mindfully.

- ➔ Know who makes your clothes and what they're made of.

- ➔ Ask yourself: Do I need it? Is it multifunctional? Do I love it? Will it last?

- ➔ Commit to your clothes.

- ➔ Buy secondhand: consignment, thrift, vintage, charity shops like Goodwill.

- ➔ Don't buy anything at all.

- ➔ Start a fashion swap.

- ➔ Sign up for Rent the Runway, Le Tote, Bag Borrow or Steal, Mine for Nine.

- ➔ Mend your clothes.

- ➔ If you don't know how, learn to sew.

- ➔ Start a sewing social.

- ➔ Love what's in your closet.

- ➔ Wear and re-wear everything you own.

uniformity, choosing their hides from the smoothest part of the animal, which is usually the rump. Huling uses it all, citing, for example, how neck leather is more wrinkled.

Her bag, in fact, is a beautiful product. The leather is matte, the color subtle, and the surface roughly pebbled, which gives it an element of authenticity. The shape is simple and clean, an unassuming piece of luxury. "It's about us having different standards," Huling says. "All of our leather is very different."

A Marlow Goods bag can cost anywhere from $250 to $700—significantly less than a basic leather Hermès Birkin. However, it's still serious change. If you are choosing to purchase Huling's type of sustainability, you are likely to buy fewer things overall in order to afford this kind of small-batch product.

What Huling offers with one of her bags is more than an artisanal (another beloved Brooklyn adjective) accessory. Her production cycle is transparent, meaning that we can know what processes happen along the way. Cows and sheep are reared, then slaughtered, in upstate New York. A renderer (the facility that processes and disposes of the remaining nonedible bits) picks up the hides and salts and freezes them until they are ready to go to a family-run tannery, which uses nontoxic vegetable tannins to treat the leather and biodegradable or vegetable dyes for color. (According to the nonprofit Blacksmith Institute, chromium pollution from tannery operations is among the major toxic threats worldwide.) Finally, the leather is sent to a

factory in Union City, New Jersey, where an Ecuadorean former shoemaker and his wife cut and sew the bags for Marlow Goods.

Buy a bag at, say, Zara at a fraction of the cost of a Marlow Goods bag, and try to find out any information about its life cycle. Even if the tag states "Made in the USA," you still don't know who made the piece, at what wage, and under what day-to-day working conditions. Nor can you find out the extent of the potential pollutants that were a by-product of the manufacturing process.

"There is a lack of transparency [in fashion]," says model and environmentalist Summer Rayne Oakes. "It's much easier in the food industry. People don't realize the complexity of the supply chain. You could say, 'Know where your things come from. Who designed your stuff?' But it's harder because you can't go into most major retailers and really know that. They aren't going to track and trace on their website where stuff has come from. But you can go to some food companies and find out where that banana is from."

Model, entrepreneur, and environmentalist Summer Rayne Oakes at her loft in Williamsburg. Her sleeveless leather Ada Zanditon top was vegetable-tanned and organically dyed.

Many consumers are unaware that garment operations are among the most-polluting industries in the world. Textile mills, dyeing plants, and tanneries are all heavy industries (like mining or oil refineries). The factories rely on vast amounts of natural resources, such as coal and water, and produce chemical by-products that are often dumped untreated into the environment. But for U.S. shoppers, most of this is invisible because we outsource some ninety-five percent of the garment

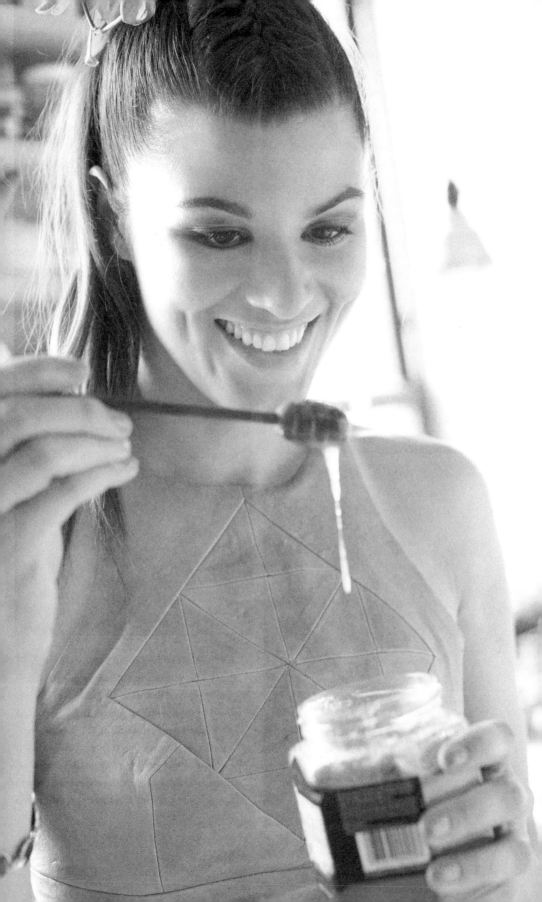

industry to countries such as China, Bangladesh, and India. Moreover, large-scale retailers and designers keep price points low by underpaying foreign workers whose wages and working conditions are not always regulated.

In part thanks to New York City fashion sustainability programs at Pratt Institute and the Fashion Institute of Technology, more local designers are addressing environmental and labor concerns. Many live and work in Brooklyn. Williamsburg-based Titania Inglis, who won the 2012 Ecco Domani Fashion Foundation award for sustainable design, calls her approach "lush minimalism." Owning less is more desirable. She creates a small line of pieces that can be worn together, work for different seasons, and endure beyond trends.

For a class that Inglis teaches at Parsons The New School for Design, she gives her students the assignment to make a piece that they must wear for seven days. "And they're like, 'You have to wear it for seven days?'"

Filmmaker Tamara Lowe incorporates vintage finds like this sheer net dress and hand-me-downs from her grandmother—such as this gold necklace worn as a bracelet with her gram's Cartier watch.

she says, laughing. "But if you don't want to wear it for seven days, you should probably consider why that is. If you're not excited about wearing it, then maybe it wasn't a good design."

For her own line, Inglis visits her factory in Manhattan's Garment District weekly, sometimes more. Workers are paid for production labor by the piece, from about $25 for a T-shirt to $200 for a coat. Inglis sources organic cotton from Japan, where, she says, the standards for organic certification are high. She also uses deadstock wool and flannel from the garment industry.

"So much of working sustainably ends up being about the quality," says Inglis. "It's an underlying philosophy, but also a predilection in choosing materials. It narrows down what materials are available to you, and it really does make it that much more of a challenge."

Inglis also works with vegetable-tanned leather from a tannery in Italy and, interestingly, fur. For her 2013 collection she made a reindeer jacket. The fur was from reindeer raised by the nomadic Sami tribes of Lapland in northern Scandinavia. The tribes have been reindeer herders for thousands of years. Many Sami still base their livelihood on reindeer. Every part of the animal is used, down to the bone marrow, which is considered a delicacy.

Similarly to how Huling approaches leather, Inglis wanted to preserve the markings and variations in the reindeer fur (the longest hair is on the animal's back). The hood has a stripe where the two legs came together to fit how the pattern was shaped. "I don't think fur

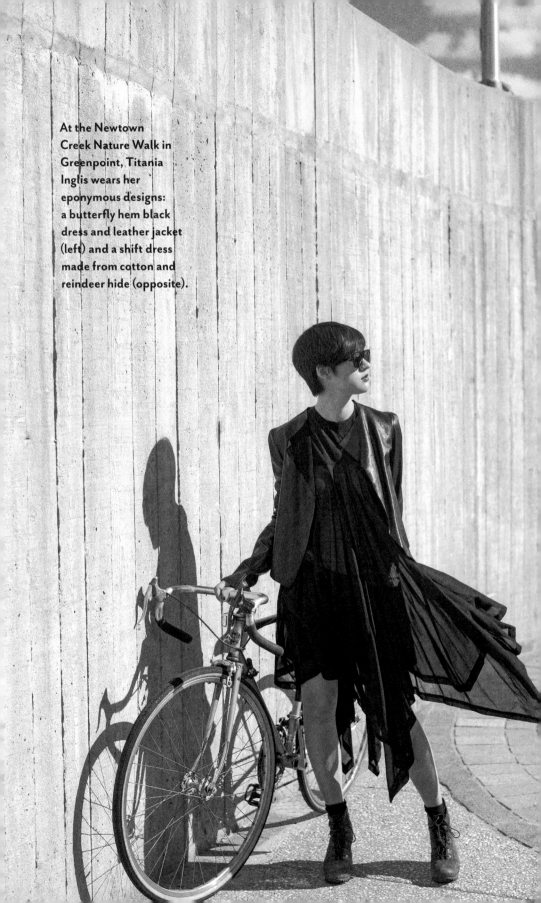

At the Newtown
Creek Nature Walk in
Greenpoint, Titania
Inglis wears her
eponymous designs:
a butterfly hem black
dress and leather jacket
(left) and a shift dress
made from cotton and
reindeer hide (opposite).

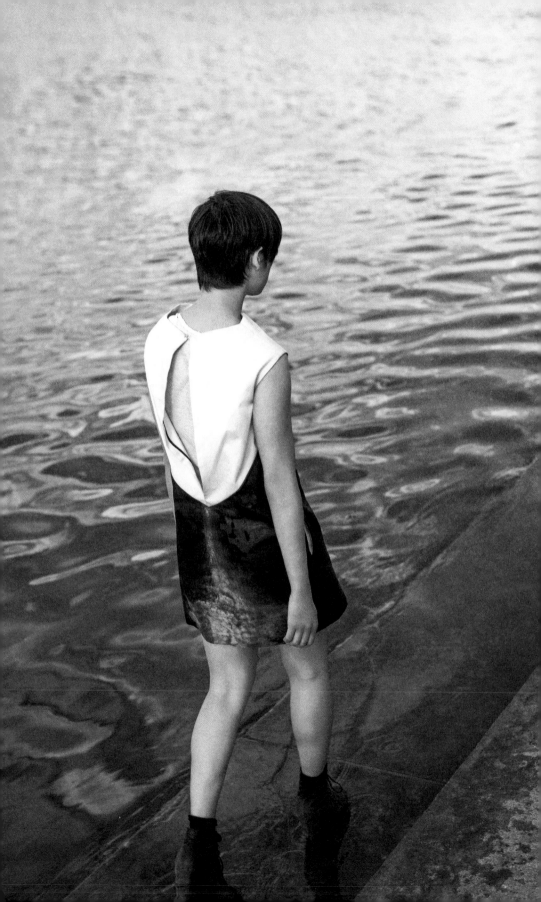

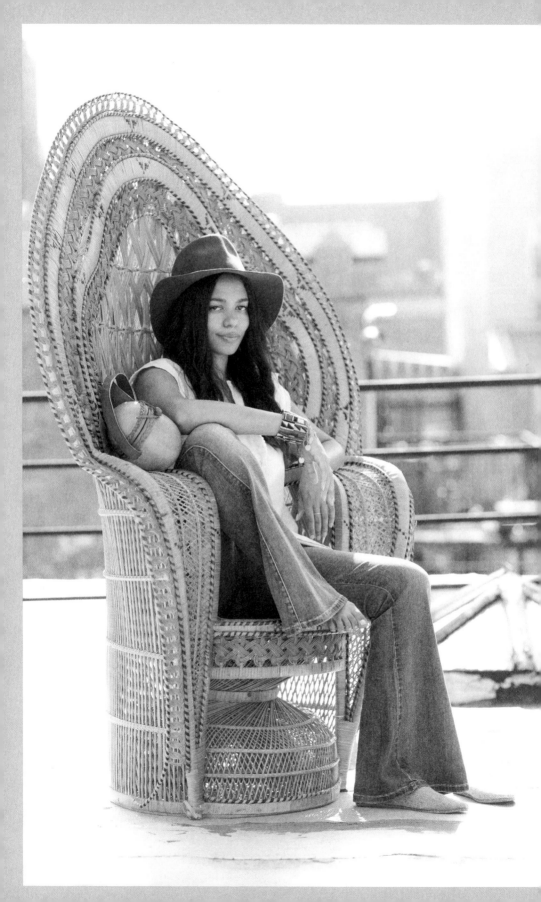

Aurora James, the Canadian-born designer of the ethical shoe line Brother Vellies, moved from Los Angeles to Bed-Stuy. "For what I find important in a home, a neighborhood, and an environment, Brooklyn was my only option. It was already my home. I just didn't know it."

needs to be inherently bad any more than leather needs to be inherently bad," says Inglis. "It's in how you treat the animals, and whether you respect them."

Of course, the topic of wearing fur is contentious. Animal-rights activists will not condone wearing any kind of fur or leather—including vintage pieces. But Inglis is unflappable on the subject. Fur and leather are the oldest wearable materials known to humans, she points out. "[They're] not going anywhere," she says.

Designer and former vegan Aurora James finds the reality of fur in fashion to be a nuanced topic. James runs the shoe label Brother Vellies, which is also head-quartered at her Bed-Stuy home studio. *Velskoen*, or "vellies," are a traditional South African and Namibian desert boot. Many of the shoes are made using rabbit, springbok, and kudu, a kind of antelope found in Africa. Production takes place in South Africa, Morocco, and Kenya, where James spends much of her time.

The kudu leather is a by-product of govern-ment-mandated hunting due to overpopulation prob-lems. Kudu, rabbit, and springbok are all consumed as food before the skins are made into shoes. "This is a very cultural thing," says James. "I understand how people are like, 'Oh, God, that's fur.' But you have to look at it on a case-by-case basis. Nothing is black and white. It's not that easy."

James admits it's hard to make everything in Africa. But she is committed to creating jobs for the local economy. The shoes are produced by both men and women artisans, and their work directly supports

their communities. However, certain batches have disappeared in transit before they reached New York. And, should anything go wrong, James gets on a plane to Nairobi, which is a bigger commitment than taking the subway to the Garment District.

James explains: "Even early on, when we were working out a lot of the kinks in our production, so many people said, 'Well, why don't you just make them in Brooklyn?' But I really wanted to keep one hundred percent of everything there. I can't leave. If I leave Africa, I will leave the company. It just isn't right."

Supporting small-scale, local, independent designers is one way to endorse fair labor practices in the garment industry. However, in reality, the most sustainable approach is to buy nothing at all.

After four years of working as a fashion journalist, Swedish-born Sofia Hedström was feeling uninspired by the industry, despite having attended elaborate shows such as Chanel's biannual Paris extravaganza at the Grand Palais. Multiple trend cycles kept happening repeatedly. She decided to undertake a shopping-free year to see if it left her feeling more energized and fulfilled with her wardrobe.

"Not shopping changed my consumption, the way I go into a store, how I think when I buy something new," Hedström says. "My goal is to inspire other people to try at least a short shopping detox. You will be surprised when you realize how you buy things. Many people buy things to celebrate something, out of boredom, or to hang out with their friends. That has nothing to do with need."

Sofia Hedström outside Kellogg's Diner in Williamsburg. After her shopping-detox project, Hedström gravitated toward old favorites, like her vintage red jumpsuit. If she buys something new, she really has to love it.

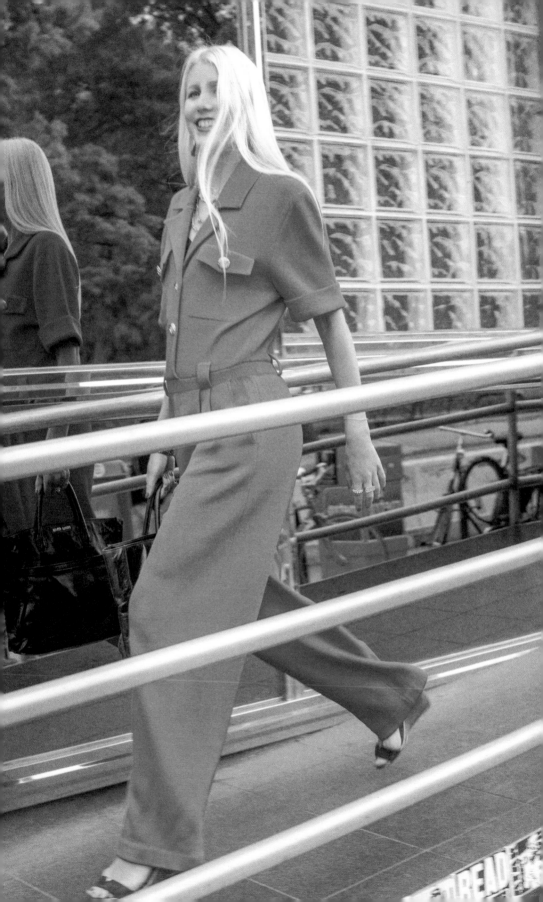

Another Brooklyn writer, Elizabeth Cline, spent three years researching and writing *Overdressed: The Shockingly High Cost of Cheap Fashion*. Cline started her story as a self-confessed fast-fashion consumer: She bought only cheap clothes. Through her work, Cline visited garment workers and factories in the United States, Bangladesh, China, and the Dominican Republic. By the end, she came to view stores like H&M as "unsightly jumbles of cheap clothes dressed up as good deals." Taken to heart, the book is potentially habit changing.

Apart from production and consumption, conscientious fashion is also about the choices women make in getting dressed and creating their own image. The multifaceted Sarah Sophie Flicker is a performer, writer, mother, and women's-rights activist who lives in Brooklyn Heights. She cofounded Lady Parts Justice, a reproductive-rights organization, and the Citizens Band, a political cabaret troupe. Flicker's style often gravitates toward a mix of suffragette and flapper showgirl looks, though we met her in a John-Lennon-and-Yoko-Ono-inspired peace T-shirt stating "War on Women Is Over! (if you want it)" with a pair of old Chloé jeans. She wears lipstick and heels and gets her hair dyed. "It's important to me to maintain my sense of self and present myself to the world in a way that I'm proud of," she says. "You can be in the struggle and get a facial." In other words, freedom of choice is empowerment.

Regardless of your underlying beliefs, conscientious fashion is about cultivating awareness and asking

WAR ON WOMEN IS OVER!
IF YOU WANT IT
x.o.

Sarah Sophie Flicker (right) represents in her Center for Reproductive Rights T-shirt. Flicker (following two pages) wears Charlotte Olympia platform heels, a Zaldy silk dress, and a Jennifer Behr tiara.

questions, first off, of yourself. What do you believe and how does that translate to your style? Perhaps garment industry labor concerns have stopped you from buying certain things. Or, maybe you've taken a stance on leather and fur. These issues, as well as fashion's impact on the environment and women's rights, are complicated. Even something as basic as a T-shirt can be interpreted in multiple ways.

In Brooklyn, it is not unusual for us to place a lens of social concern in front of our basic needs, such as food and, increasingly, our clothes. This is what drives the work of innovative chefs, restaurateurs, designers, and boutique owners whose end products incorporate their beliefs. Sometimes a T-shirt is not just a T-shirt, especially when it's from Brooklyn.

Mary Alice Stephenson in an
Isabel Marant top, Ann Taylor skirt,
Alexander Wang ankle boots, and
Sama Eyewear sunglasses with her
GLAM4GOOD team. From left: Lindsey
Coco, Isabella Benavides, Jedda Kahn,
and Gabrielle Swan.

Q&A

with Mary Alice Stephenson,
style and beauty expert and founder, GLAM4GOOD

Originally from Birmingham, Michigan, six-foot-tall, blond Mary Alice Stephenson has been a force in American fashion, and has lived in Cobble Hill, Brooklyn, for the past two decades. As a fashion director, editor, stylist, commentator, and consultant, she has dressed supermodels and celebrities, conceived epic magazine covers, and talked fashion on nearly every media venue out there. However, it's her fashion-beauty empowerment movement, GLAM4GOOD, that's really her bag.

What was your personal style journey?

Well, when I came to New York and sat across from Anna Wintour to be interviewed for a job at *Vogue*, I had on a god-awful shoulder-padded Tahari jacket. My hair was uncool. I was very chubby. But I was passionate and knew fashion and gave it my all.

I was never the most stylish girl in the neighborhood. And I'm still not. Some people are just born with style and they know what to do and how to do it. I was born with a passion for all things stylish. I learned by being surrounded by stylish people. And I learned the ingredients and elements of style. Many of the most stylish people make it look easy, but there's a lot of work that goes into it.

Why is finding one's style even important?

Style is this glamorous armor that we have as women…and it helps us deal with far more difficult things in life. Self-esteem pretty much powers all of the things we need to be successful human beings.

Look at Michelle Obama. One of the reasons people are so fascinated and have paid so much attention to her Let's Move initiative is not just because of her powerful message. They have loved seeing what she was wearing. Style is a very

powerful agent of social change. So, style connected with social conscience can move mountains. Fashion is a tool to draw people in, to express yourself, and to amplify that power in a lot of ways.

How did you tap into fashion as philanthropy?

I started seeing this false sense of perfection that I was contributing to in my career. No one can look that good. It's not realistic. So I needed to counterbalance that to feel good about being in fashion.

So how do you work with all these different women?

GLAM4GOOD is a fashion-and-beauty movement, community, and organization that ignites positive social change through style. We honor and pamper deserving people— heroic women—with style. And it's really igniting and empowering. I understand fashion's power to make people feel good.

I have seen how looking good can change someone's life because they feel great. It elevates everything. It's not the most important

thing in the world to look good. There are far more important things to cultivate in oneself. But when you use fashion as a tool on your journey of living your life to the fullest, it can be a powerful way to ignite your best you!

How do real women find their style and love the way they dress every day?

For women who have a career and family, there's so much more we have to do than worry about ourselves. So the number one tip would be to give yourself permission to pamper yourself with fashion, give yourself permission to try it on, to take the time out of your busy schedule and day to ensure that you feel and look good. We're always taking care of everybody else. As women, that's what we do. We need to nurture ourselves. And fashion is a powerful way that women can do that.

Tailoring is my number two tip. The reason that stars look so beautiful in magazines is because everything they wear is tailored. Nowadays you can find a tailor at

your local dry cleaner. Take things in or out at the waist, shorten pants, reinvent clothes you haven't worn in a while by taking off a sleeve or turning a bridesmaid gown into a cute cocktail dress. If you wear something that you really love and you make it fit perfectly to you, it might cost you an extra $5 to an extra $50, but it's worth it.

And if you have curves, this is critical: shapewear. Nowadays there's so much shapewear out there that's technologically advanced. It's no longer ugly, hot, ill-fitting biker pants under your dress. Great, sexy shapewear really accentuates your curves in a way that's flattering and helps you look great in everything you wear. And that's the key. Even the thinnest stars use shapewear.

Wow! That's good to know.
And also, my last tip, which I think is the most important, is: Break the rules. It's about what looks best on you. You know what you like to show off and what you like to hide. In every outfit, show off what you love, disguise what you don't. In the words of the great Donna Karan, "If all else fails, show your shoulders. They never gain weight."

What inspires you about style in Brooklyn?
Brooklyn style is people following their own paths. Brooklyn style is about individuals with flair and their own way of expressing themselves through beauty and fashion. Some of the most stylish people I've met live in Brooklyn. And it's more than just what they wear. It's their lifestyle. It's how they live their lives. In Brooklyn there's more risk taking. It has more diverse style—there are people from all over the world, and that is what contributes to the beautiful expressions of personal style.

Have you seen Brooklyn style change over the years?
Yes, it's become more polished. It's more luxurious. It's more glamorous. So when you take that kind of cool edge that Brooklyn's always had and combine it with glamour and diversity, it's elevated more than it used to be. In Brooklyn you can wear anything and feel good in it!

MAKE
IT
YOURSELF

6

It's not uncommon to see Brooklyn folks wearing work boots, a pair of lived-in jeans, and a work shirt in plaid flannel, chambray, or denim. More often than not this person is in the line of making something—Kings County pickles, perhaps; whiskey; shoes; soap; or art. While handmade-embracing, local-loving Brooklyn deserves to be the punch line of an artisanal pickle joke, there's also talk of the DIY maker movement driving the economy of the twenty-first century.

The boom of Brooklyn's creative class has been happening in and around the remains of the borough's industrial era. Until the mid-twentieth century, Brooklyn shouldered much of the country's manufacturing business: everything from sugar and beer to ironworks, pencils, and pharmaceuticals. When industries moved out of the city for affordable space elsewhere, vacant warehouses were left behind. Artists, musicians, and mavericks took over empty commercial buildings

where they lived and worked (as happened in SoHo lofts during the 1970s). Brooklyn neighborhoods along the waterfront (Dumbo, the Brooklyn Navy Yard, and Williamsburg) slowly transitioned from blighted, defunct factories to zones filled with small-scale producers, technology companies, and designers aplenty.

Emily Bidwell, a former sculptor who is the resident style expert at e-commerce craft site Etsy, moved to Williamsburg in 1998. Bidwell describes the vibe at the time as "lawless"; it was an open territory with no neighbors to complain about loud music, or, really, about anything at all. The community had its own art openings, music shows, and parties. Manhattan was forgotten.

"In Brooklyn we achieved a type of artistic independence," Bidwell says. "It was this sense of self-empowerment."

Etsy was founded on the idea that artisans could sell their own goods online as part of a community. The company distills the image of Brooklyn makers—both the products and the people. But even if you never personally knit a thing, the maker look has become a style choice ranging from rugged work boots and plaid flannel to unique accessories like clay bead necklaces, crocheted hats, or recycled canvas backpacks. Both creators and customers can look like they have been working with their hands all day in the shop.

It's a golden time for handmade goods. At the same time, pickled, hammered, earnest Brooklyn can

Ceramicist Stephanie Tran, at the Dobbin Mews studios in Greenpoint, in a UNIQLO oxford shirt, Isabel Marant skirt, and Nikes. Tran is also a stylist, writer, and runner.

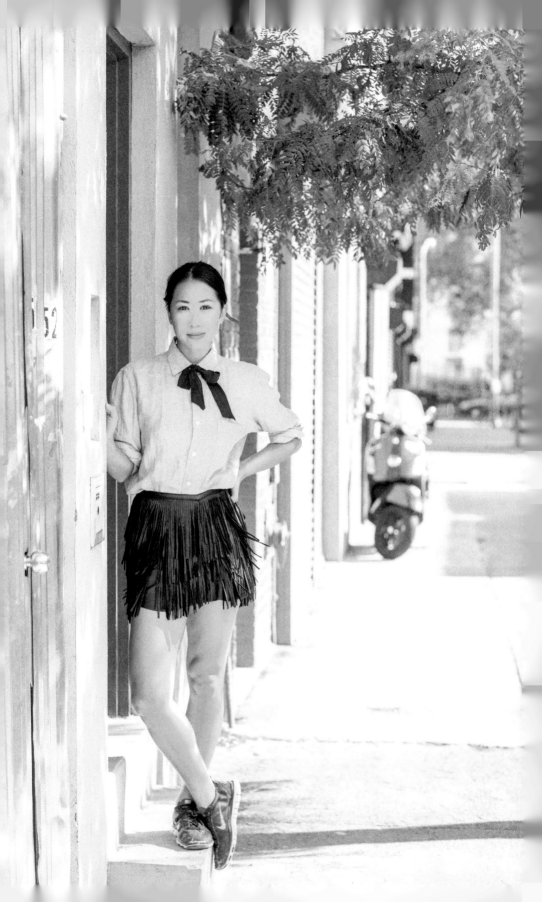

Glorious Maker Goods

Who's better poised than Stephanie Tran to share some favorite Brooklyn makers (and vintage sellers) on Etsy? Stylist and ceramicist Tran curated a pop-up shop that was a joint project between Etsy and *Dossier* journal, where she also contributes. We trust her taste. She is also a former accessories editor for *Vogue*.

Demestiks New York For someone who wears a lot of black, Reuben Reuel's colorful wax-print dresses, skirts, tops, and jackets are a fun addition to the mix.

Rebecca Schoneveld I got married at City Hall in a vintage Comme des Garçons dress, but if I had a big wedding, I'd want one of Rebecca's custom, elegant, understated designs. When you start to appreciate things that are well made, the cost is justified.

Friends Vintage The selection of eighties and nineties pieces is wacky, clubby, and affordable. I've found things from Thierry Mugler, Jean Paul Gaultier, Azzedine Alaïa, and Norma Kamali. They also have a shop at Mary Meyer in Bushwick.

Victory Mills Vintage I like Briana Thomas' muted, romantic color palette and simple presentation. Sweet stuff.

K. Hansen Jewelry Kristina Hansen's modernist, geometric items dress up an everyday outfit, which is important to me when I'm wearing something like my Carhartt jumpsuit in the studio. I'm still comfortable, but I like to look presentable.

The Seam Designs Love Lyndsay Senerchia's hand-knit, chunky turbans, slouchy beanies, and infinity scarves (especially in oatmeal).

Bar Soap Brooklyn LLC The natural body oils and triangular soaps made by KaKyung Cho are pretty, smell amazing, and come in awesome packaging.

 The creators of independent brands have a hand in everything they make. And people love that. When you have a human connection, it feels special.

—Stephanie Tran,
stylist and ceramicist

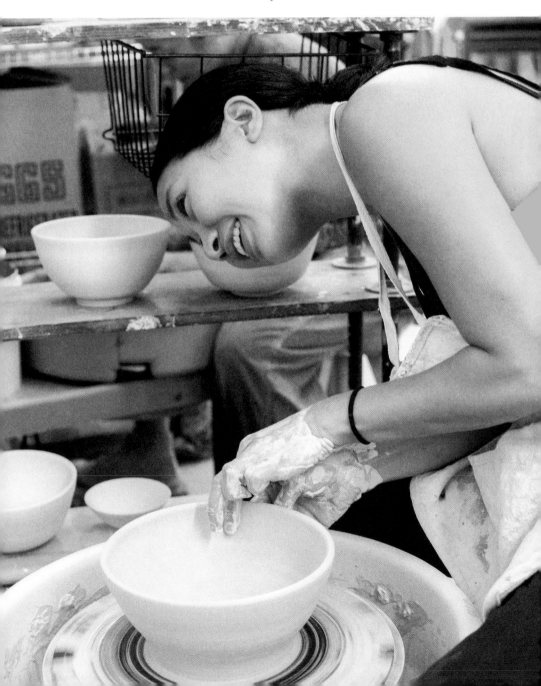

 There is a strong ethos behind people's work in Brooklyn. The community is made stronger by everyone sharing similar morals in terms of where their goods are produced, what they're made from, and whom they're selling to.
—*Dani Griffiths,* milliner, Clyde

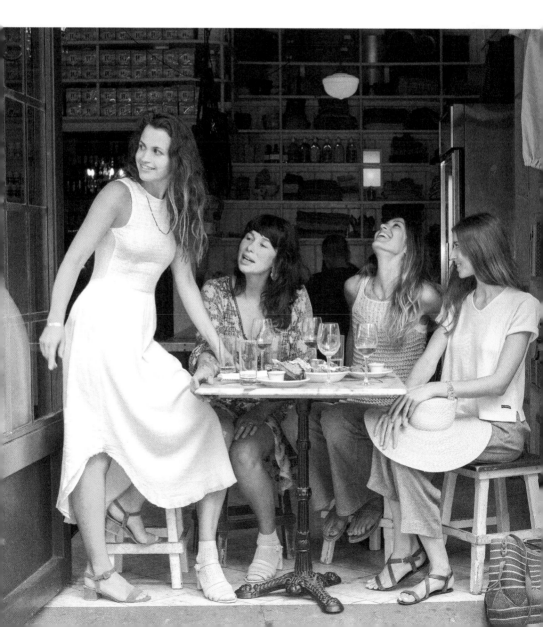

withstand a little mockery (lest we succumb to taking ourselves too seriously). Painter/jeweler Suzannah Wainhouse says there is only so much we need of the "organic, grass fed, and hand poured. It seems to be a bit of a caricature of itself." She is also bemused by Brooklyn makers who dress in Carhartt jackets, emulating rural Vermont farmers and loggers from her home territory. On the other hand, "In terms of a value system, it's a great thing," she says. "If fads and fashion have to follow something, better this than the opposite, living with mindless consumerism and 'who cares where it was made?'"

Originally from Brattleboro, Vermont, Wainhouse sees some similarity between her hometown and Brooklyn in the love of craft. She has been making things for as long as she can remember. In high school she built furniture, did blacksmithing, and painted.

"Living in the country, we were all resourceful," Wainhouse says. "That sort of mentality is what I was around. It's a lot of what we have here in Brooklyn. People are hyper-good at something, really into it, obsessed."

Wainhouse's painting is similar in style to her self-named jewelry line, which has a rough quality of textures and bold geometrical shapes. She combines different metals and casts these into icons from the natural world: snakes, wings, skulls, and arrows. When her first collection was picked up by Barneys, she quickly figured out how to increase production.

Harboring no romantic idolization for rugged Vermont, Wainhouse loves fine vintage clothes—anything

A community of makers (from left): Kate Huling, Suzannah Wainhouse, Ulla Johnson, and Dani Griffiths at Marlow & Sons in Williamsburg.

with intricate details in the stitching or buttons, or just things that come from a time when better fabrics were commonplace. She loves high-waisted trousers, vintage dresses, and oversize cashmere men's sweaters. To switch it up, she also loves a good 1970s CBGB-era biker jacket. Wainhouse recently found just such a jacket at the vintage store Narnia in her neighborhood, Williamsburg, and was pondering how to get out the cigarette smell.

Her style needs to be practical because everything gets dirty and covered in paint. However, she still must occasionally step through the looking glass into the world of Barneys meetings on Manhattan's Upper East Side. "Everyone is so coiffed and put together," Wainhouse says. "No matter how much I blow-dry my hair or try to get the dirt off my hands, I look so crazy."

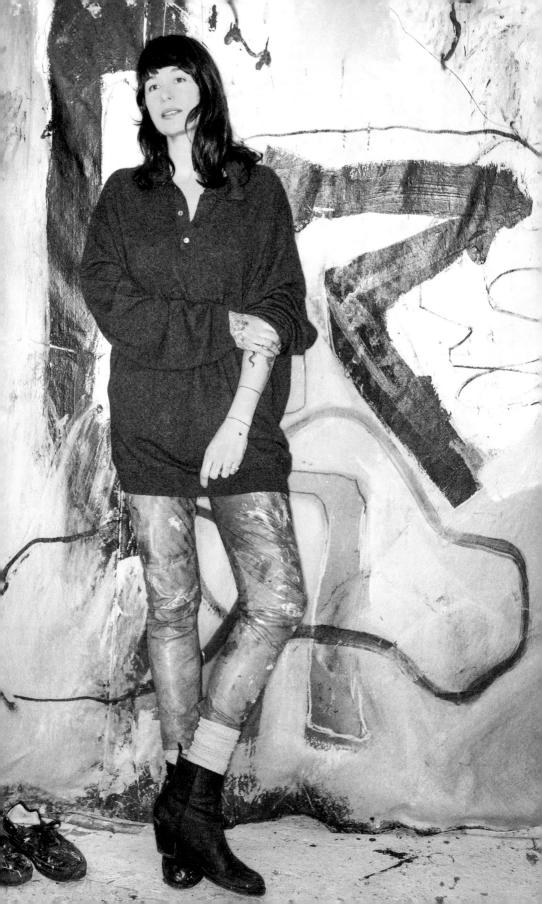

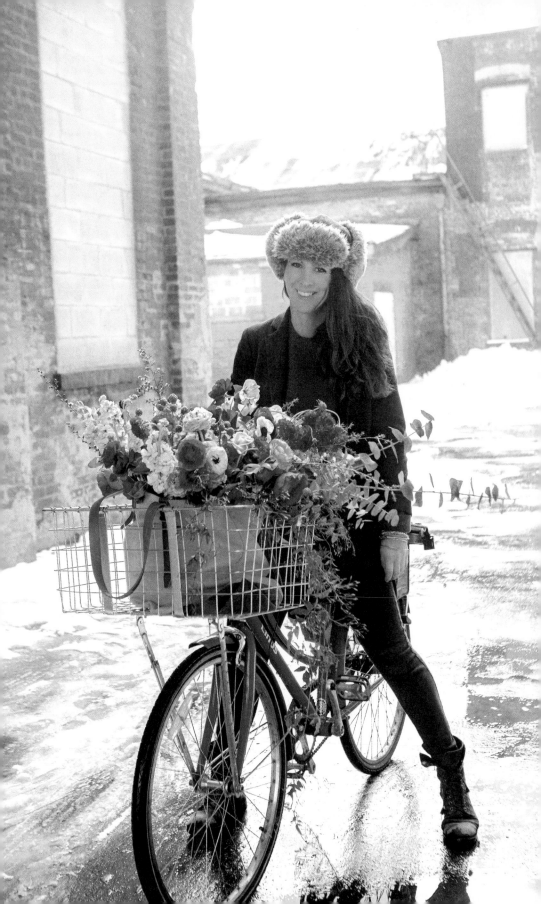

Florist Ingrid Carozzi outside the Recycled Brooklyn studio in Red Hook. Her canvas-and-leather tote is made by Brooklyn-based TM1985. The fur trapper hat is vintage.

Well, we'd say that's doubtful. While she may not feel as comfortable in her formal attire as in her casual clothes, Wainhouse always pulls off majorly creative style. She relies on a few lush, billowy pieces from the Brooklyn label Electric Feathers and a killer Isabel Marant jacket for her uptown look.

For retailers like Barneys, high fashion and funky Brooklyn pair together perfectly. Barneys' scouts continually look to appropriate Brooklyn designers and brands. Part of the desire for these unique goods stems from consumers' desire to know about an item's provenance, meaning the story behind it. (The idea is akin to the wine lover's terroir.) Building a sense of authenticity is part of the appeal. At the same time, maker style challenges the model of traditional retailers, which hawk high volumes of mass-produced goods.

Nana Spears, a former assistant buyer at Barneys, left a career in fashion to cofound Fort Makers, an artists' collective housed across from the industrial park at the former Brooklyn Navy Yard. Fort Makers is the kind of artist/artisan enclave that makes Brooklyn so very…well, Brooklyn. The collective's first project was a series of tapestries made from painting vintage camp blankets. These hung in Steven Alan stores around the country for about five years. Next, the group made a line of hand-painted silk shirtdresses using fabrics created by fellow Fort Maker and painter Naomi Clark.

Now that she is part of the maker world, Spears says her entire wardrobe has changed. For her job at

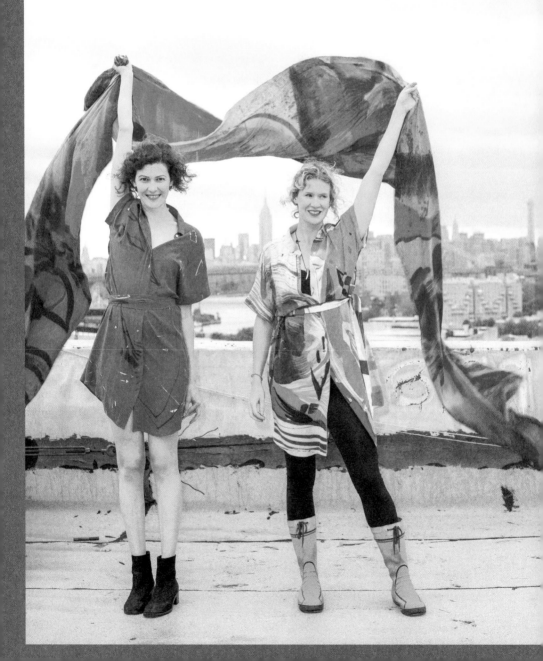

Nana Spears (left) and Naomi Clark of the artist collective Fort Makers on their Clinton Hill studio's rooftop near the Brooklyn Navy Yard. Spears and Clark (opposite) at work.

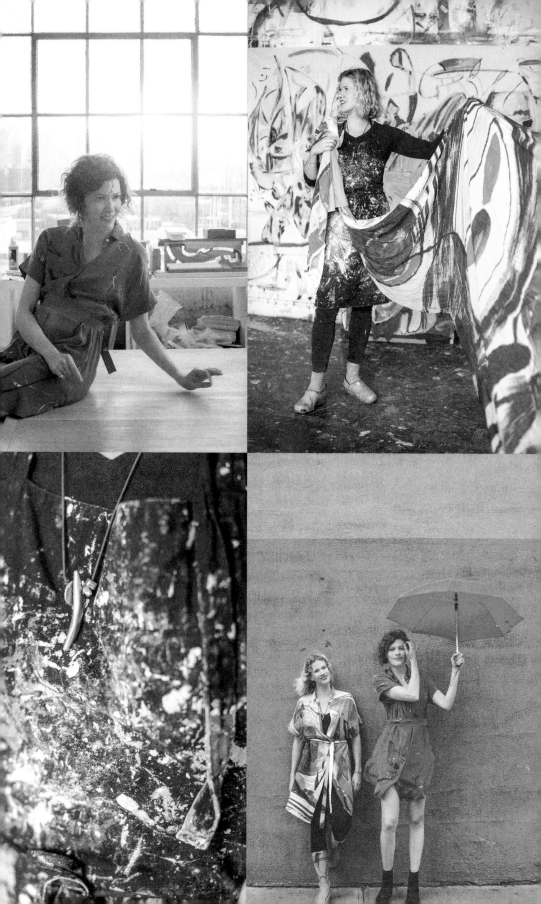

Barneys, Spears wore heels and the appropriate level of current fashion to underscore her professionalism. Her closet is still filled with some of her favorite designers from the day: Dries Van Noten, Marni, Zero + Maria Cornejo. She saves these looks for going out.

When Spears started making things, she found it to be more fulfilling than her old shopping habits. Fort Makers introduced her to a different way of living, one centered more on creativity and less on consumerism. Like Wainhouse, Spears now has a comfortable wardrobe for getting dirty. "I find myself dressing like a little boy in shorts and high-tops," she says.

The thrifty element of refashioning clothes rather than buying new things is also a part of maker style. Clark helped Spears revamp her wardrobe by doing things like painting over stains to create a new pattern or patching up holes. "It makes your sweater better than it was originally," Spears says. "You hope for a hole."

The hands that create: Suzannah Wainhouse (top) in gold and diamond rings from her jewelry line, and Jeanette Lai Thomas (bottom) in silver Moratorium pieces of her design.

Brooklyn maker style revels in the practice of crafting original things. It's creative, independent, unique, rough, and gritty. The artisans themselves might be indifferent to trends, but fashion cool-hunters are watching them. The more that all things small batch and handmade are packaged for the mass market, the more they lose that sense of provenance. We suggest staying away from anything that shouts "Made in Brooklyn." Instead, it's more Brooklyn to get your hands dirty and sew, paint, cut, or craft something that you wear—and have a solid pair of work boots.

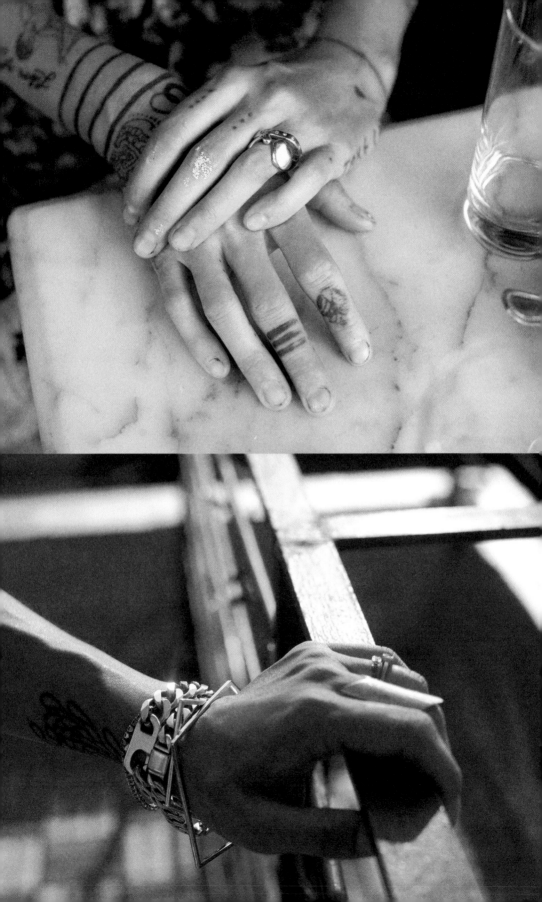

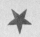

Brooklyn's Place In Fashion History

Jan Glier Reeder, consulting curator for the Brooklyn Museum Costume Collection at The Metropolitan Museum of Art, fills us in on Brooklyn's role as an influential fashion center.

In 2009, the most significant collection of American fashion from the early twentieth century moved from the Brooklyn Museum to its new, more famous home across the river: The Metropolitan Museum of Art on Manhattan's Fifth Avenue. The collection is a rich trove of nearly twenty-four thousand American and European costumes and accessories dating back to 1903.

Though the collection left the borough, it retains its lengthy title—the Brooklyn Museum Costume Collection at The Metropolitan Museum of Art—and significantly so, as Brooklyn played a pivotal role in fashion history. A century before the borough's explosion as a locus for all things in vogue, it was a center for the origins of American style.

Founded in 1890, the Brooklyn Museum supported commercial art from the beginning by encouraging designers to use it as a resource. In 1914, Stewart Culin, the museum's first curator of ethnology,

traveled across Asia to collect textiles, clothing, and other objects to study. When he returned, Culin partnered with Morris de Camp (M.D.C.) Crawford, a research editor for Fairchild Publications, which owned *Women's Wear Daily*. Crawford was as committed as Culin to bringing the museum's artifacts to the public and creating a place where designers could do research for inspiration.

"During the First World War, Americans, who had always looked to Paris for fashion ideas, realized that they were cut off from these sources," says curator and historian Jan Glier Reeder, who spent nearly four years cataloging and documenting the collection's thousands of pieces in a Brooklyn warehouse. "Influential people in American fashion decided that it was important to develop an American style and look, to not be dependent on Paris. The Brooklyn Museum was not founded as an art museum; it was founded as an ethnographic museum. Designers

looked into the collections to be inspired and develop their own style. The museum became a center of fashion and style. And so Brooklyn was really a hub of that movement to inspire designers."

During World War II, American designers were again cut off from the continent. The movement toward American fashion autonomy that started during World War I continued to influence designers.

Reeder says: "An important part of the Brooklyn collection is the American women designers who really hit their stride during World War II. Several of them were involved with the Design Lab [at the Brooklyn Museum] and were going there for inspiration. These American women were the promoters and originators of the idea of American sportswear, which is always said to be America's greatest contribution to fashion. That's where it started."

From the 1930s to the early 1970s, American ingenuity forever changed fashion into something attainable and affordable. Designers Bonnie Cashin, Vera Maxwell, Carolyn Schnurer, and Claire McCardell created clothes that formed the template for how we dress today. Their presentation of sportswear was a radical rethinking, independent from French couture, of what modern women would wear. The garments were casual, versatile, and in fabrics like cotton that could easily be cared for. Of all these instrumental women's contributions, McCardell's was most associated with this new American look: She made pants a chic, comfortable, everyday wardrobe staple for women.

Because these early tastemakers had been involved with the Brooklyn Museum's Design Lab, they donated a significant portion of their legacy to the museum's collection, which Reeder describes as "unparalleled in scope and quality," and which includes many of their most important designs. She adds that the fashion-forward work of milliner Sally Victor is another highlight of the collection. Victor's hats took inspiration from all over the world—everything from Japanese samurai armor to Piet Mondrian's multicolored grid painting *Broadway Boogie Woogie*. "They're really out-there kind of hats," Reeder says. "They were just part of every American woman's wardrobe during the forties, fifties, and into the sixties."

The reality is that the inspiration for early American style and current Brooklyn style hasn't changed much. Brooklynites today continue to pull from looks across the globe—say, a blouse from India, jewelry from Nepal, or an "out-there kind of hat" from midcentury New York. These pieces get added into our daily vocabulary of dress. It's the philosophy of the American melting pot. We embrace our mixed heritage from all parts of the world and put these influences together to form something new.

DON'T FUSS

For many critics, the American style of dressing down has gone too far. Yoga pants, hoodies, and flip-flops appear in all sorts of places they shouldn't, like restaurants, offices, and European capitals. However, we have a long history of keeping it casual. Jeans were a stateside innovation patented by Levi Strauss & Co. in 1873. During the 1930s, American women designers invented sportswear, or separates, which is our basic concept of modern dress.

Comfort is not to blame. It appears that we've forgotten about panache. The most classic American style icons always perfect both. Think of Jackie O. and Carolyn Bessette-Kennedy, Lauren Hutton and Michelle Obama. They share a simplicity and elegance in their choice of clothes, adding a pop of flair with a scarf or hat, a hair twist, or an elegant shoe.

Some women create their own comfort-chic by developing a uniform that suits them. DJ Lauren Flax of the electronic duo CREEP doesn't stray from her punk-rock look: jeans, a button-down or T-shirt, and Dr. Martens or creepers. She picked up her black

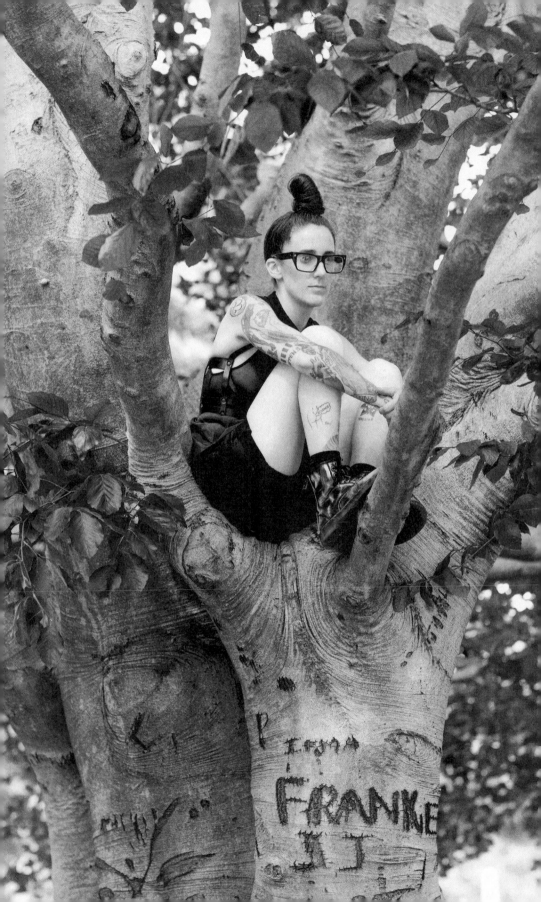

square-framed glasses at a flea market in Rome. Her hair is usually in a bun on top of her head. Then Flax wears some stellar, out-there pieces. She may add an architectural, cage-like Chromat bustier or harness and sunglasses (also favored by Lady Gaga) from Coco & Breezy, both lines by Brooklyn designers who live close to Flax's Bushwick home.

"I think it's obvious I'm a Brooklynite just judging by my fashion sense, especially when I'm in other cities or countries," Flax says. "I'm not even exactly sure what Brooklyn fashion is, though! But I'm down with it."

Florist Taylor Patterson also centers her working uniform around jeans with a chambray shirt and boots. She calls her look "messy, but dressy."

"I don't want to put on anything too nice on a regular basis," Patterson says, "anything that can get stained or ripped easily. I don't wear a lot of skirts, for example. I like jeans and boots—but nice jeans and boots. I need things to be easy to move in and machine washable. I don't have time to go home in between work and any social activity. Even if it gets dirty it has to be something that isn't obviously dirty."

DJ Lauren Flax at the Evergreens Cemetery near her Bushwick home. In Dr. Martens, cargo shorts, and a Chromat bralette, she easily climbed up a European beech tree for this shot. The historic, park-like cemetery is on the Brooklyn-Queens border.

You should be able to nap in your clothes. Even in your very nice clothes, you should be able to take a nap.
—*Mona Kowalska,*
founder/designer, A Détacher

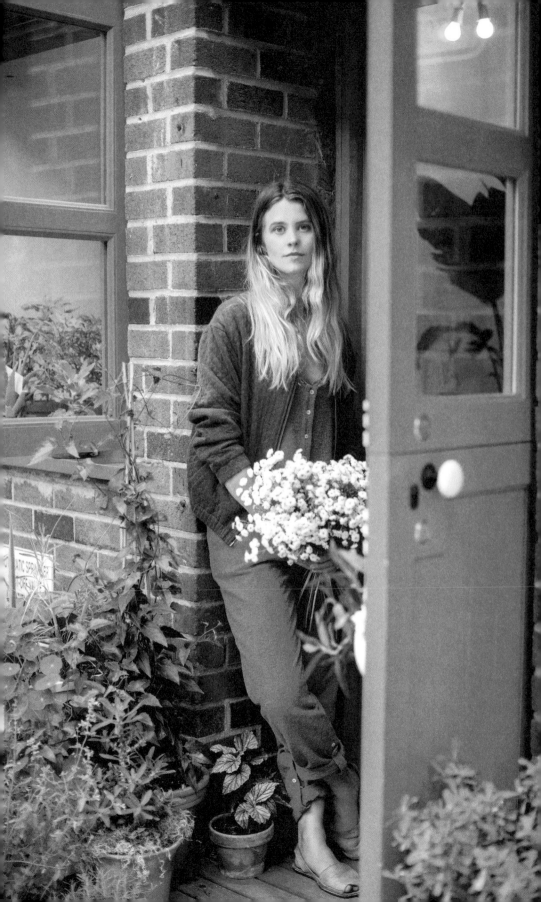

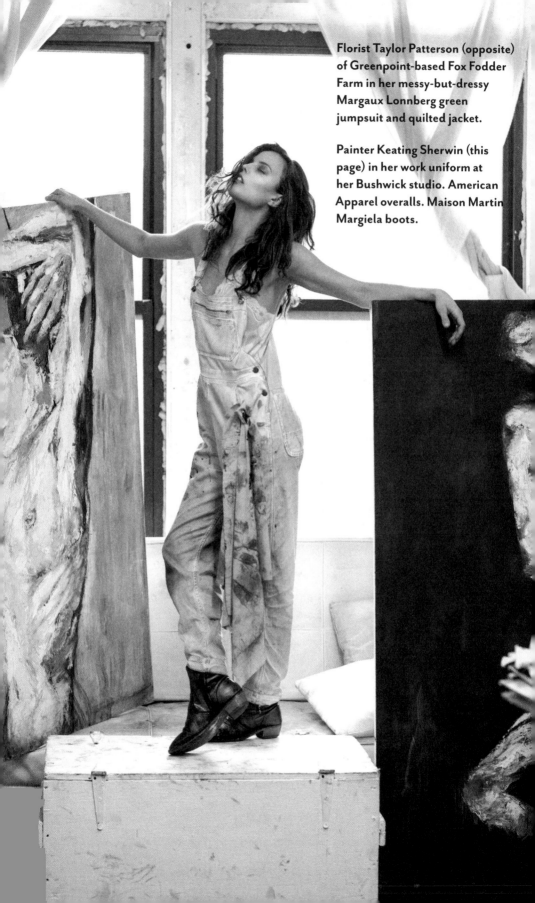

Florist Taylor Patterson (opposite) of Greenpoint-based Fox Fodder Farm in her messy-but-dressy Margaux Lonnberg green jumpsuit and quilted jacket.

Painter Keating Sherwin (this page) in her work uniform at her Bushwick studio. American Apparel overalls. Maison Martin Margiela boots.

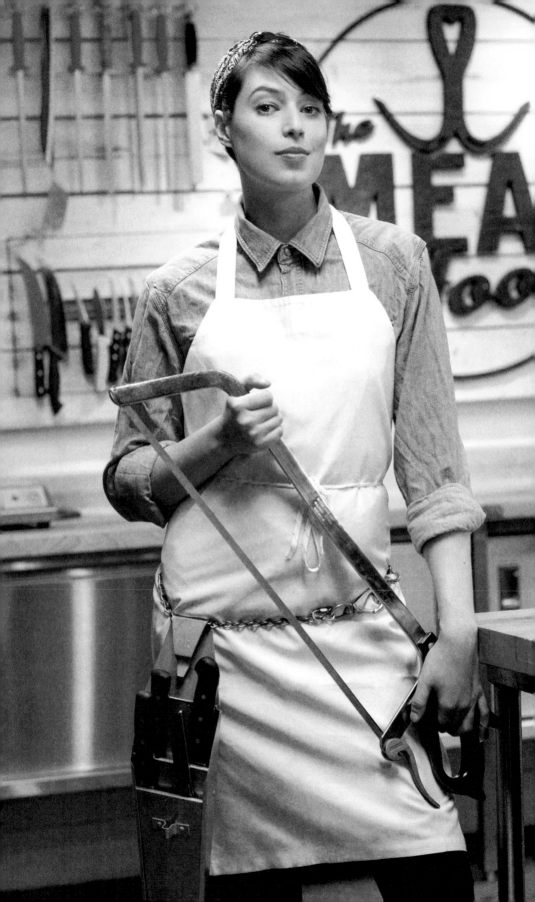

> *It's sexy to see curves under straight-cut men's clothes.*
>
> —*Lauren Hutton*

The most beautiful, baddest butcher in Brooklyn: Sara Bigelow at the Meat Hook in Williamsburg.

Patterson, like many Brooklyn women, relies on her style choices to see her through a workday to a night out. She never stops by her Clinton Hill apartment to change. Her favorite pieces are simple, well made, and, it must be noted, priced to match. That said, the ideal closet is best filled with a few treasured items of quality rather than amassing quantity. Patterson likes Dieppa Restrepo oxfords, Penelope Chilvers boots, Acne Studios jeans, and basics from Apiece Apart, all things that are "functional and wearable, but nice," she says. "My being fancy and my being casual are kind of the same. I pretty much wear the same thing every day, and I don't mind."

The same uniform that works for Patterson and Flax also works for women across Brooklyn's food scene. Chefs, waitresses, bartenders, and butchers all seem to gravitate to fitted jeans, T-shirts, baseball jerseys, or button-downs with a sturdy pair of shoes. The differentiation is in the details. A bandanna wrapped around her hair, kerchief-style, or across the forehead as perfected by country singer Willie Nelson. Degrees of tattoos vary from one discreet symbol to a full sleeve—ditto with jewelry, from minimalist to layered necklaces and multiple piercings.

Of course, when our grandmothers said, "Accessorize!" they did not mean ink. A standout bag, beautiful scarf, or shoes can elevate the simplest look. Milliner Dani Griffiths dresses for hats. Originally from Vancouver, Canada, and now a Williamsburg resident, she

Keep It Simple

Marina Muñoz could be at a bar in her Brooklyn neighborhood (Williamsburg) or a countryside estancia in Argentina, and she would be in vogue. The Argentine American started modeling when she was fourteen years old. From her time in Paris, Buenos Aires, and Mexico City, Muñoz learned the beauty tips of both dressy Latinas and the understated French. Her menswear-inspired gaucho-chic, perfect for Brooklyn, is a testament to simplicity, always in style.

My approach to style I don't follow the trends. I identify with the French version of being a tomboy, like wearing a YSL suit and still feeling feminine. Now, being a mother, I want to be comfortable but still look presentable. I like my men's shirts, trousers, and jeans.

Classic is better Look at the things that are so lovely about American style, like jeans. Find a jean shape that works for you, whether it's a boyfriend jean or a straight leg. If you don't look good in jeans, maybe it's a pair of khakis or trousers. Wear with a black turtleneck and a white shirt to frame your face. Some brands I love are A.P.C., J Brand, Rag & Bone, Madewell, and AG. The best khakis and trousers in the world are from 1.61 Studio.

Uniform I've developed a quick uniform for my weekday style because I want to spend time with my kids in the morning. I have ten minutes to get out the door. I throw on a sweater, a pair of jeans, and a cute pair of shoes (flat Céline lace-ups or Robert Clergerie boots).

Favorite brands A.P.C., Apiece Apart, Ryan Roche sweaters, Clyde hats, Acne, RTH, Black Crane, J.Crew

Blown away I recently worked on a shoot with Stella McCartney, who wore a white piqué shirt, a black cropped pair of trousers, and black stilettos. It was simple and beautiful, yet also sexy. You could re-create that look with a Nine West stiletto, black Gap trousers, and a white men's shirt. You don't need to wear the earrings, necklace, and bracelet. Sometimes over-accessorizing can kill the look. For shirts, I prefer to shop in the men's section because women's designs are often loaded up with darts. Keep it loose and classy.

Saved by When I feel frumpy and don't know what to do, I will borrow one of my husband's pinstriped cotton shirts. I either tuck it in or do a half-tuck. If I knot the bottom, I'll wear it with a high-waisted jean, Jack Purcells, and a blazer. It looks chic and timeless.

Always There's nothing better than a cashmere crewneck or V-neck sweater. Choose your colors wisely: black, blue, and beige. When you can, invest in good quality. These will last you many years.

Hoodies Stay away from a solid color, like a purple or pink. Try a floral printed hoodie and add a denim jacket over it. A gray sweatshirt is cuter than doing the full head-to-toe pink or purple. There's a reason DKNY looks so good. Do a legging with a cool pair of Nikes, New Balance, or Adidas. Let's not do a sock. Also, jogging pants can be cool. I prefer the ones with a wide band at the bottom. It's getting a tapered ankle, a groovier sneaker. That's a little more Rick Owens.

Caveat There's a time and a place for casual athletic wear. You don't have to wear that all day long. It's good to make some effort!

The Brooklyn element My holey jeans are acceptable here. The trickle-down effect is that I'll go to Condé Nast, see an editor in jeans, and it's someone living in Brooklyn. I never wore relaxed, slouchy jeans in Paris.

Favorite Brooklyn boutiques Oroboro, Electric Nest, Pilgrim Surf & Supply, Bird, Jumelle, Marlow Goods

Loves I tailor everything. I shorten my jeans to just above the ankle. It makes me look taller. When I was pregnant, I customized my jeans by adding elastic triangles to the sides. It's great for pre- and post-baby. I love a good tailor.

 Classic pieces always look beautiful.
—*Marina Muñoz,* stylist

is so laid-back and flush with positive vibes that it's part of her style. Griffiths prefers to shop vintage or thrift, and she favors soft, flowy pants. Sometimes she might appear to be wearing pajamas, but beautiful silk striped ones that are drapey and elegant on her and are a simple base to display one of her wide-brimmed, sculpted hats. "I'm concerned with silhouettes," Griffiths says. "So much of a hat is a silhouette. I think about a shape and a shadow that something might create."

Boxer Heather Hardy, a featherweight champion who grew up in the Irish American Gerritsen Beach section of Brooklyn, accessorizes with knee socks. A single mother, she is almost always training or teaching at Gleason's Gym in Dumbo, where she lives around the corner with her daughter. Her knee socks collection dates back to Catholic school, when she sported them with skirts. "It was my thing," she says. "It was the only way to be expressive." On the boxing circuit, knee socks are a defining element of Hardy's style. She varies her socks the way some women switch handbags to change up their look.

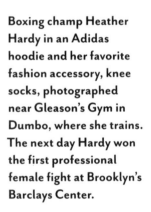

Boxing champ Heather Hardy in an Adidas hoodie and her favorite fashion accessory, knee socks, photographed near Gleason's Gym in Dumbo, where she trains. The next day Hardy won the first professional female fight at Brooklyn's Barclays Center.

In fact, many Brooklyn designers are inspired by sports and athletes. Nomia's Yara Flinn makes a version of men's long basketball shorts, trimmed in silk organza. She has worn these with a crop top, a blazer, and a pair of oxfords. A fan of contrast in style, Flinn likes to pair something masculine with feminine, or sporty with dressy. Mona Kowalska's A Détacher fall 2014 collection, Sports Injury, is about a woman who

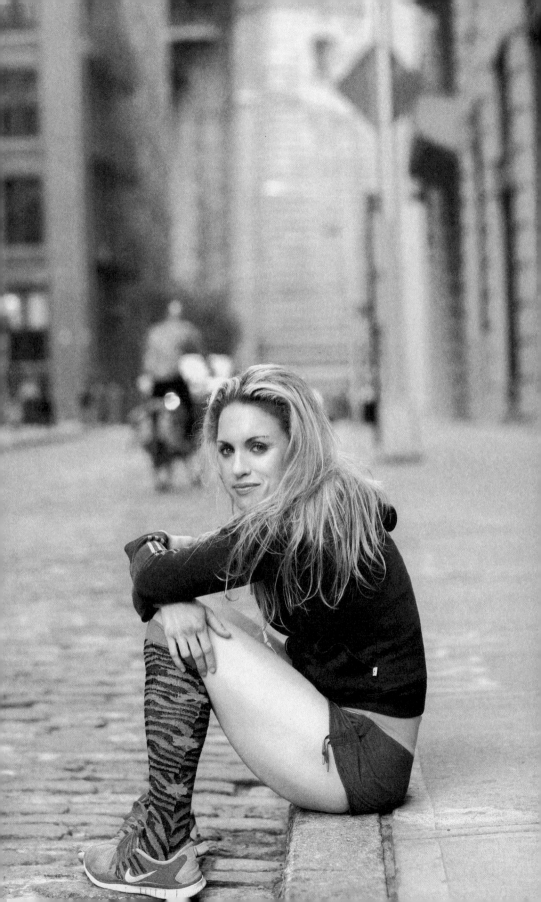

played sports in her past. There are car coats based on the shape of a baseball jersey, athletic polyester mesh pleated skirts, and three-inch-heel boots with sneaker details. For her line Chromat, Becca McCharen has been toying with adding fitness-tracking technology to the garments. Some of the striking black-and-white pieces, including leotards, bustiers, and biker shorts with exposed details such as supportive straps and boning, already look like futuristic, racy uniforms for an extreme sport.

The aesthetic of blending sporty apparel with something more dressy does create disparity, which is never a bad thing in fashion. It adds the unexpected. For recent Chanel collections, Karl Lagerfeld added an element that Brooklyn gals have been working for years—sneakers with a dress. For Chanel, the sneakers were haute couture, handcrafted by master shoemaker Massaro. And yet, how *outré* to pair athletic comfort gear with the iconic French tweed suit!

When comfort-chic is presented by Chanel, we know that it has officially landed. However, throwing on the nearest yoga pants and hoodie is not what we are talking about. Be practical, comfortable, and bring your charisma. Be relaxed and be elegant. Wear what makes you feel like your most confident self. "That's when you're the most attractive to the world," Griffiths says. "When your outfit makes you happy, people want to be around you, and you love life more."

Dancer/choreographer Elle Erdman in Sven clogs and vintage Levino Verna pants. Erdman lives in Bushwick.

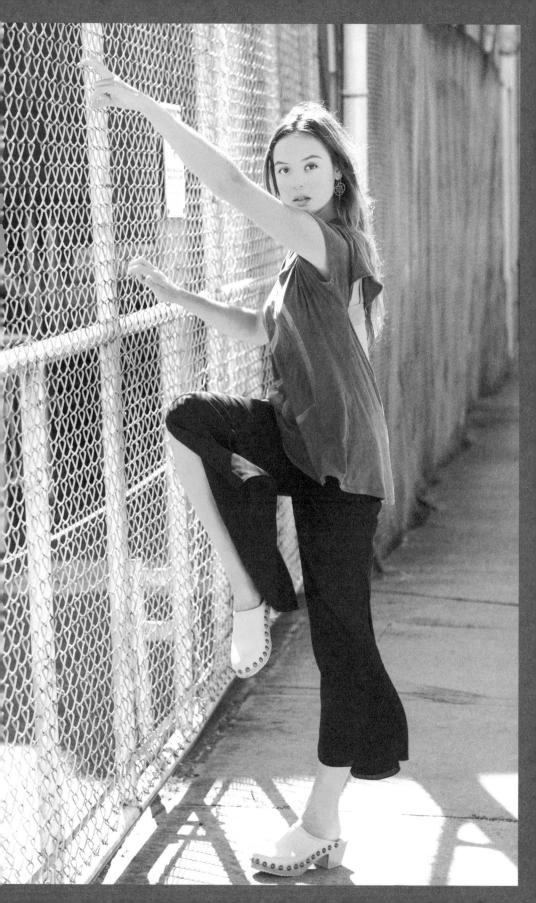

Interlude...
BEAUTY

The mantra for Brooklyn beauty is "natural and organic" (of course). Skincare and hair receive most of the attention. Makeup and nails are more of an accent.

"People are more interested in nice skin, nice eyebrows, and lashes," says beauty and style expert Jessica Richards, owner of the Carroll Gardens beauty boutique Shen. "Brooklyn women are not painted dragons." The light-blond Richards, a mother of two, adds that most Brooklyn moms prefer simple and quick routines based around skincare.

Singer Alexis Krauss of the noise-pop band Sleigh Bells has a full arm of tattoos (including the grim reaper) and dyed jet-black hair and lives in Greenpoint, but her approach to beauty is the same as that of Richards'. "Classic is always good," Krauss says. "Don't worry about what's trendy. Don't cake your face with makeup. Go for a simple face and beautiful hair."

Krauss is an advocate for the regulation of chemicals used in the mainstream beauty industry. In addition to her career as a rocker, she cofounded a website called Beauty Lies Truth. The site lays out ways to clean up your beauty regime, starting with educating yourself at the Campaign for Safe Cosmetics website (safecosmetics.org). "It's not that each one of these products is individually going to give you cancer," she says. "That's ridiculous and it's not the message that we're sending. It's about thinking of this lifetime of exposure."

On the site, Krauss also covers issues and alternative products, some from Brooklyn-based companies such as Meow Meow Tweet or S.W. Basics. "I've started quite a conversation amongst my friends. Many had a reaction similar to mine, which was like, 'Damn, I had no idea.' It's the next step in how people consume. Not only is it healthy for your body, it's much more sustainable."

In line with the demand for organic and sustainable food and fashion, many Brooklynites prefer their beauty products to be small batch and nontoxic. "Everybody wants something different and unique," says Richards of her Shen

Originally from Southern California, Jessica Richards of Shen favors good skincare, minimal makeup, and brow and lash tints.

Singer Alexis Krauss advocates for a healthier cosmetics industry.

Sustainability-minded designer Titania Inglis adores the We See Beauty Foundation's Make Silk Satin Lipstick in Beetroot. "It's a black-cherry sort of red with a hint of a metallic sheen," she says. "They also work with excellent causes."

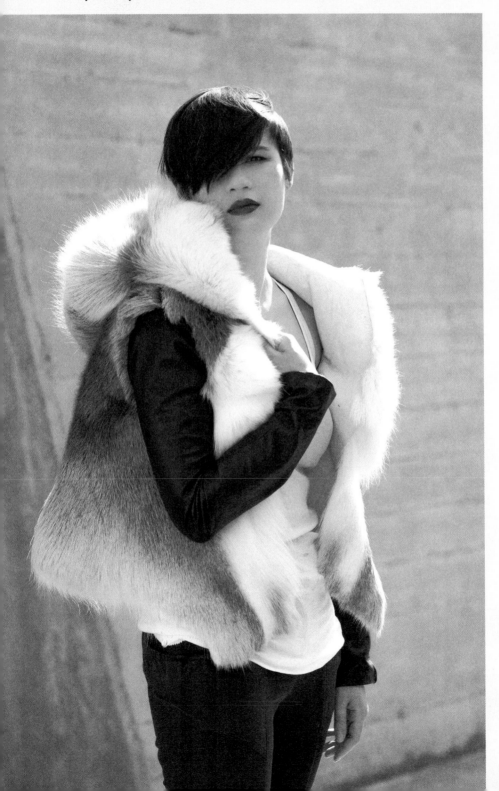

Cat-eye liner and an ear-cuff earring make the statement on musician Vandana Jain, so there's no need to add a dramatic lip.

clientele. "They read a lot of blogs. They know what ingredients are in things, and they're interested in the products."

Richards is a devotee of face oil made with essential botanical oils from argan, rose, and jojoba. Brands she loves are Pai, Aurelia, Georgia Louise, and Kahina Giving Beauty. In addition to face oil, Richards says a great face cream, such as British skincare guru Amanda Lacey's line, is another worthy investment. In lieu of mascara, many women have their eyelashes tinted along with their eyebrows. Then they'll add concealer, a highlighter to make the skin glow, and perhaps a bronzer to add definition (for what Richards calls "the Kim Kardashian effect"). For these, Richards loves products from RMS Beauty, Kjaer Weis, and By Terry.

After the emphasis on skincare, Brooklyn style for beauty is about "accenting a simple face with a pop of color or a dramatic eye," Krauss says. Think of wearing mascara as your only eye makeup with a dark color on the lips. Or, keep the lip light with a sheen of gloss and add metallic, black, and smoky colors to the eye. By playing up one or the other, you can't overdo it.

Even with her preference for simplicity, Krauss still loves black metallic nails done by Brooklyn-born nail artist Ria Lopez. She keeps her nails rounded and short, and her polish of choice is Brooklyn-based Floss Gloss. "It's about being able to function with your nails, work, go rock climbing," she says. Even with beauty, practicality still rules in Brooklyn.

Becca McCharen of the fashion-forward label Chromat wears a cat-eye during the day and amps up her eye makeup at night.

EMBRACE THE WORLD

8

Aurora James of the shoe label Brother Vellies had just landed in Brooklyn after a trip to Kenya. Sitting at a café in Bed-Stuy, James was fighting jet lag with a coffee. She wore a long, glass-beaded colorful necklace with a simple sleeveless blue dress and a floppy brown felt hat. The necklace was made by an older Maasai woman in the Maasai Mara national game reserve, where the tribe lives along the border of Kenya and Tanzania. Maasai women, known for their beading work, wear different pieces of jewelry to denote their status, such as age or marriage.

On James, with her simple dress and wide-brimmed hat, the necklace looked just right—the complement of an object from a faraway land against the simplicity of the dress. "I love taking certain things from different cultures and bringing them into my everyday wardrobe," she says. "As you learn more about cultures and

Aurora James bought her beaded necklace (left) from the Maasai woman who made it. James' simple dress is the perfect canvas for the statement piece. "I get really interested in other people's cultures and what they're wearing," she says.

become more attached to cultures, you start looking at things differently. Also, as you understand more about how things are made and what certain things mean to certain groups of people, that makes you look at things very differently."

Traveling and experiencing new places leave a mark. Often, it carries over to our style. Picture the person who returns from India and wears only kurtas. The clothes make us feel part of something we relate to across the world. The trick is in how you incorporate newfound pieces from far-flung places with old favorites sitting in your wardrobe.

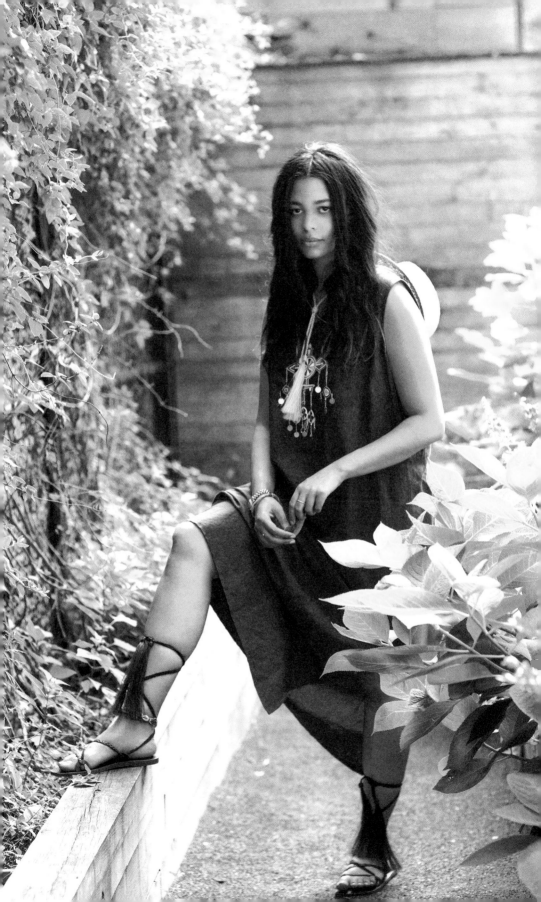

Cotton dresses at Martine's Dream in Crown Heights.

Stylist/designer Debbie Hardy has a knack for this. Hardy, born and raised in Jamaica, spends several months each year traveling in India and Africa to source fabric and textiles. These are for Martine's Dream, the name of Hardy's line of colorful cotton dresses and her small Crown Heights boutique. (Martine is Hardy's middle name.) The shop is filled with colors and patterns, scarves, bags, and jewelry—it's like visiting a bazaar in a foreign city somewhere warm. Hardy speaks to women about what colors move them. She wants to know how a color makes you feel and what it reminds you of—a color therapy session of sorts.

"Some women are shy," Hardy says. "They think that color makes them more bold and they feel uncomfortable. It brings the attention to them. But then, little by little, they start to embrace it, in terms of us connecting." All women can wear color, Hardy says. It's a matter of finding the color that makes them feel right.

Hardy's own connection to color is what led her to India. She remembers seeing pops of orange, green, and yellow from women's saris, like butterflies against

a monochromatic background of green fields. In Delhi, Hardy visited the Kinari bazaar and was immediately obsessed with the fabrics. She spent all the rupees she had. "My heart responds to different prints," she says.

Tall and long limbed, in head-to-toe bold prints, Hardy is her own best model. She wears large rings made of antique Indian coins called *pies*. In colder weather, she prefers a layered look—a blouse, sweater, scarf, and blanket, belted to hold it all together and show her waist. Over her shoulder she adds a multi-print embroidered tote for another layer of color. The summation of the effect is chic, though on someone else it might look a bit wacky.

"Ever see someone down the street in an outfit that you think on you would look so absolutely outrageous?" Hardy says. "And yet, you're like, 'But she works it, she's doing it.' It's because something within that person connects to what they're wearing. And that's what makes it work, that individual thing."

English interior designer Hilary Robertson moved to Fort Greene from London nearly a decade ago. For her, the foreign treasures are at flea markets across America. From the Alameda flea market near San Francisco, she scored a cream-colored, thick-pile alpaca coat and a red-and-navy baseball jacket.

Robertson has a uniform: ankle boots; jeans or skinny moto pants with zippers; and a layered vest, sweater, and jacket. She also sticks to her core colors: navy, black, khaki, and, in the summer, white and cream. When she picks up something colorful and interesting,

> It's not about the dress you wear, but it's about the life you lead in the dress.
>
> —*Diana Vreeland,* fashion editor

Travel Light

When Debbie Hardy travels in India, or wherever her journeys take her, she wants to move easily. The designer/stylist makes many stops, hitting the markets or working with artisans on her dress line, Martine's Dream. At one time in her past, she toured with Erykah Badu as a stylist in the singer's camp. Lucky for us, she now sources striking accessories and textiles for her shop. Here's her packing list:

- **3 T-shirts in dark colors** I wash them out and wear the same T-shirt for a week.

- **1 denim shirt and 1 sweater** Most times I wear them to the airport.

- **2 pairs of pants (may include cargos and/or jeans)** The jeans are good because you never know when you need to go somewhere and look a little more together. You can always find an inexpensive top or a little thing somewhere, but I'm a jeans girl. I gotta have the right jeans. (Hardy's brands: James Jeans and Rock & Republic.)

- **1 dress or caftan** It looks good in any place and it's super comfortable.

- **1 scarf or blanket-shawl** It can be multipurposed as a blanket, sheet, or sarong.

- **3 different weights of sock** Sometimes one place can be hot and another place will be freezing.

- **7 pairs of underwear**

- **1 pair of hiking boots, optional** If I'm trekking in Nepal.

- **1 pair of worn-in Converse Chuck Taylors**

- **1 pair of flip-flops**

- **Cosmetics kit** No makeup, just Mario Badescu face wash and moisturizer and Medex lip balm.

Debbie Hardy soaks up the summer rain in her Crown Heights backyard. Hardy's cotton Martine's Dream maxi dress is her own design.

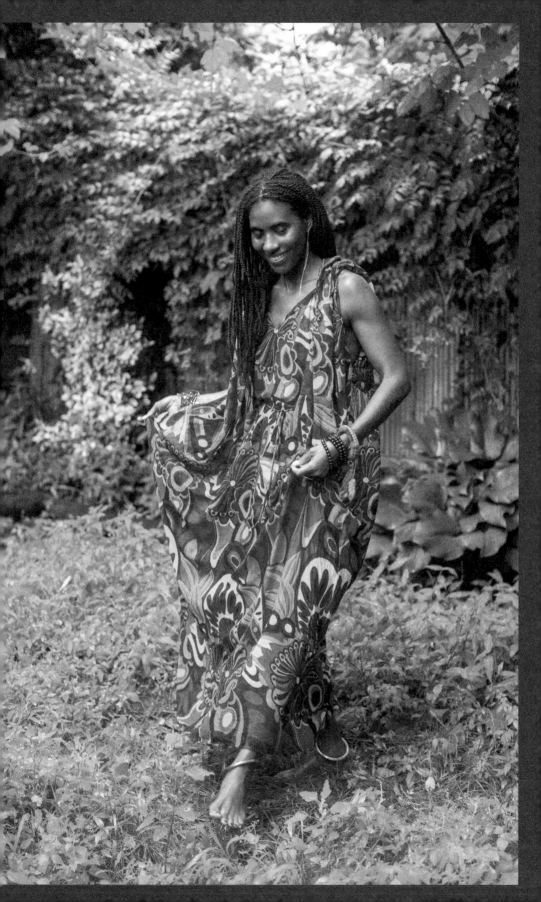

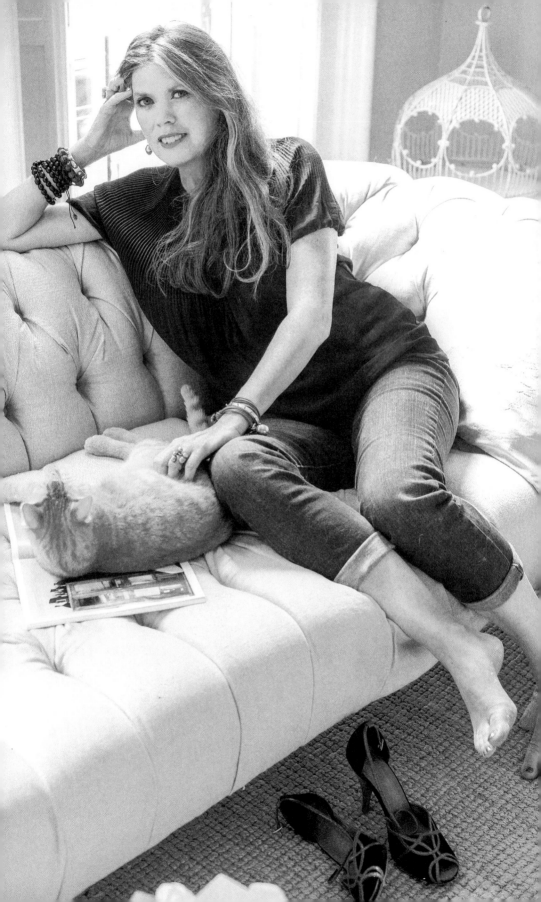

> *Travel, even if it's just armchair travel by way of flipping through a magazine, informs all of my aesthetic decisions.*
> —*Hilary Robertson,*
> interior designer

Hilary Robertson at home in Clinton Hill with Fred the tabby cat. She wears Joe Fresh jeans, a COS top, and a bronze Monica Castiglioni ring she picked up in Italy.

like the baseball jacket, she knows it will work with the rest of her wardrobe. "I'd wear more color in England," Robertson says. "I was always very anti-black because I thought black was a massive cop-out. It's like, yeah black, whatever. Here, I wear a lot more neutrals than I did in England. That happened gradually."

Living in the States has led Robertson toward a more classic style, incorporating more quality, basic pieces. She stresses that Americans do classics well, even just T-shirts, which is based on our history of creating separates and ready-to-wear clothes. English style is more eccentric. "It's more crazy, sort of bohemian," she says. "It's more fashion-forward than here. In England, I get distracted by some kind of glittery thing. The clothes are fun. There's so much more going on with them. Whereas here, I hone in on quality and detail."

For comfort, Robertson loves handmade shoes from Texas-based The Office of Angela Scott. When she is in Los Angeles, her go-to shop is Heist in Venice, which carries California-made shirts by Frank & Eileen. Robertson is tall and likes to play off the masculine-feminine tension in her style. "Lauren Hutton is definitely one of my icons," Robertson says. "I love it when people have found their personal style, and they do it, and they keep doing that. Sometimes that takes a lot of time.

Sometimes it doesn't take any time at all when people have that identity. You have to know what suits your body and work with what you've got."

Designer Eniola Dawodu's style inspiration comes from her Nigerian heritage. Born in London to Nigerian parents, Dawodu moved with her family to Tallahassee, Florida, at the age of twelve. She moved to Brooklyn nearly ten years ago, when she came to New York City for a career in fashion, eventually settling into costume design for independent films. All along, she noticed people with a distinct style as an expression of the self, which prompted her to explore the subject.

As Dawodu perused the Chelsea flea market in Manhattan one weekend, she found a stack of antique *aso oke*, handwoven fabric made by the Yoruba people of Nigeria. She recognized it from her mother's vintage pieces and from elaborate outfits she had seen at parties and weddings. Dawodu was intrigued by the intricacy of the older designs—the overlay work, diagonal threading, and weaving, which is a craft passed from fathers to sons.

Hilary Robertson scored her pony-skin bag at a souk in Marrakech and her cashmere jacket at a thrift store. Zara fur stole and trousers. The Office of Angela Scott two-toned pumps.

"[In New York] I was surrounded by people from all over the world," Dawodu says. "And I was working with creative people who traveled a lot. You could see the inspirations of that in their work. And I was trying to find my creative voice. Through these textiles, my researching them, and the idea of traveling, I felt like I could find my creative voice. And I would also feel this connection to my past and my history through the textiles."

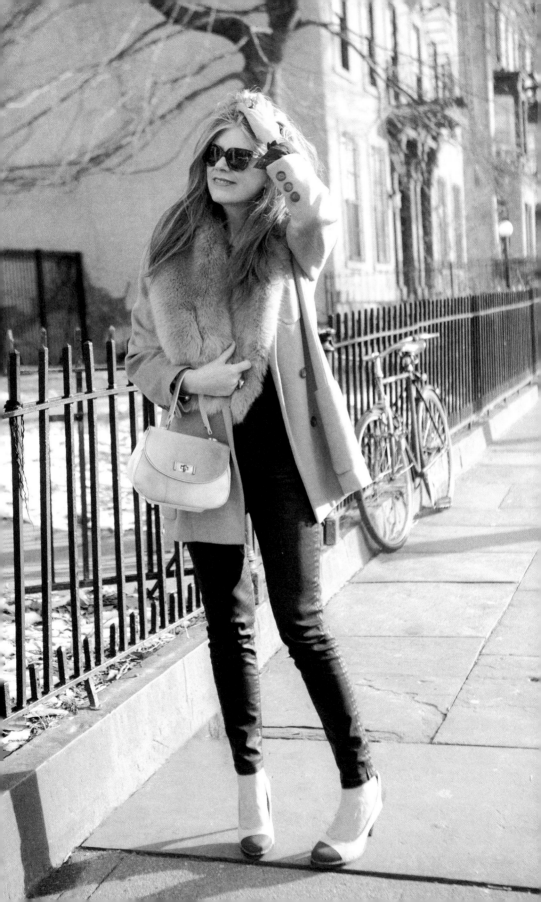

Eniola Dawodu, at her Dumbo studio (left), in her own Aramidé Diallo tunic made from *aso oke* fabric that hangs in strips above her. Opposite, Dawodu wears a vintage chambray embroidered Mexican top and a vintage pleated silk skirt.

Dawodu started working with *aso oke* to create a collection she calls Aramidé Diallo, which roughly translates from Yoruba as "family is here." In her small, white-walled studio in Dumbo, she is surrounded by books on African art and weaving, black-and-white photos of fantastic-looking Nigerian women in formal dress, and piles of neatly folded *aso oke*. Dawodu uses the textile for tunics, cloaks, pillows, and upholstery. The tunics and cloaks are based on a wide-sleeve embroidered robe called an *agbada*, which is typically worn by West African males.

In the spring of 2014, Dawodu took her first major trip to Nigeria. She traveled in the coastal city of Lagos and nearby cities Ibadan and Ijebu Ode, seeking out *aso oke* weaving communities where the men might remember the old forms of their craft. "There's so much

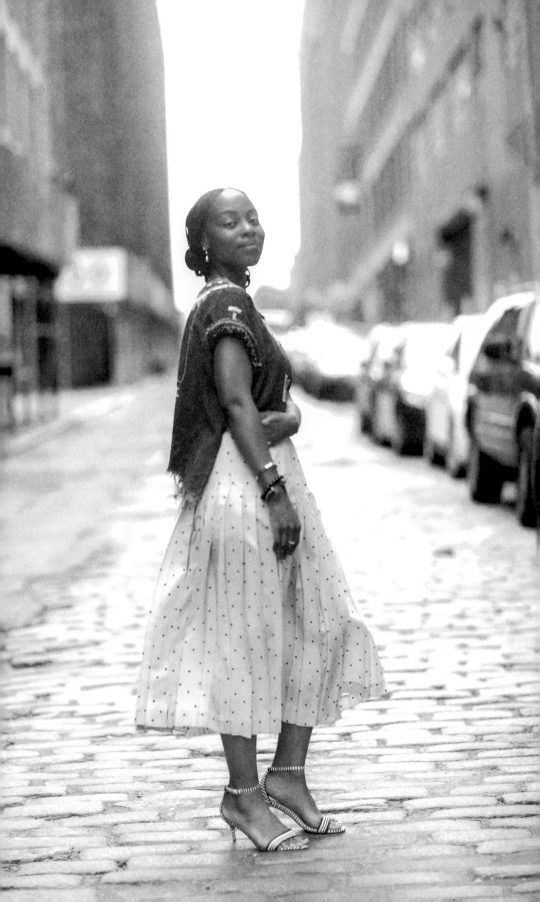

beauty in West African textiles that isn't really seen here," Dawodu says.

Inspired by her Africa travels, Dawodu prefers a traditional look for herself, mixing in vintage items she collects: a loincloth from the tribal Wodaabe people that she wears as a scarf and beaded jewelry from Ethiopia's Omo Valley. But almost anyone could pull off one of Dawodu's pieces and look chic with skinny jeans, leggings, or a pencil skirt.

Here, in Dawodu's Crown Heights neighborhood, West Africans wear a mix of Western and customary styles. A man may wear an *agbada* robe with jeans and sneakers. A woman might have on an *aso oke* blouse, scarf, and head wrap with her winter coat and another scarf on top.

There is a connection between traveling far and coming home. The journey gives us ideas from the people, cultures, and places we've seen. When we return, we have new things we want to say, and we're not ready to let go of the bigger sense of the world. Adding unique elements from our travels to our wardrobes of existing classics and favorites physically incorporates what we've experienced into our style. It keeps things interesting.

"I see style as an expression of culture, and I see that as art," Dawodu says. "Style is something, for me, that's become very honest. It allows me to transfer my experiences, different stories, and history in a wearable way."

Marina Muñoz wears a typical Argentine gaucho belt with jeans and her husband's shirt, both J.Crew, and her old Gucci horsebit loafers. Her family brings the red-and-black buffalo-plaid blanket camping "We're adventurous and consider ourselves a gypsy tribe," she says.

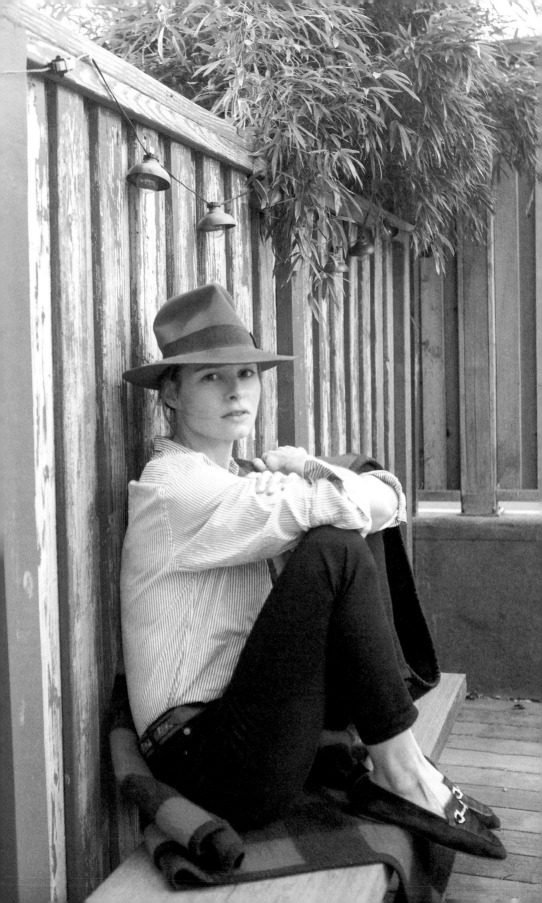

Interlude...
ACCESSORIES

On one end are subtlety and simplicity—whether modern or classic.
Then there's the opposite: bold shapes and the appeal of more. Either
way, accessories can take a look to the next level.

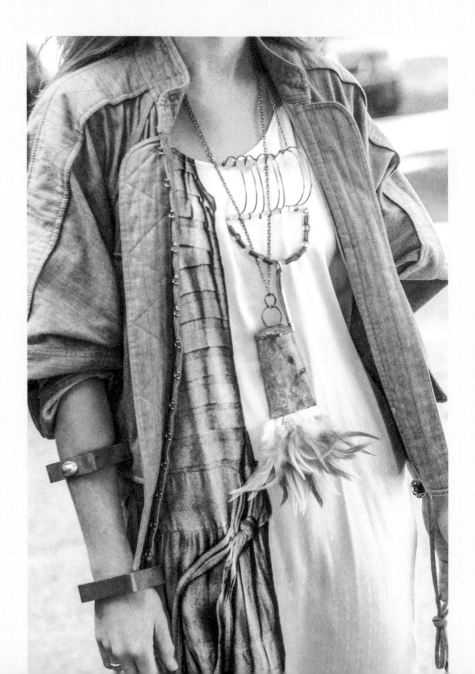

Stylist Simi Polonsky (opposite) wears a cowbell-and-feather necklace by SBNY Accessories. The one-of-a-kind Melissa Joy Manning necklace on Bird owner Jennifer Mankins (top right) is made of ocean picture jasper, hemimorphite, chrysocolla druzy, and naturally shed antler tip.

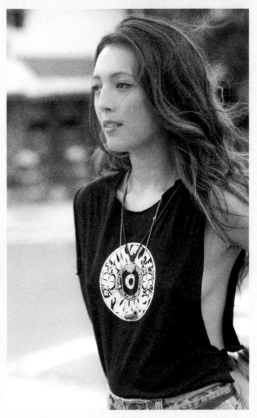

A Détacher's Mona Kowalska (above) reinterprets the choker with her own sleek gold cuff worn over a turtleneck sweater. Longboard skater Priscilla Bouillon (bottom right) skates around the city doing tricks, and she wears a couple of necklaces or a leather bracelet while she does it.

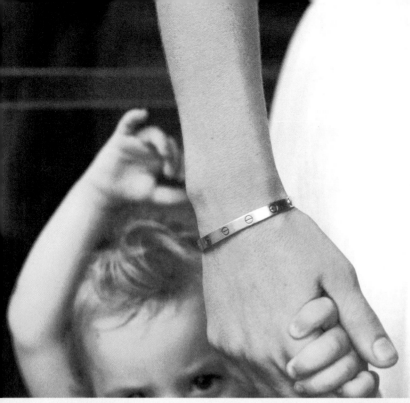

Clockwise, from top: Entrepreneur/designer Kate Huling wears Cartier's solid-gold Love bracelet, which, fastened onto the wrist—like love—is a commitment. Her mustard-colored Marlow Goods Dinan purse converts from a long-strapped shoulder bag to a clutch. Like her Cartier bracelet, Huling's designs are clean and classic. Artist Mickalene Thomas' Chrome Hearts aviator shades add some badass to her look.

Clockwise, from top: Writer Sofia Hedström had a cursive, rapper-style ring made saying "Slätta," which is the name of her home territory in Sweden. Actor Trae Harris wears a representation of Robert Indiana's iconic *Love* sculpture with rings from Soull Ogun's L'Enchanteur line. She and stylist Debbie Hardy prefer maximalist, layered jewelry. Hardy wears a favorite ring made from antique Indian coins.

HAVE SOME FUN

9

Artist and costume designer Christian Joy always looks for street-style visual candy. She loves the colorful and the eccentric, citing Afropunks and dapper older ladies dressing in the spirit of ninety-plus-year-old fashion icon Iris Apfel. "You almost try to not look at people because they might get mad or feel insecure that you're staring at them," says Joy. "But, at the same time, it's like, 'What the hell does that person have on?' I never fail to be completely gawking."

Joy has lived in Brooklyn for almost twenty years (currently in Greenpoint). She knows how to enjoy herself with extreme fashion. As costume designer for the band Yeah Yeah Yeahs' front woman Karen O (for Orzolek), Joy has created some of the most outlandish looks in indie rock. Her designs have included a silver, tinsel-fringed, black-and-white zigzag-print cape that looked like butterfly wings when Orzolek raised her arms onstage and a Day of the Dead skeleton unitard. Joy has also made Orzolek silk gowns and sparkly suits in the style of tailor Nudie Cohn, who dressed such

legends as Elvis Presley and Gram Parsons. (In 2007, London's Victoria and Albert Museum featured Joy's work in a contemporary New York fashion exhibit.)

As an indie rock phenomenon, the Yeah Yeah Yeahs popped in 2000 when they were part of the New York music scene that included the White Stripes and the Strokes. At the time, Joy was working at East Village designer Daryl K's boutique, where Orzolek used to shop. Joy was refashioning eighties prom dresses that she cut up, painted, and stapled; covered in newspaper and packing tape; and then sold to a store on Orchard Street. The two women became friends when Orzolek asked Joy for one of her warped creations to perform in.

Christian Joy added both real and hand-drawn studs to her bleached denim jacket. She found her floor-length taffeta ball skirt at a thrift store and styles it by tying a knot. Her leopard-print gloves were a gift from Karen O of the Yeah Yeah Yeahs. Sigerson Morrison magenta ankle boots.

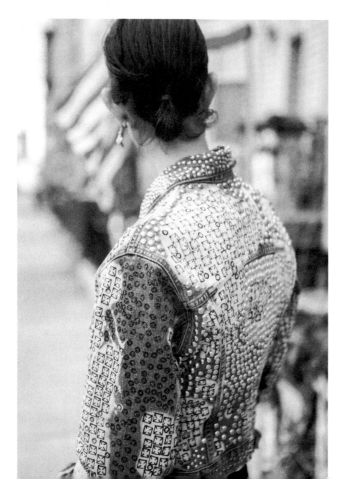

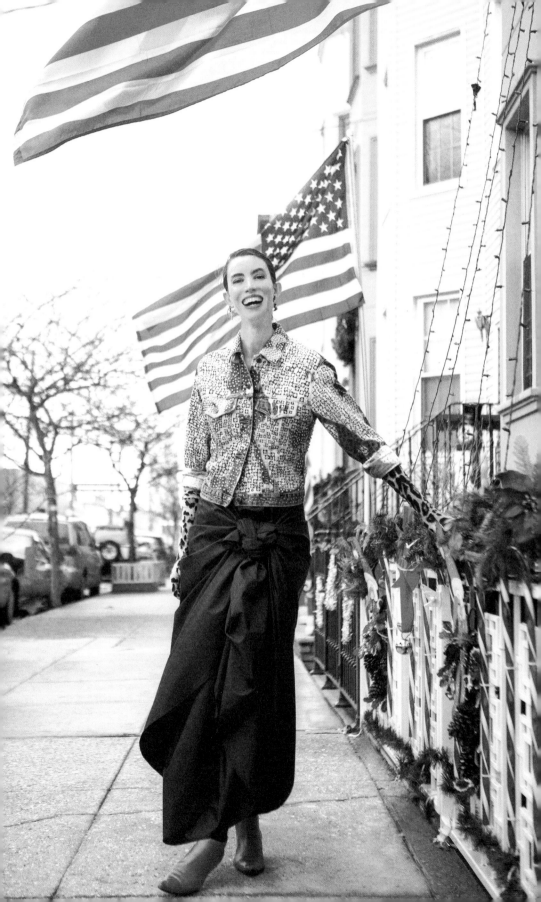

Do Play
With Your Clothes

With scissors, paint, and her own enjoyment, costume designer Christian Joy creates irreverent style.

❥ **Don't rely on trends and marketing** Joy does most of her wardrobe shopping at military surplus stores, thrift stores, dollar stores, and consignment shops. She might pick up an Italian military field jacket, T-shirts, or sweatshirts and then add in nicer pieces found on consignment. With this approach, she can put together a stellar outfit that might include Maison Martin Margiela trousers or a Comme des Garçons skirt for less than one hundred dollars.

❥ **Personalize your clothing** "Wear a towel instead of a coat," says British iconoclastic designer Vivienne Westwood. "Or your husband's boxer shorts with a belt, or something from your grandmother. It's all about do-it-yourself." Spray-paint your shoes. Cut the backs out of T-shirts. Paint over old garments that may be faded or stained. Screen-print a men's oversize shirt, add a belt, and wear it as a dress. "You can get a men's white button-down anywhere," Joy says. "Cut into it. Reshape the neckline. That creates its own style."

❥ **Don't depend on the past** Everyone draws on looks from other eras—sixties long sundresses, seventies suits, nineties grunge. Joy says, "If you want to take a past look, screw it up. Or, do something with it; try to make it your own." This could be as simple as mixing up fashion history. Wear a plaid shirt with a 1950s-style pencil skirt and a pair of platform heels.

❥ **Keep your sense of humor** "Just go for it," Joy says. "People aren't as rebellious as they used to be."

Christian Joy at her Greenpoint studio in her own designed smock dress.

Artist Keating Sherwin (left) wears a tattered vintage fur coat over her jean jacket. Defective (but cherished) possessions can add a layer of character to otherwise mainstream pieces, like Sherwin's jean jacket.

Originally from Marion, Iowa, Joy is a self-taught seamstress and designer. At the beginning, she worked with not much more than a glue gun, scissors, and a stapler. "I just hacked together a lot of Karen's stuff when I was learning," Joy says. "It was part of the way it looked. I really enjoyed it." The early creations were punk rock in spirit (torn fishnets, painted T-shirts, a black leather studded jacket). Joy's let's-do-this approach is also emblematic of her pragmatic Midwestern roots. Coming from a family of maternal DIY homemakers, Joy just forged ahead, taking inspiration from her great-grandmother, who, for example, crocheted the ends of bath towels. "People have always made their own clothes," Joy points out. "I figured if they could do it, then I could do it, too."

In a vintage jumpsuit and Nancy Stella Soto kimono, musician Vandana Jain (opposite) cuts a bold figure.

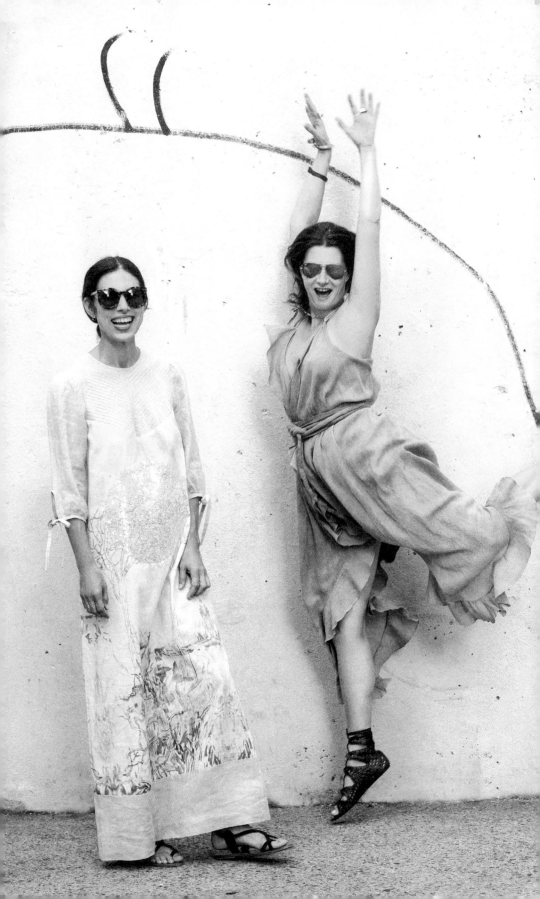

April Hughes (left), in Japanese designer Cosmic Wonder, and Marina Burini, in Brooklyn-based Electric Feathers, are all about fun at the Williamsburg playground near their homes.

Joy's own style encompasses clean, classic lines. She loves men's clothes, white T-shirts, and pointy-toed winklepickers. She also loves the odd Americana piece: an embroidered denim shirt, a poodle skirt, or a Cadillac sweatshirt—something that could have come from a *Grease* revival. "To me, great style is having a personal style," Joy says. "Someone might be, like, 'Oh, that woman is wearing Chanel.' So? She wouldn't look that interesting to me. But if she's wearing Chanel with her five-dollar earrings, vintage shoes, and her hair in a certain way, that's a whole other story. Clothes don't create style. It's your choice of clothing, how you put something together, and having your own flair."

Many Brooklyn women echo Joy's philosophy. Former stylist Marina Burini , who now curates events as a designer for lifestyle brands, believes that experimenting with style fulfills the human need for expression.

As a young woman living in Paris, Burini shopped the flea markets and would build a look around a piece she loved—a kimono or a pair of agnès b. hot shorts. A constant traveler, she also went through phases of incorporating elements from different places. In her closet from years ago, Burini still has a traditional Anatolian white dress with embroidery that she picked up in Turkey. Though her taste has become more minimalist in recent years, she still tries out styles, colors, and shapes that she might not have worn before. Burini suggests treating your wardrobe with a sense of playfulness and thinking counterintuitively. "If you think,

'Oh, I could not wear that,' then it gets into, well, why is that?" she asks. "Is it really something that you believe you can't do? Or, is it something that's been put upon you, in a sense?"

This may be a challenging concept to consider while getting dressed in the morning. How do we shed preconceived ideas of what one "should" or "should not" wear? It gets into the territory of your own psychology. The delightful, flamboyant Iris Apfel is quite serious about the need for self-exploration to arrive at your inherent sense of chic. In an interview with *Elle Decor*, Apfel says: "You have to know who you are and you have to be comfortable with it. You just have to do it."

It may be easier for many women to dress with more abandon at night than during the day. This is true enough in Bushwick's nightlife scene, which has a prominent spirit of sartorial recreation. Chromat designer Becca McCharen is an influential presence here. Not only does Chromat host parties, but also many revelers emulate her look.

Beauty and style expert Mary Alice Stephenson in a Haney silk chiffon wrap dress.

McCharen is originally from Virginia and studied architecture before working as an urban planner. On the side, she experimented with fabric and put together small collections, selling some pieces along the way. She moved to New York to start her career as an architect. While looking for work, McCharen was making cage bras, similar to Jean Paul Gaultier's black strappy cone bras infamously worn by Madonna. McCharen would fill orders and then say to herself, "Seriously, I need to send my résumé out. I need a job." As the months went

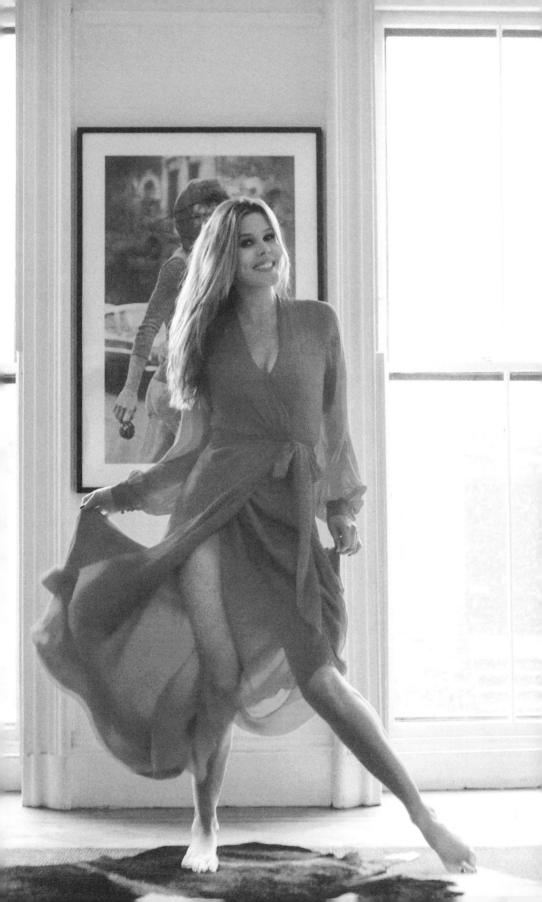

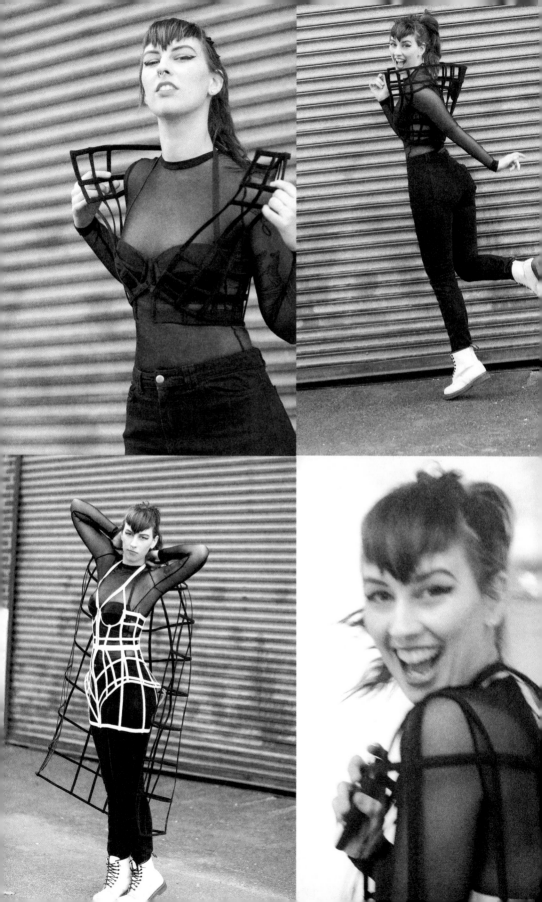

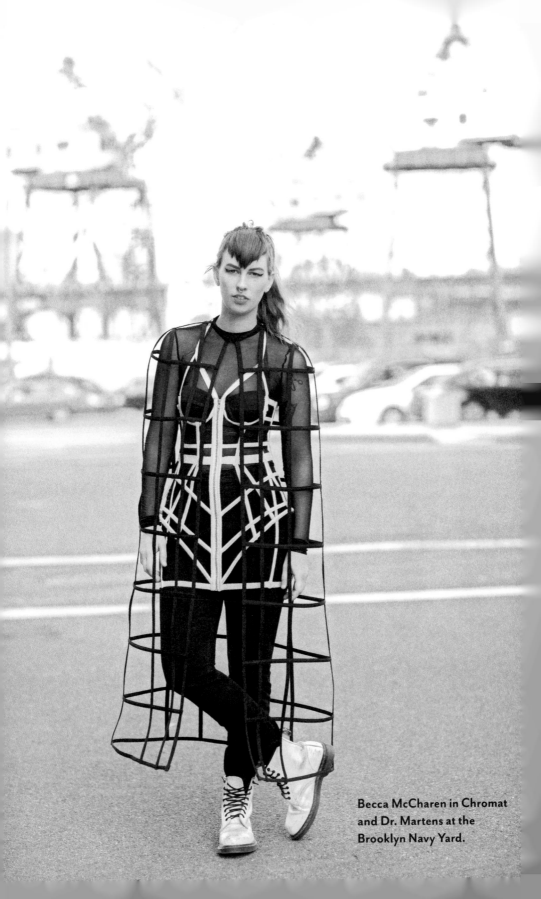

Becca McCharen in Chromat and Dr. Martens at the Brooklyn Navy Yard.

by, the pieces kept selling, and McCharen realized that cage bras were her job.

Chromat is wearable architecture, in the form of harnesses or cages. The pieces could also be described as exoskeletons for the female form. Some shapes exaggerate hips, shoulders, or the bust. There are wings, bustiers, garters, face masks, dresses, shoes, and bathing suits. The bionic cage cape does, in fact, resemble a human-scale birdcage placed over someone's head. "The thing that interests me about Chromat is analyzing the structure of a garment, thinking about all the seams, boning, and underwire—all the things that go into the garment—and then bringing it to the exterior," McCharen says.

In less than five years, McCharen expanded the Chromat collection and built a significant following. Madonna (still loving the look since her Blond Ambition tour twenty-five years ago) and Beyoncé have both performed in Chromat. The designer herself is among the slim number of women who can pull off her creations as a day look. With a translucent black mesh top underneath a bralette, she'll add a high-waisted pencil skirt or a pair of pants. When not in Chromat, McCharen likes to wear labels by some of her friends, all fellow Brooklynites. Some of the pieces couldn't be

William Okpo founders Darlene (left) and Lizzy Okpo, in Bed-Stuy, wear tops of their own design. The Exodus Goods bag is from the New Orleans boutique the sisters co-own with Solange Knowles.

"My number one style requirement is to have fun getting dressed. Nothing is too old, expensive, cheap, cute, or ugly for me.
—*Valerie June*, singer

Fashion sometimes has a way of homogenizing a crowd with a similar look. Everyone is in the newest blah, blah, blah. It's cool to see characters doing their own thing. We find endless inspiration in that.

—**Jack McCollough and Lazaro Hernandez,**
Proenza Schouler

more different from Chromat: Degen colorful knitwear that has two holes cut out at the breasts; shibori-dyed, loose, flowing pieces from Upstate; and minimalist tops from Titania Inglis.

For nightlife, McCharen amps up her makeup, often painting on bright blue eyebrows. And she wears bolder, bigger Chromat pieces, or something more playful from the line: black wire cat ears, alien antennae, or a face mask. Why rock a pair of alien antennae if, first and foremost, you're not amusing yourself? McCharen is not one to let inhibitions stand in the way of her accessories. If she's wearing antennae, she owns that look.

Admittedly, Chromat may not be for everyone. But even if you're not drawn to exoskeletons, you can still glean lessons from McCharen, whose style is unique and comes from a place of strength. She visually articulates a particular look and does not appear to adhere to anyone's idea of what she "should" or "should not" wear. Whoever said a woman can't wear alien antennae as a stylish accessory? If that's your thing, do it.

Taylor LaShae channels 1960s Jean-Luc Godard. D'Blanc sunglasses. Gypsy Warrior jeans. The cropped sweater and hat are both vintage finds.

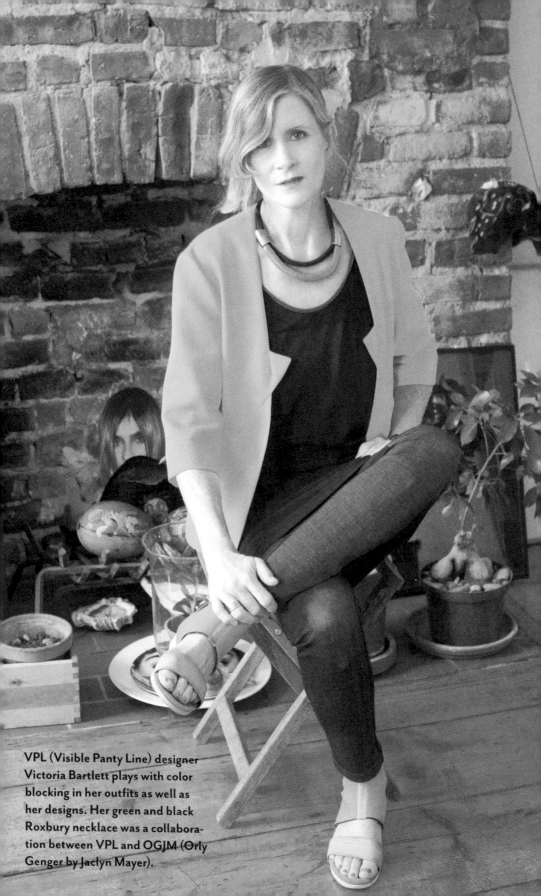

VPL (Visible Panty Line) designer Victoria Bartlett plays with color blocking in her outfits as well as her designs. Her green and black Roxbury necklace was a collaboration between VPL and OGJM (Orly Genger by Jaclyn Mayer).

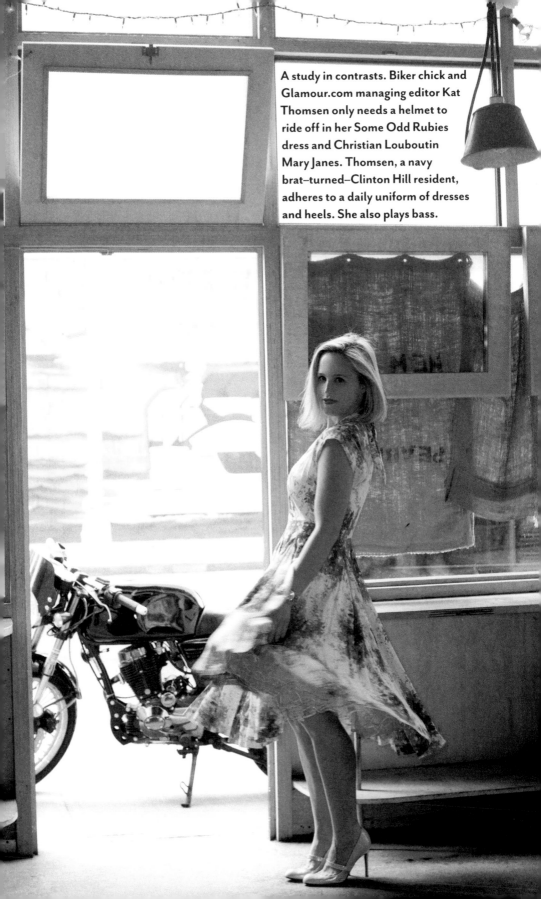

A study in contrasts. Biker chick and Glamour.com managing editor Kat Thomsen only needs a helmet to ride off in her Some Odd Rubies dress and Christian Louboutin Mary Janes. Thomsen, a navy brat–turned–Clinton Hill resident, adheres to a daily uniform of dresses and heels. She also plays bass.

Interlude...
HEADWEAR

Headpiece adornments made from braided cloth, feathers, bone, and even a gold cobra replica date back to early civilizations. Centuries later, these ancient styles still feel new.

[S]arah Sophie Flicker (opposite) [w]ears a crown of ranunculus and [ca]llas made by Taylor Patterson [of] Fox Fodder Farm. Flicker is a [pe]rformer and feminist activist. Her [en]sembles, influenced by suffragettes [an]d 1920s flappers, often include the [dr]amatic flair of headwear.

[St]ylist Karyn Starr (right) in a [Je]nnifer Behr halo. Headpieces [sh]ouldn't only be left to the bridal [pa]rty; Starr even wears the halo to [yo]ga. The Jennifer Behr Margaritte [ti]ara on Flicker (below left) is based [on] a brass detail that was inlaid in [wo]od furniture during the twenties [and] thirties. The Riot Grrrls of the [ni]neties last reinvented the tiara [as] a feminist punk princess symbol. [Fa]iola Dawodu's (below right) [an]tique brass hairpin from Burkina [al]so adds elegance to her twist.

["Yo]u have to be a little bit brave to [pu]t something on your head," says [Br]ooklyn-based headpiece designer [Je]nnifer Behr. "It's something [un]expected, a mark of individuality. [It] sets you apart from the average [w]oman on the street."

How many ways can they wear it? Brooklyn women can take a piece of cloth and turn it into a vast array of looks. *The bohemian:* Karyn Starr (left) braided three of her mother's vintage scarves to create one piece. *The swami:* Actor Trae Harris (below) used a hand-dyed textile from a friend's line called 3rd Cult to create her towering turban. *The Africa:* Taking inspiration from the place where arguably more women wear varying headwraps than any other, singer Adeline Michèle (opposite, top) tied up her curls with the knot and fold at the top.

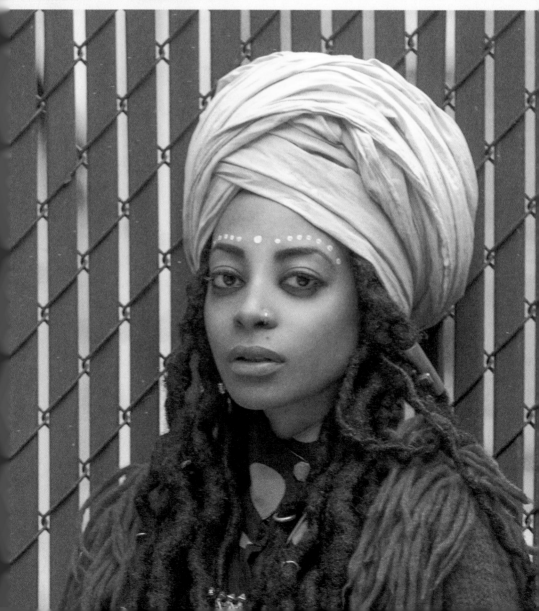

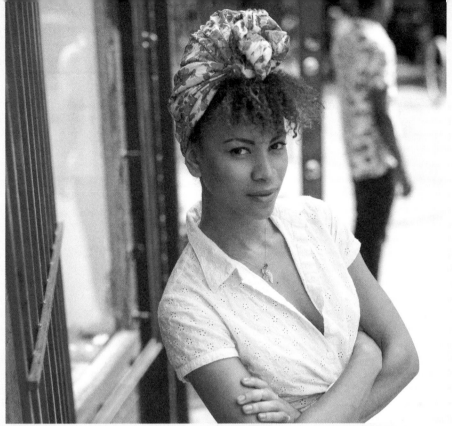

The pirate: A simple triangular-shaped scarf swept under the nape of the neck. Chef Leslie Parks (right) wears the classic look of the high seas. *The Americana:* Butcher Sara Bigelow (below) in her bandanna, a necessary wardrobe element of nearly every woman working in Brooklyn restaurants.

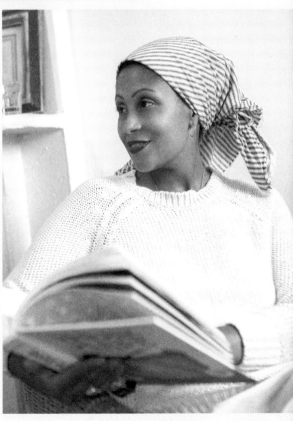

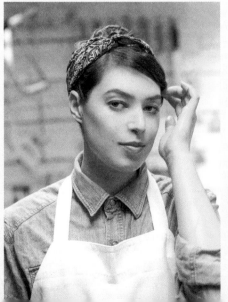

LOVE
THE
STREET

10

New York City is always changing. While now we enjoy more bike lanes and greener parks, the old black-and-white city that was quirkier and filled with characters (and lower rents) is slowly being rubbed out. This is most visible in Manhattan, where, for example, the Bowery is no longer a skid row and home to the rocker/punk subculture throne CBGB. Yes, we feel more secure on the streets. We can enjoy the bar at the boutique Bowery Hotel. But the city's spirit has lost something of its "Noo Yawk" undercurrent.

The fashions of the city reflect the experience. From the Brooklyn side of the river, the experience feels more authentic: grittier, diverse, small scale, and creative. It's reminiscent of the perfectly imperfect New York.

In the borough's style, Jennifer Minniti, chair of Pratt Institute's fashion design department, appreciates "this edge that's a little funky and well put together." Minniti describes a man on her Clinton Hill block wearing a holey sweatshirt that could have

been eighties Comme des Garçons or Yohji Yamamoto. Instead, he'd made it himself.

Minniti's students say that they're not interested in trends. "They go out in the streets or to the clubs and draw what they're observing. Just being really immersed in culture. It's a return to the street for inspiration, to see what young people are doing and bring that back into high fashion. That dialogue is returning, and that's because of Brooklyn."

To absorb city street life, you've got to be open to the possibility of it happening. You know, keep it old-school, put the phone away, tune in to what's around you. New York native Yara Flinn, who has a line called Nomia, is an alert observer during the subway ride from her Williamsburg neighborhood. "Everything has the ability to inspire," she says. "I'm always checking on people's outfits, and usually people that you wouldn't expect, like Hasidic women. That's going to catch my eye."

When she was in middle school, Flinn used to exit the subway at the West Fourth Street stop in Greenwich Village, where her father lived. On this stretch of Sixth Avenue are the legendary street basketball courts called the Cage. Smaller than regulated court size, the Cage is the place for theatrical, intense, physical games, which attract thousands of spectators throughout the year.

Flinn, who is six feet tall and plays basketball herself, would always watch for a while. "That was a formative part of what I thought was cool," she says. "And

Yara Flinn at dusk on the Williamsburg Bridge. She designed the Nomia parka based on a military fishtail parka. A.P.C. jeans. MM6 sneakers.

" *The street seems to have become the Internet, and so many people are speaking on it at the same time.*
—*Rick Owens,* designer

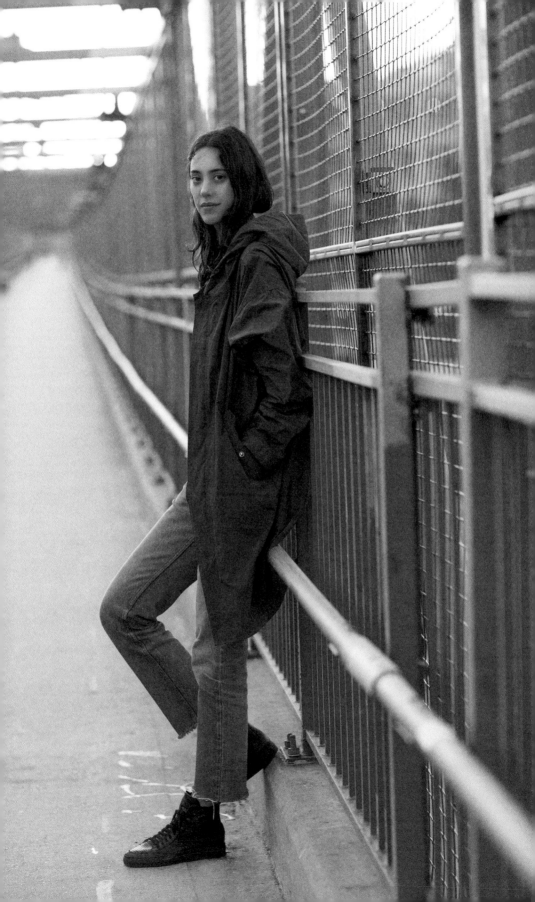

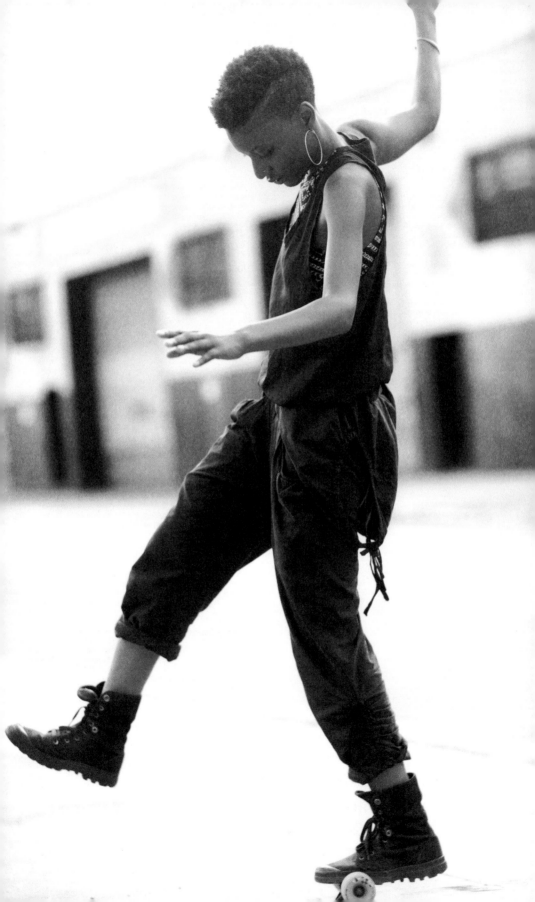

kids on the train were always cool. There wasn't Internet, so you had to observe people and incorporate or copy parts of their style. But you didn't even know where to get it. So you would just go around on missions to source things."

During her high school years, Flinn took her style through many phases: goth, grunge, hip-hop, and preppy. "I was always interested in the way you could present yourself and be aligned with different subcultures," Flinn says. "Then I also had weird thrift-store years where I was wearing everything. Looking like an individual was really important."

Longboard skater Nathalie Herring in a Jil Sander jumpsuit.

Much of Flinn's sourcing led her to the sprawling street-fashion outlet Canal Jeans, which was located until 2003 on lower Broadway in SoHo. The Canal Jean Co. sold an odd lot of merchandise: vintage, army surplus, wigs, vinyl clothes, plaid shirts, underwear, and jeans. The wooden floors creaked. The outdoor bargain bins held possibilities for anyone's personal style mission. In a telling example of how the old, more abrasive New York has been replaced by the new, polished, urban-playground New York, the one-hundred-thousand-square-foot, nineteenth-century cast-iron building is now a Bloomingdale's.

There was a lot more boundary pushing among the stylish of pre-twenty-first-century New York. The spry octogenarian street photographer Bill Cunningham has seen it all. "A lot of people have taste," Cunningham says of contemporary fashion. "But they don't have the daring to be creative." Cunningham's *New York Times*

> *The best fashion show is definitely on the street. Always has been and always will be.*
> —**Bill Cunningham**, street photographer

style columns are a work of living history. His lens, however, is focused on Manhattan.

What would Cunningham think if he pedaled his bike over the bridge to Brooklyn? He'd probably get a kick out of twin sisters Soull and Dynasty Ogun, who grew up in Flatbush. They wear pieces from their lifestyle brand, L'Enchanteur: a long-bill hat on Dynasty and multiple rings and draped necklaces by Soull. Their outfits veer toward the androgynous, mixing in pieces such as vests, bow ties, and oxford shoes with the occasional far-out element, like a pair of Shakespearean balloon pants.

The Oguns' father is Nigerian; their mother, from Dominica, in the West Indies. For middle school, Mrs. Ogun sent her daughters across the borough to a neighborhood called Sunset Park, where the school had a mix of Jewish, Asian, and Hispanic kids. The girls were unfamiliar with traditional Orthodox Jewish black clothes or the kinds of structured white tops and gray pants worn by Asian women.

"It was an exploration of Brooklyn that we had never seen before," says Dynasty. "But it was here. There were so many different communities, ideas, and lifestyles that we got to experience. It shows up in our design."

Both Soull and Dynasty are high concept about their style. Dynasty says they are from a place that has

Brooklyn original. Sincerely, Tommy boutique owner Kai Avent-deLeon on her Bed-Stuy brownstone stoop. The Adidas shell-toe kicks are perfectly street. Sincerely, Tommy blue alpaca coat. Rachel Comey pants. Lautem bag. ByDori bracelet. Sorelli earrings.

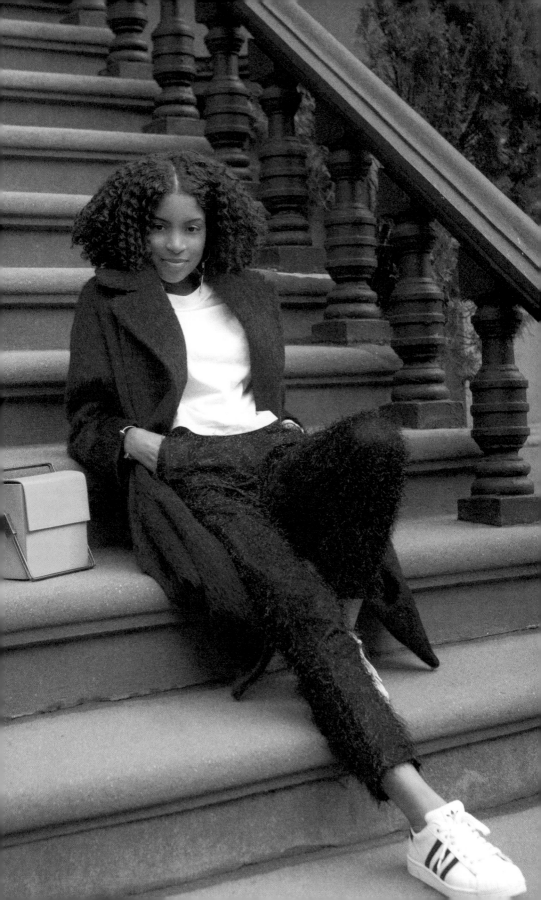

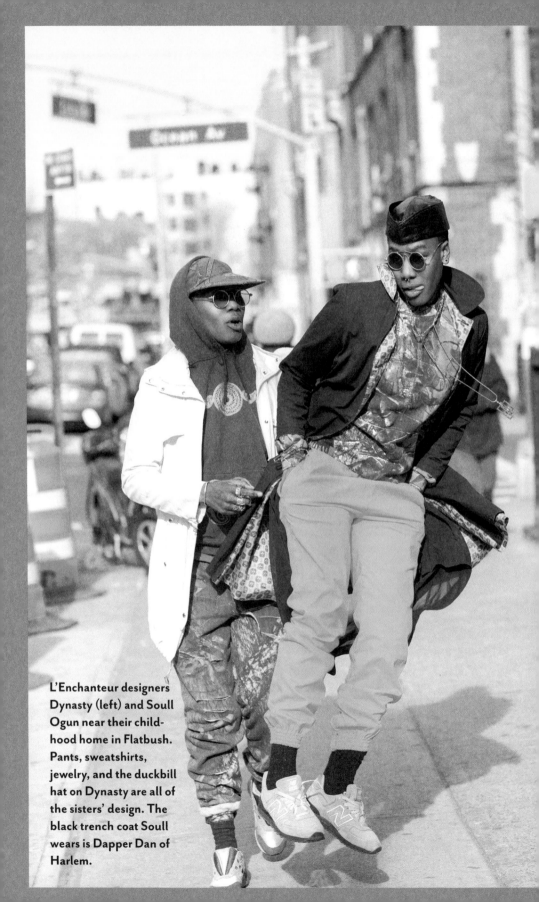

L'Enchanteur designers Dynasty (left) and Soull Ogun near their childhood home in Flatbush. Pants, sweatshirts, jewelry, and the duckbill hat on Dynasty are all of the sisters' design. The black trench coat Soull wears is Dapper Dan of Harlem.

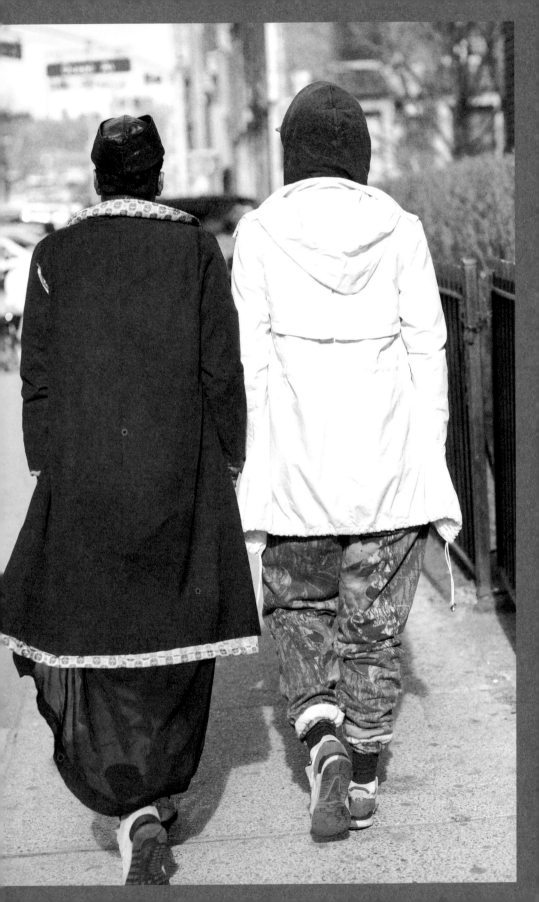

"a hardness" to it. Her clothing line includes streetwear pieces like hoodies and camouflage cargo pants. Then she adds elegant chain stitching onto the garments. "I wanted to go back to my dad's culture in African embroidered design and put it onto things from the concrete jungle," she says. "So, there's a regalness, but keep it hood. That's what these are about. When you look closer you can see it's intricate, but it's on a camouflage crewneck."

Jeweler Soull makes a necklace called the "sun-soul pendulum," a brass pendant that is based on the circle and the square, "the feminine and the masculine merged together," she says. "This piece is playing around with metaphysics: the macrocosm and the microcosm."

The Ogun sisters have high street style: a unique expression of their own story. It's the distinguished style that happens when those who wear it partake in the culture of the street. The look can be offbeat, avant-garde, or influenced by anything from the hood to sports, science, music, or art. It can be about belonging to a culture or group. Or, it can be about rejecting those identities altogether. Whether we like it or hate it, we love to see it walking by.

Dancer Elle Erdman got her X-Girl T-shirt from X-Girl streetwear designer Kim Gordon of Sonic Youth, who is also Erdman's aunt.

In Brooklyn's contemporary street style, we see women who are comfortable with themselves. The range of looks is endlessly compelling. To emulate that spirit, think about what you want to say and how you will wear that on your body. No one can tell you how to get a Brooklyn look. However, we hope we've given you enough inspiration to find your way.

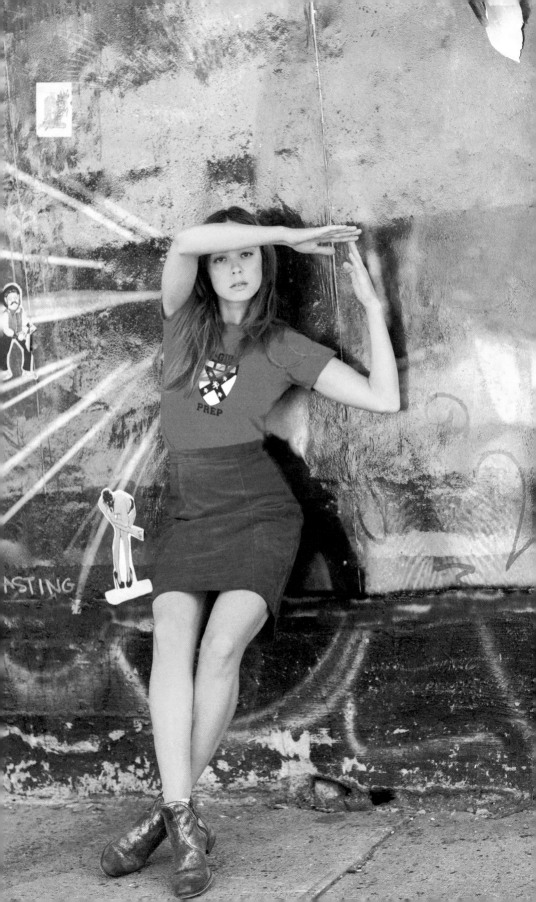

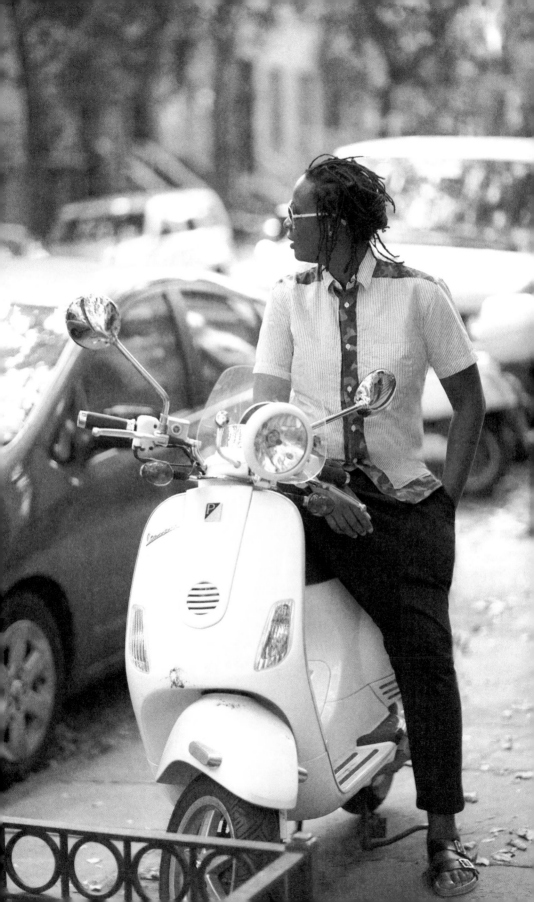

Q & A

with Mickalene Thomas, artist

Mickalene Thomas brings an artist's eye to how she dresses. Not one to follow trends, Thomas found her biggest influence was her mother, Sandra "Mama" Bush, who was a six-foot-one model during the seventies. However, Thomas developed her own sense of style when she moved from her hometown, Camden, New Jersey, to Portland, Oregon, at the age of seventeen. She now lives in Clinton Hill with an enviable closet of things that she collects like art.

What influences your style?

My mother was quite fashionable and stylish. A lot of my influences come from her, but also just come from where I grew up in New Jersey. I grew up during a time when style was everything, like hip-hop. Although I wasn't a hip-hop kid. In junior high and high school, I was into the Cure and the Dead Milkmen. I was dressing quite gothic, wearing a lot of Dr. Martens and spiking and coloring my hair like a punk kid. Sex Pistols and all that was my scene. My family thought something was wrong with me. Especially when I played the Dead Milkmen.

It wasn't until I moved away from home to Portland, Oregon, that I adopted a sense of my own style. I like that look of comfort, an everyday relaxed look, but with a little flair, the sensibility of Paul Harnden, like English, maybe 1940s.

I remember always looking at magazines and thinking about style. When I became an artist, it was always in the back of my mind. But I could never afford it. I could go to secondhand stores and the Salvation Army to get used clothing, mix it up, and layer to create my own sense of what I saw in the magazines. People looked at me and said I had a great sense of style, but I never walked around with that ego. I wore what felt comfortable to me. It's how it feels on my skin. If it doesn't feel good to me, I can't wear it. My mother always expressed that. You should wear what feels comfortable, not what people think you should wear.

Mickalene Thomas, outside her Clinton Hill home, in a Comme des Garçons seersucker shirt with camo trim, Junya Watanabe track pants, and Givenchy slides.

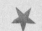

Who are your favorite designers?
Comme des Garçons was my first introduction to high fashion. My friend Dan McCall, who is a Portland fashion designer and artist, introduced me to Rei Kawakubo. We would try to dress like that.

What's your philosophy now about investment pieces?
I like to think when collectors buy my work that they'll want to keep it in their life and in their families for generations. You don't want a collector buying and flipping your art. For me, thinking of sustainability, when I want to buy a designer, I look at the quality—whether it's a Rick Owens, Comme des Garçons, Paul Harnden, or a designer I haven't heard of before. I don't want to have a lot of clothes. For me, it's important to have items in my closet that are like, "Oh, that shirt. I remember when I bought that in, like, 1997. Let me pull that out."

How do you pull off the layered look?
Layering is a good sense of expression. I think of dressing the same way that I put together my collages for my paintings—a little texture and color and boldness. Then having it be simple but also with some function. Today I'm layered. I have on a thin cotton Maison Martin Margiela shirt, wool drawstring pants by Rick Owens, some leg warmers, and a Comme des Garçons wool sweater wrapped around my waist. And on top I have a vintage black painter's jacket that I got in Paris.

I woke up and thought about the weather, how I was feeling, and what I'm doing today. So layering is about your day. I'm at work, but I'm also going out for the evening. So I think of trying to create two outfits in one.

Does Brooklyn influence you?
Brooklyn style is amalgamated with different cultures, different ethnicities. What's exciting about it is you have different enclaves of types of people. You can say there is a Williamsburg look or there could be a Park Slope style or a Fort Greene style. But for me, Brooklyn exudes this style that is bohemian. I remember traveling ten years ago, and when I said I was from Brooklyn people asked, "Do you carry a gun?" Now everyone is loving the word "Brooklyn." It's not just a place anymore. It's an adjective.

Sneakers

Our love of sneakers dates back to the New York City street styles of the 1970s. Brooklyn women still wear that heritage on their feet today.

Sneakerhead culture originated in New York City almost forty years ago. From Harlem uptown to the southern reaches of Brooklyn, it was about getting ahold of those obscure, coveted shoes. These early sneaker fiends were obsessed with kicks—brands, models, limited releases—and tended to have an affinity for urban culture, such as hip-hop, punk, skateboarding,

basketball, or graffiti. Finding the ultimate pair of shoes affirmed your own original identity. "This group would wind up influencing the sneaker industry, the music industry, the fashion world, the vintage market, and the global consumer market," writes Bobbito Garcia in *Where'd You Get Those?*

While sneaker culture rocketed through the eighties and onward, it admittedly seemed to be dominated by the guys. In 2011, Bostonian Lori Lobenstine, a basketball coach

Sneakerhead Erica Rubinstein's Adidas Big Tongue Originals by Jeremy Scott. Her reaction when she saw them: "Whaaat? I'm going to need those."

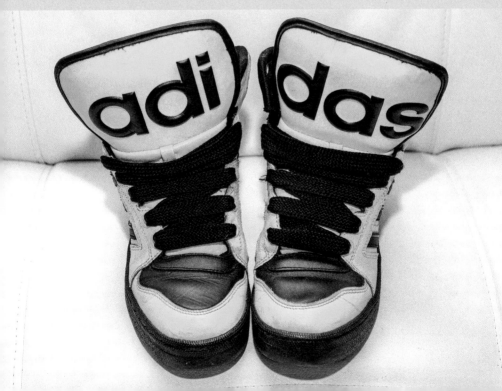

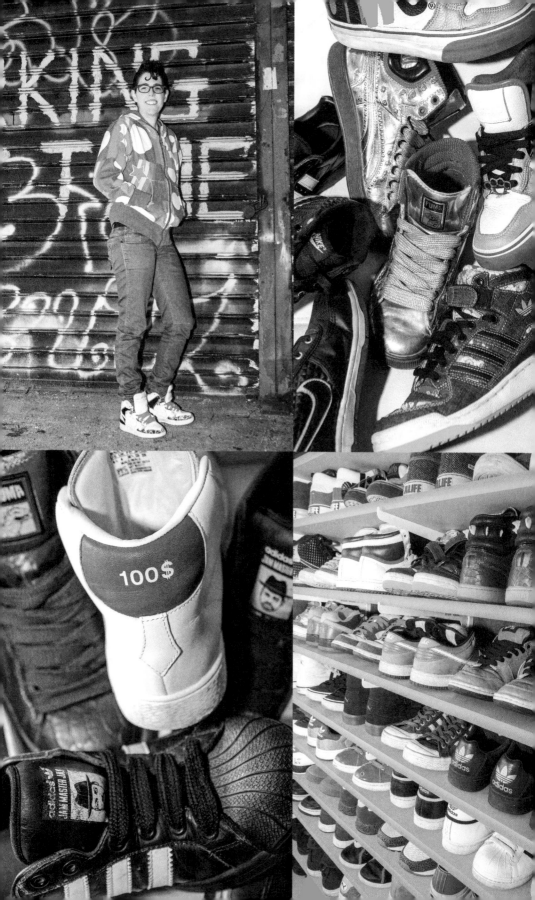

and self-professed sneakerhead, came out with a book called *Girls Got Kicks.* It documented women, their sneaks, and their style—with all the same attitude as the boys. Apparently female sneaker fiends had always been out there; they just never got play.

Brooklyn-born Erica Rubinstein, an artist/graphic designer who lives in Park Slope, has been collecting sneakers for some fifteen years and, at last count, has sixty-six pairs. She owns the limited-edition Jason Mizell Ultrastars made by Adidas in 2003 to commemorate Jam Master Jay, Run-DMC's cut-and-scratch DJ who was shot at his Queens studio. At the Colette boutique in Paris, Rubinstein picked up a rare pair of Adidas Materials of the World Japan high-tops made from Japanese selvage denim and a red kimono-style print on silk. She found Puma's Mecha King silver shoes in her size in Los Angeles.

"First it was a pair here and a pair there," Rubinstein says. "Now I buy several at once. It was just part of a culture that I connected with. It wasn't solely about the sneakers. It was more about a style." Rubinstein loves street art and hip-hop. She has visited Berlin, Paris, Reykjavik, and other cities to discover and photograph street art around the world. Wherever she goes, people notice her sneakers.

While Rubinstein appreciates fashion, her sneaker fixation relates to her love of street life, not a love of the runway. She is mostly unmoved by couture kicks from the likes of Chanel or Dior. Regarding Isabel Marant's hidden-wedge high-tops, Rubinstein says: "It did grow on me. But it's not my thing.... I love a straight-up classic shoe. The Adidas shell toe is my favorite. It's simple. It's tight. I could dress up and wear it."

For fashion fiends who are just discovering the love of kicks: It's good to know how you got here. You share the legacy of New York City's streets and are bringing it home to the pavement near you.

Opposite, clockwise from top left:

Erica Rubinstein in a Kid Robot hoodie, G-Star Raw jeans, and Nike SB Dunk High "De La Soul" sneakers.

Some choice selects from Rubinstein's collection: Nike black and gold-studded Vandal High Rock n' Roll; silver Mecha King high-tops from Puma; Adidas Materials of the World Japan sneakers; and Alife shoes from the downtown Manhattan shop.

The full collection is in a floor-to-ceiling shelf tucked under the stairs of Rubinstein's apartment.

Adidas Monte Carlo Mid 84-Lab by Mark McNairy says 100$ on one heel, and BILL on the other. Proceeds from the JMJ Ultrastars went to the Scratch DJ Academy in New York, where JMJ taught.

STYLE KNOWS NO AGE

Postscript
●●●●●●

A funny thing about getting older is how surprised people are when you do things. "She looks great for fifty-seven!" "She's eighty-nine and went to the Great Wall of China?" American women are uncomfortable with aging. We fight off gray hairs and wrinkles in hopes it will all just go away.

No dispute: Aging is a bitch. Our bodies need more maintenance to rev up and do what was easy before. But many older women don't think of themselves as old. Centenarian Sylvia Perelson (writer Anya's grandmother), born in Brownsville, Brooklyn, used to walk by the mirror and wonder, "Who's that old lady?" She pulled off black leather Louis Vuitton pants, a cashmere V-neck, and a wrist of silver bangle bracelets through her nineties—and never left the house without a bold red lip.

We recently learned there is a gap between someone's numeric age and their "felt age." According to a Pew Research report on aging, many adults over

fifty say they feel at least ten years younger. A third of sixty-five- to seventy-four-year-olds say they feel somewhere between ten and nineteen years younger.

Photographer/blogger Ari Seth Cohen captures this joie de vivre in *Advanced Style*, a blog, book, and film all with the same title. He walks the streets to find his muses, women over sixty who "challenge our notion of getting older. They really embrace their age, feel good about themselves, and every time they leave the house, they look and feel their best." Ilona Royce Smithkin, ninety-three, trims her bright orange hair to make her own thick, matching false eyelashes—so punk rock. Tziporah Salamon, sixty-two, builds her sculptural style by layering hats, bracelets, colors, and textures, which she flaunts when riding her bike around the city. Lanvin cast Salamon to model for its fall 2012 campaign. "Advanced-style ladies are inspiring and have a lot of wisdom in them. I see my future in them," burlesque star Dita Von Teese says in the film.

As it turns out, the themes of *Advanced Style* are the same as Brooklyn style. Older beauties make their own rules and don't follow trends. They dress for the occasion of *life*. They know who they are and, in turn, are comfortable with their look. Most striking of all, they're having fun. When a woman has been around for a few years, she is going to enjoy what she wears. These are also essential building blocks for style that are relevant at any age—and it's happening in Brooklyn every day.

Nothing keeps you warmer than leather pants.
—*Sylvia Perelson*
centenarian

Sylvia Perelson, at her home in Rockaway, Queens, wears a few of her favorite things.

Brooklyn Guide

It's a great time for eating and drinking/shopping/doing things in Brooklyn. Here are some of our favorite spots in the following pages (and some selects from the women featured on the previous pages). Once you're all dressed up, you'll want to know the best places to go.

Williamsburg

Perhaps it's not surprising that mid-nineteenth-century Williamsburg was a wealthy center for railroad and sugar magnates' shoreside mansions and private clubs. From today's sunset view at the Ides bar, the entire city has splendid possibility. However, the current return to a luxury era has come after many years of post-industrial abandonment and decline. And Williamsburg's fortunes still fluctuate today, depending on which block you're standing. Southside, long a predominantly Hasidic Jewish and Hispanic neighborhood, is increasingly dotted by small designer boutiques and high-end restaurants. Northside's buzzy Bedford Avenue is loaded with cafés and shops. Williamsburg is a large and varied neighborhood—you'd be equally inclined to drop a few bucks on an excellent taco or a few Benjamins on a vintage find.

ALTER

WOMEN'S / MEN'S / SHOES

Most of the fetching and economical selections at the Alter boutiques (from brands like Cheap Monday, Kill City, and MINKPINK) are spot-on keepers. (The Greenpoint location is larger.)
407 Graham Ave. (Jackson and Withers Sts.) • 718-609-0203 • alterbrooklyn.com

AMARCORD VINTAGE FASHION

VINTAGE

Amarcord (Italian for "I remember") stocks an eclectic mix of high-end designers and more obscure fashion labels—all vintage. Prices are reasonable given the quality, but don't expect to pay less than $20.
223 Bedford Ave. (N. 4th and N. 5th Sts.) • 718-963-4001 • amarcordvintagefashion.com

ANTOINETTE

VINTAGE

A spunky vintage boutique that charms you with its well-priced, impressive finds from the seventies, eighties, and nineties.
119 Grand St. (Berry St. and Wythe Ave.) • 718-387-8664 • antoinettebrooklyn.com

ARTISTS & FLEAS

VARIETY / WOMEN'S / MEN'S / HOME / EAT

This year-round weekend-only marketplace in a warehouse offers plenty of quirky finds among the more than twenty vendors, including artist-made pottery, vintage eyewear, and even knuckle-tattoo gloves.
70 N. 7th St. (Wythe and Kent Aves.) • 917-488-4203 • artistsandfleas.com

BAKERI

EAT / BAKERY

A tiny spot to grab delicious pastries, sandwiches, and strong coffee. (Try their second location in Greenpoint as well.)
150 Wythe Ave. (N. 7th and N. 8th Sts.) • 718-388-8037 • bakeribrooklyn.com

BIRD

WOMEN'S / MEN'S / JEWELRY

Bird boutiques feature all the elements of a luxury-bohemian wardrobe—flowing dresses, vests, jumpsuits, nubby sweaters, colorful patterns, clog boots, artsy accessories—from the likes of Isabel Marant, Rachel Comey, Zero + Maria Cornejo, Tsumori Chisato, Pamela Love, and many others. Owner Jennifer Mankins has been called the curator of the Brooklyn look, and her stores display the art form at its best. Prices here are decidedly upscale, but when every piece is this

beautiful, it's hard to resist.
203 Grand St. (Driggs and Bedford
Aves.) • 718-388-1655 • shopbird.com

BROOKLYN ART LIBRARY
LIBRARY / ART SUPPLIES

Home to the Sketchbook Project,
a repository of thousands of artists'
journals that you can pore over
for inspiration. Art supplies and
blank books are available for
sale, which you can then use to
contribute your own sketchbook to
the project.
103A N. 3rd St. (Berry St. and
Wythe Ave.) • 718-388-7941 •
sketchbookproject.com

BROOKLYN BOWL
BOWLING / MUSIC / EAT / DRINK

It's not a throwback from the
1950s, but a modern sixteen-lane
bowling alley and music venue
that's also LEED-certified. The
menu is cooked by chefs from the
American restaurant Blue Ribbon
in SoHo. Their fried chicken is
so good that some fans come just
for that.
61 Wythe Ave. (N. 11th and N. 12th Sts.) •
718-963-3369 • brooklynbowl.com

BROOKLYN BREWERY
VISIT / DRINK

The borough's famous craft beer
brewery (in production since
1988) offers small-group tours
Monday through Thursday by
reservation only ($10). Free tours
are available during the weekend
(first come, first served). Beer
sampling is encouraged.
79 N. 11th St. (Berry St. and Wythe Ave.) •
718-486-7422 • brooklynbrewery.com

BROOKLYN DENIM CO.
WOMEN'S / MEN'S / DENIM

Brooklyn Denim Co.'s extensive
collection of jeans (from classic
Levi's to lesser-knowns like
Tellason and Kill City) makes
finding the perfect pair less of a
challenge; on-site alterations also
help. Prices range from low $100s
to high $200s.
85 N. 3rd St. (Wythe Ave.) •
718-782-2600 • brooklyndenimco.com

BROOKLYN FOX LINGERIE
LINGERIE

Find extra-fine-quality lingerie
that's sexy (not trampy) in a
selection that's fit for any figure—
from AA- to G-cup. A spin-off
location around the corner
provides garments to cover up
those beautiful underpinnings.
132 N. 5th St. (Bedford Ave. and
Berry St.) • 718-599-1555 •
brooklynfoxlingerie.com

Brooklyn Fox—200 Bedford Ave.
(N. 6th St.) • 718-388-7010 •
brooklynfox.com

CAFÉ COLETTE
EAT / CAFÉ

With full dining and cocktail
menus, Café Colette is really a
small, charming bistro. There's
a lovely garden out back, the
best locally sourced ingredients,
and an urban/rustic mash-up of
decor—all things we love about
Brooklyn.
79 Berry St. (N. 9th St.) •
347-599-1381 • cafe-colette.com

CATBIRD
JEWELRY

The beloved jeweler Catbird
equals serious objects of desire,
such as gold or sterling silver
stackable rings, knuckle rings,
and delicate necklaces with
precious gems. Edgier items

include a miniature skull ring,
gold-and-diamond spiderweb
earrings, and the Kitten Mitten, a
draped-chain that fastens around
the hand. The recently opened
(appointment only) wedding
annex around the corner awaits
the betrothed.
219 Bedford Ave. (N. 4th and N. 5th
Sts.) • 718-599-3457 • catbirdnyc.com

CHINANTLA
EAT

For a taqueria located in the back
of a Mexican bodega, Chinantla
is all the authenticity you'd hope
for. Everyone who eats here has
a favorite dish, so just keep at it
until you find yours.
657 Myrtle Ave. (Skillman St. and
Franklin Ave.) • 718-222-1719 •
chinantlarestaurant.com

COURTSHOP
DENIM

Famed for its brand of high-
waisted, rocker skinny jeans, the
Courtshop store also carries
plenty of other denim and denim-
friendly designs.
218 Bedford Ave. (N. 4th and N. 5th
Sts.) • 718-388-5880 • courtshop.com

DADDY'S BAR
DRINK

Daddy's working fireplace
and comfy booths make it a
neighborhood favorite.
437 Graham Ave. (Frost and
Richardson Sts.) • 718-609-6388 •
daddysbarbrooklyn.com

DINER
EAT

See *Marlow & Sons* in
Williamsburg.
85 Broadway (Berry St.) •
718-486-3077 • dinernyc.com

Blogs of the City

Some of the essential Brooklyn, and
New York City, style websites to keep you chic.

Backyard Bill backyardbill.com
BLOGGER: Photographer William Gentle

De Lune deluneblog.com
BLOGGER: Claire Geist

Eat.Sleep.Wear eatsleepwear.com
BLOGGER: Graphic designer Kimberly Pesch

The Fashion Philosophy
thefashionphilosophy.com
BLOGGER: Wardrobe stylist Erica Lavelanet

The Glamourai theglamourai.com
BLOGGER: Stylist Kelly Framel

Into the Gloss intothegloss.com
BLOGGER: Emily Weiss

Jag Lever jaglever.com
BLOGGER: Rachel-Marie Iwanyszyn

Just Another Me just-another.me
BLOGGER: Lisa Dengler

Keiko Lynn keikolynn.com
BLOGGER: Keiko Lynn

Man Repeller manrepeller.com
BLOGGER: Leandra Medine

Natalie Off Duty natalieoffduty.com
BLOGGER: Model Natalie Suarez

Nicolette Mason nicolettemason.com
BLOGGER: Creative consultant and contributing editor, Marie Claire, Nicolette Mason

Refinery29 refinery29.com
EDITOR IN CHIEF: Christene Barberich

The Sartorialist thesartorialist.com
BLOGGER: Photographer Scott Schuman

StyleLikeU stylelikeu.com
FOUNDERS: Mother and daughter Elisa Goodkind and Lily Mandelbaum

Tales of Endearment
talesofendearment.com
BLOGGER: Casting agent and consultant Natalie Joos

Who Is Apneet whoisapneet.com
BLOGGER: Apneet Kaur

ELECTRIC NEST
WOMEN'S

A noteworthy stop for those whose insouciant but bold approach to style is along the line of the character Jessa in *Girls*.
60 Broadway (Berry St. and Wythe Ave.) • 347-227-7023 • electricnest.info

FORTUNATO BROTHERS
EAT / BAKERY

A bakery with traditional Italian pastries and homemade gelato.
289 Manhattan Ave. (Devoe St.) • 718-387-2281 • fortunatobrothers.com

FUEGO 718
HOME

Overflowing with the curious, colorful, and charming, this shop is packed with goods sourced from Mexico, Peru, Cambodia, and Nepal, ranging from wall hangings to notebooks.
249 Grand St. (Roebling St. and Driggs Ave.) • 718-302-2913 • fuego718.com

GET UP AND RIDE
BIKE TOURS

Explore Brooklyn by bike as a part of a small group tour. Make sure to book ahead.
135 N. 11th St. (Bedford Ave. and Berry St.) • 646-801-2453 • getupandride.com

THE GORBALS
EAT / DRINK

See *Space Ninety 8* in Williamsburg.

98 N. 6th St., 3rd Fl. (Berry St. and Wythe Ave.) • 718-387-0195 • thegorbalsbk.com

HICKOREE'S FLOOR TWO
MEN'S / VINTAGE / GIFTS
From Silly Putty and garden shears to beanies and shaving cream, the wide assortment of knickknacks and clothing gives Hickoree's the feeling of an old-fashioned general store.
109 S. 6th St., 2nd Fl. (Bedford Ave. and Berry St.) • 347-294-0005 • hickorees.com/hickorees-floor-two

HOTEL DELMANO
DRINK
High-style, old-world cocktail bar with seasonal drinks menu (featuring house-made syrups, bitters, and shrubs) and raw bar/small plates.
82 Berry St. (Enter on N. 9th St.) • 718-387-1945 • hoteldelmano.com

THE IDES
DRINK
See *Marlow & Sons* in Williamsburg.
Wythe Hotel, 80 Wythe Ave., 6th Fl. (N. 11th St.) • 718-460-8006 • wythehotel.com/the-ides

IN GOD WE TRUST
WOMEN'S / MEN'S / JEWELRY
This NYC chainlet offers in-house, American-made designs including a women's and men's collection of basic garments, jewelry, and gifts.
129 Bedford Ave. (N. 9th and N. 10th Sts.) • 718-384-0700 • ingodwetrustnyc.com

JOINERY
WOMEN'S / MEN'S / HOME
A minimal, earthy, and select presentation of items, including handwoven rugs from Brazil, household boar-bristle cleaning brushes, and a few dozen timeless garments.
263 S. 1st St. (Marcy Ave. and Havemeyer St.) • 347-889-6164 • joinerynyc.com

JUMELLE
WOMEN'S / SHOES
Owner Candice Waldron has an eye for elegant but easygoing items from designers such as Raquel Allegra, Christophe Lemaire, and Steven Alan.
148 Bedford Ave. (N. 8th and N. 9th Sts.) • 718-388-9525 • shopjumelle.com

KCDC
SPORT / SNEAKERS
Proprietor Amy Gunther runs a skate shop that welcomes skaters of all abilities (as well as non-skaters). Located in an old warehouse, the store features an indoor mini-ramp and art gallery, alongside several walls decked out in shoes and skate gear.
85 N. 3rd St. (Wythe Ave.) • 718-387-9006 • kcdcskateshop.com

MARLOW & DAUGHTERS
EAT / SHOP
See *Marlow & Sons* below.
95 Broadway (Bedford Ave. and Berry St.) • 718-388-5700 • marlowanddaughters.com

MARLOW & SONS
EAT / DRINK
Originally started as a place to have a drink while you waited for a table at Diner next door, Marlow & Sons has become a neighborhood meet-up joint

where actors, models, and artists drink lattes outside during the day and eat oysters in the small dining room at night. Marlow & Sons is part of Brooklyn restaurateur Andrew Tarlow's local, sustainable eating-and-drinking empire that includes the Wythe Hotel's Reynard and the Ides, Marlow & Daughters, Roman's, and Achilles Heel.
81 Broadway (Berry St. and Wythe Ave.) • 718-384-1441 • marlowandsons.com

MARLOW GOODS
ACCESSORIES
Completing the nose-to-tail ethos prescribed at the restaurants she owns with her husband (see *Marlow & Sons*, above), Kate Huling has a line of accessories made with wool and hides from their farmers' animals.
81 Broadway (Berry St. and Wythe Ave.) • 718-384-1441 • marlowgoods.com

MAST BROTHERS CHOCOLATE MAKERS

VISIT / EAT

Epitomizing the entrepreneurial, artisanal movement in Brooklyn, the two Mast brothers founded their small-batch chocolate business by selling at local farmers' markets. Tour their factory and sample some of their unique blends, or stop in the Brew Bar for the beverage version.
111A N. 3rd St. (Berry St. and Wythe Ave.) • 718-388-2644 • mastbrothers.com

THE MEAT HOOK

FOOD / KITCHEN / CLASSES

If chefs are rock stars, then butchers are their lead guitarists. Before opening his whole-animal butcher shop, Tom Mylan worked at Marlow & Sons and was instrumental in converting many Brooklyn eaters to the local-and-grass-fed meat phenomenon. The Meat Hook has a sandwich shop, a small grocery section, and all the offerings of a carnivore's dream. At the adjoining Brooklyn Kitchen, the staff runs classes in everything from knife skills, butchery, and sausage making to home brewing and, yes, pickling.
100 Frost St. (Meeker Ave.) • 718-349-5032 • the-meathook.com

MEG

WOMEN'S

See BoCoCa.
54 N. 6th St. (Wythe and Kent Aves.) • 347-294-0777 • megshops.com

MIOMIA APOTHECARY

BEAUTY

A unisex beauty and grooming shop that offers top-notch products such as Ursa Major, Osea, and the Brooklyn brands McBride and Armour.
318 Bedford Ave. (S. 1st and S. 2nd Sts.) • 917-834-3438 • shopmiomia.com

NITEHAWK CINEMA

FILM / EAT / DRINK

Visit this cinephile's gem for Saturday-morning cartoon-and-booze specials, midnight viewings of cult classics, and new independent films. Upgrading from popcorn, the cinema has a full-service food menu available in every theater.
136 Metropolitan Ave. (Berry St. and Wythe Ave.) • 718-384-3980 • nitehawkcinema.com

OROBORO

WOMEN'S / JEWELRY

Part art gallery, part boutique, this airy space with display racks made of tree branches makes for a Zen shopping experience. Everything here is sustainably sourced, including clothing from Electric Feathers, Caron Callahan, Lauren Manoogian, Cosmic Wonder, and Ace & Jig. There is also a limited collection of art books, apothecary products, and pieces for the home.
326 Wythe Ave. (S. 1st St.) • 718-388-4884 • oroborostore.com

PILGRIM SURF & SUPPLY

SPORT / WOMEN'S / MEN'S

Find surfing supplies to catch a wave at Rockaway Beach along with bikinis, flannels, T-shirts, and backpacks (brands include Engineered Garments and Chop Wood Carry Water).
68 N. 3rd St. (Wythe Ave.) • 718-218-7456 • pilgrimsurfsupply.com

REYNARD

EAT

See Marlow & Sons in Williamsburg.
Wythe Hotel, 80 Wythe Ave. (N. 11th St.) • 718-460-8004 • reynardnyc.com

SHOE MARKET

SHOES / ACCESSORIES

Independent store dedicated to the neighborhood's clientele, hence the endlessly wearable selections by Swedish Hasbeens, Jeffrey Campbell, Frye, and Brooklyn favorite Rachel Comey.
160 N. 6th St. (Bedford Ave.) • 718-388-8495 • shoemarketnyc.com

SLAPBACK

WOMEN'S

This pink emporium will bring out your femme fatale. Owner Renee DiDio has collected an excellent variety of neovintage dresses, wiggle skirts, corsets, and all things dedicated to bosom- and derriere-emphasizing, as well as other girly goodies like fishnets and fascinators to complete your pinup look.
490 Metropolitan Ave. (Between Rodney St. and Union Ave., near Meeker Ave.) • 347-227-7133 • slapbacknyc.com

SMORGASBURG

EAT / SHOP

A gourmand food marketplace where delicacies including donuts, grilled cheese, hot dogs, and ice cream are taken as seriously as fresh oysters, kale salad, and Vietnamese banh mi, all made for equal-opportunity good eating.
Various locations and at the Brooklyn Flea markets; Saturdays in summer at East River Park, 90 Kent Ave. (N. 7th St.) • smorgasburg.com

SOULA SHOES

SHOES

See Soula Shoes in BoCoCa.
85 N. 3rd St., #114 (Berry St. and
Wythe Ave.) • 718-230-0038 •
soulashoes.com

SPACE NINETY 8

WOMEN'S / MEN'S / EAT / DRINK

This Urban Outfitters multi-floor
concept store features the Urban
Renewal line of one-of-a-kind
reworked vintage clothes, a
large selection of New York–
made designs, several rotating
collections, and the Gorbals
restaurant and rooftop bar.
98 N. 6th St. (Berry St. and
Wythe Ave.) • 718-599-0209 •
spaceninety8.com

SPECIES BY THE THOUSANDS

JEWELRY / GIFTS

Mystical, spiritual, unknowable—
if these describe your interests,
then this little jewelry/gift store
will captivate you.
171 S. 4th St. (Driggs
Ave.) • 718-599-0049 •
speciesbythethousands.com

SPOONBILL & SUGARTOWN BOOKSELLERS

BOOKS

Every inch is crammed with new,
used, and rare titles primarily
focused on illustrated books in
the art and design fields, but
there is also a fantastic selection
of hard-to-find magazines and
literature.
218 Bedford Ave. (N. 4th and
N. 5th Sts.) • 718-387-7322 •
spoonbillbooks.com

Shopping Vintage and Thrift

*Costume designer Jenn Rogien
reveals her top tips*

Vintage silhouettes differ from contemporary designs, so
it can sometimes be challenging to incorporate vintage
into your everyday wardrobe. That said, find things that
work for you and just have fun with it.

Take a tape measure. The number size that's in the
garment may have no relation to current sizing.

Check the condition of the fabric. If it's falling apart
due to age, that cannot be repaired, but you may decide
you like that as part of a garment's appeal. Just know that
once fabric reaches a certain age, it can easily tear, shred,
or disintegrate.

Know how to recognize quality. Details like a
boned bodice, a handset zipper, covered buttons, or a silk
lining indicate that a piece is well made.

Watch out for staining. Use the right cleaning method
or rely on someone who really knows what they're doing.
Some things will never come out—particularly sweat stains
under the arm, or stains set into polyester fabrics. Some-
times you can make an alteration around a stain. Other
times, perhaps it doesn't matter because it's for you to
have fun.

Store your vintage finds properly. Plastic dry-
cleaning bags don't let clothing breathe. If you want to
cover a garment to protect it from dust, use a cloth bag or a
cotton sheet with a hole in it. Always zip zippers and fasten
buttons to keep the shape of a piece. If something is heavy,
like a beaded garment, lay it flat or roll it in acid-free paper.

SWORDS-SMITH

WOMEN'S / MEN'S

Wife-husband team Briana Swords and R. Smith opened this spacious store in a former factory. Find several NYC designers, including Samantha Pleet, Morgan Carper, Feral Childe, and their house label.
98 S. 4th St. (Bedford Ave. and Berry St.) • 347-599-2969 • swords-smith.com

TOBY'S ESTATE

CAFÉ / CLASSES

Caffeine aficionados respect Toby's Estate for its meticulously brewed coffee and can further their addiction by learning how to evaluate freshly roasted beans at the shop's weekly cupping classes (advance reservation required).
125 N. 6th St. (Berry St.) • 347-457-6160 • tobysestate.com

UNION POOL

DRINK / MUSIC

It's all the fun you can have with a spacious beer garden, taco truck, indie music shows, and a photo booth. With its reputation for hipster hookups, Union Pool can feel like a lascivious carnival, especially on weekends.
484 Union Ave. (Meeker Ave.) • union-pool.com

Alexis Krauss, Sleigh Bells vocalist and Beauty Lies Truth website cofounder at Troost café/bar in Greenpoint.

WILLIAMSBURG FLEA

VARIETY / WOMEN'S / MEN'S / HOME / EAT

See *Brooklyn Flea* in Fort Greene. 50 Kent Ave. (N. 11th and N. 12th Sts.) • brooklynflea.com

Greenpoint

A low-key, mostly residential neighborhood with a large Polish community, Greenpoint has become more of a recreational destination as the hip and the happening spill over from neighboring Williamsburg. Several local indie boutiques and restaurants here warrant the ride on the G train, the only subway line that bypasses Manhattan.

ACHILLES HEEL

EAT / DRINK

See *Marlow & Sons* in Williamsburg.
180 West St. (Green St.) • 347-987-3666 • achillesheelnyc.com

ALAMEDA

DRINK / SNACKS

A grown-up establishment where you can sit around the handsome marble bar and drink a proper cocktail. The bistro menu is limited, but it's enough to fortify before you order the next round.

195 Franklin St. (Green St.) •
347-227-7296 • facebook.com/
alamedabk

ALTER
WOMEN'S / MEN'S / SHOES
See Williamsburg.
140 Franklin St. (Greenpoint Ave.) •
718-349-0203 • alterbrooklyn.com

BAKERI
EAT / BAKERY
See Williamsburg.
105 Freeman St. (Manhattan Ave.
and Franklin St.) • 718-349-1542 •
bakeribrooklyn.com

BEACON'S CLOSET
RESALE / VINTAGE
Legendary buy-sell-trade shop
with a choice selection of vintage
and modern clothing. The staff
has an excellent fashion eye.
74 Guernsey St. (Nassau and
Norman Aves.) • 718-486-0816 •
beaconscloset.com

DUSTY ROSE VINTAGE
VINTAGE
Dig through the bins of clothing
stacked and scattered throughout
the large space. We've scored
fruitful finds, like $15 sneakers
and $10 denim shorts.
251 Greenpoint Ave. (Provost
St. and McGuinness Blvd.) •
www.dustyrosevintage.com

FOX & FAWN
RESALE
The two locations of this buy-
sell-trade store (the other is in
Bushwick) focus on designer
labels and current trends.
Check their Instagram feed
(@foxandfawn) for the latest
inventory.
570 Manhattan Ave. (Driggs and

Nassau Aves.) • 718-349-9510 •
shopfoxandfawn.com

IN GOD WE TRUST
WOMEN'S / MEN'S / JEWELRY
See Williamsburg.
70 Greenpoint Ave. (Franklin
and West Sts.) • 718-389-3545 •
ingodwetrustnyc.com

LINE & LABEL
WOMEN'S / JEWELRY
"Line" as in proprietor Kate
O'Reily's own line of clothes
and leather accessories, and
"Label" for the emerging and local
designers' labels she carries, such
as Harlyn and Christian Joy.
568 Manhattan Ave. (Driggs and
Nassau Aves.) • 347-384-2678 •
lineandlabel.com

LITTLENECK OUTPOST
EAT
See Park Slope / Gowanus.
128 Franklin St. (Milton St.) •
718-383-3080 • littleneckoutpost.com

LOMZYNIANKA
EAT
For the authentic Greenpoint
experience, the locals go to a
tiny joint with the tag line "Fine
Polish Cuisine" for pierogies,
borscht, blintzes, and goulash.
646 Manhattan Ave. (Nassau and
Norman Aves.) • 718-389-9439 •
lomzynianka.com

OAK
WOMEN'S / MEN'S / SHOES
Find Brooklyn-based edgy
daywear along with pieces from
avant-garde designers like Kaelen,
Priory of Ten, and Preen.
55 Nassau Ave. (Guernsey and Lorimer
Sts.) • 718-782-0521 • oaknyc.com

PEOPLE OF 2MORROW
RESALE / GIFTS
The store's home goods—sourced
from Peru, Afghanistan, and
India—help create a worldly vibe
to go along with the vintage and
resale clothing stocked in the
lofty space.
65 Franklin St. (Oak St.) •
718-383-4402 • peopleof2morrow.com

PETER PAN DONUT & PASTRY SHOP
EAT
Devoted customers once rolled
up their pants and traipsed
through a flooded bakery rather
than miss out. That's because
it's an old-Brooklyn kinda place,
filled with "poisanality" and
ridiculously delicious donuts.
727 Manhattan Ave. (Norman and
Meserole Aves.) • 718-389-3676 •
peterpan-donuts.com

TROOST
DRINK / CAFÉ
During the day, Troost attracts
laptop-toting workers who fancy
the café's La Colombe coffee and
sunny garden. At night, Troost
gets cozy with a curated selection
of draft beer and wine.
1011 Manhattan Ave. (Huron and
Green Sts.) • 347-889-6761 •
troostny.com

VIOLET PEPPER
WOMEN'S / SHOES
This spare boutique pares
its selection to a surprisingly
affordable price point—many
items hover around $100—but
the style quotient computes at a
much higher rate.
688 Manhattan Ave. (Nassau and
Norman Aves.) • 718-383-0869 •
violetpepperbk.com

WOLVES WITHIN
WOMEN'S / MEN'S

A comely shop that stocks well-known brands like Dolce Vita and Funktional, while also offering American-made knickknacks like suede coin pouches and ceramic glazed mugs.
174 Franklin St. (Java St.) • 347-889-5798 • wolveswithin.com

WORD
BOOKS

This small indie bookstore carries an excellent selection of new, classic, and obscure titles, and hosts book groups and author signings.
126 Franklin St. (Milton St.) • 718-383-0096 • wordbrooklyn.com

Bushwick

Depending on your point of view, Bushwick is either one of the coolest places on the planet or a diverse neighborhood recovering from years of violence and crime. Either way, street art, pop-up raves, bars, and the ever-popular Roberta's pizza have prevailed over the darkest days of Bushwick's blighted past.

BEACON'S CLOSET
RESALE / VINTAGE

See Greenpoint.
23 Bogart St. (Cook and Varet Sts.) • 718-417-5683 • beaconscloset.com

BUNNA CAFE
ETHIOPIAN EAT / CAFÉ

Originating in Ethiopia, the coffee plant is the country's mainstay. This congenial Ethiopian restaurant performs traditional coffee ceremonies, serves a vegetarian menu of the national cuisine with injera flatbread, and hosts concerts and cooking classes.
1084 Flushing Ave. (Varick and Knickerbocker Aves.) • 347-295-2227 • bunnaethiopia.net

DILLINGER'S
EAT / CAFÉ

A bright, modern Russian café—the buckwheat bowl (with kale, mushrooms, and topped with an egg) and the hot dog on a pretzel bun are delish—with lots of tables and a backyard to take advantage of the Wi-Fi.
146 Evergreen Ave. (Jefferson St.) • 718-484-3222 • facebook.com/dillingersnyc

FOX & FAWN
RESALE

See Greenpoint.
222 Varet St. (White St.) • 718-366-6814 • shopfoxandfawn.com

PEARL'S SOCIAL & BILLY CLUB
DRINK

Dark, divey, and opens early enough for a long afternoon of beer/shot combos and mason jars full of whiskey gingers.
40 Saint Nicholas Ave. (Starr and Troutman Sts.) • 347-627-9985 • pearlssocial.com

ROBERTA'S
EAT / PIZZA

Behind its graffiti-tagged, cinder-block facade, Roberta's is one of the most exceptional restaurants in Brooklyn. Epicureans love the thin-crust, smoky pizzas; cocktails; and dishes from the ingredient-driven kitchen. Be forewarned: The popularity and no-reservations policy can be daunting during peak dining hours.
261 Moore St. (Bogart St.) • 718-417-1118 • robertaspizza.com

SHOPS AT THE LOOM
VARIETY

The twenty-store emporium located near the Morgan L stop features a vast array of independent shops, including Kave Espresso Bar, Gnostic Tattoo, Loom Yoga Center, and Silky's Screen Printing.
1087 Flushing Ave. (Knickerbocker Ave.) • 718-417-1616 • shopsattheloom.com

TANDEM BAR AND RESTAURANT
EAT / DRINK / POP-UP

Tandem is a bar, a restaurant, a hot brunch spot, a late-night dance party, and home to a monthly pop-up shop aptly called Multitask. Look for wares from young designers such as Tilly and William, Ruffeo Hearts Lil' Snotty, and Fashion Origins New York.
236 Troutman St. (Wilson and Knickerbocker Aves.) • 718-386-2369 • facebook.com/tandembar

URBAN JUNGLE
VINTAGE

See sister location *Vice Versa* below.
118 Knickerbocker St. (Flushing Ave. and Thames St.) • 718-381-8510 • ltrainvintage.com

VICE VERSA
VINTAGE

A low-key, low-priced thrift store

where you should set aside some time for digging through the racks to find that perfect, most covetable item.
71 White St. (McKibben and Boerum Sts.) • 347-881-9111 • ltrainvintage.com

THE WICK
MUSIC

A musical marketplace filled with multifarious options, this venue occupies eight thousand square feet of a former brewery and attracts fans of all genres with an eclectic schedule. It's also the home of Main Drag Music's Bushwick Supply equipment shop, the Sweat Shop rehearsal spaces, *Tom Tom* magazine, and Newtown radio station.
260 Meserole St. (Bushwick Pl.) • 347-338-3612 • thewicknyc.com

Bedford–Stuyvesant / Crown Heights / Prospect Heights

There is no skirting around the G-word when speaking of the changes in these central-Brooklyn neighborhoods. Gentrification has brought with it hipsters, yuppies, and buppies and many establishments for them to patronize. Rapper Biggie Smalls' Bed-Stuy, the location for Spike Lee's film *Do the Right Thing*, is now also home to the restaurant Do or Dine, which is featured in the elite Michelin Guide.

BROOKLYN KOLACHE CO.
EAT / CAFÉ

Don't get so distracted by the donut craze that you ignore the kolache, a Czech pastry that is stuffed with sweet or savory fillings. The poppyseed is more traditional, while the kielbasa and cheese hits the spot, especially on a nice day in the café's garden.
520 Dekalb Ave. (Bedford Ave. and Skillman St.) • 718-398-1111 • brooklynkolacheco.com

CAFÉ RUE DIX
EAT / DRINK / CAFÉ

A striking French-Senegalese café/bar with a full menu all day and night. It's a neighborhood place that is also worldly, serving up moules frites and *thiebou djeun* (Senegal's national dish) to a soundtrack of Edith Piaf mixed in with griot rap and Youssou N'Dour.
1451 Bedford Ave. (Park Pl.) • 929-234-2543 • caferuedix.com

Leslie Parks visits the Hattie Carthan Community Garden in Bed-Stuy.

COOL PONY CROWN HEIGHTS

VINTAGE / MUSIC

Spunky thrift shop by day, musical hot spot by night—just the unusual kind of combo that works well in Brooklyn.
733 Franklin Ave. (Sterling and Park Pls.) • 347-927-4718 • coolponycrownheights.com

DEKALB RESTAURANT

EAT

The decor's reclaimed wood creates the overall warm vibe, which is boosted by friendly service, live music, and a creative American menu that is also friendly to vegetarians.
564 Dekalb Ave. (Walworth and Spencer Sts.) • 347-857-7097 • dekalbrestaurant.com

DO OR DINE

EAT

It is a unique experience to walk under the yellow diner-style misnomer sign (left over from the previous restaurant) and find everything here clever and slightly irreverent—from the name, a spin on Biggie Smalls' line "Bed-Stuy do or die," to the menu, which includes, if you're lucky, foie gras donuts.
1108 Bedford Ave. (Quincy St. and Lexington Ave.) • 718-684-2290 • doordinebk.com

DOUGH

EAT / BAKERY

Artisanal donuts infamously the size of your head, with out-of-this-world flavors like hibiscus and tropical chili.
448 Lafayette Ave. (Franklin Ave.) • 347-533-7544 • doughbrooklyn.com

HULLABALOO BOOKS

BOOKS / USED BOOKS

The owner of nearby Little Zelda café and Wedge cheese shop opened this community bookshop (volunteer-run, so hours are unpredictable). It feels like someone's well-loved, funky library, complete with a pay-what-you-will section.
711a Franklin Ave. (enter on Park Pl.) • 917-499-3244 • facebook.com/hullabaloobooks

INSTALLATION

RESALE / VINTAGE

Owner Israel David channels Solange Knowles in choosing his stock of secondhand items, so you know something will vibe. Lots of knockout Brooklyn-themed T-shirts as well.
733 Franklin Ave. (Sterling and Park Pls.) • 718-975-2680 • installationnyc.tumblr.com

OWL AND THISTLE GENERAL STORE

GIFTS / VARIETY / CLASSES

True to its "general store" name, Owl and Thistle stocks Brooklyn-made edibles, wearables, and giftables, as well as other sustainable, fair-trade items. Craft classes are also offered.
833 Franklin Ave. (Union St.) • 347-722-5836 • owlandthistlegeneral.com

ROSEBUD VINTAGE AT THE PEACOCK ROOM

VINTAGE

Serious vintage—clean, quality items from the late 1800s through the 1970s—means the prices won't compete with a typical thrift shop, but the finds here are sublime.
721 Franklin Ave. (Sterling and Park Pls.) • 347-435-0568 • rosebudvintage.com

SINCERELY, TOMMY

WOMEN'S / CAFÉ

The fabulously chic, Bed-Stuy born Kai Avent-deLeon created a gallery-like modernist boutique where clothing resembles art. Her offerings, including accessories and BK-made furniture, are unique veering toward avant garde. A sleek coffee counter adds a bonus respite.
343 Tompkins Ave. (Monroe St.) • 718-484-8484 • sincerelytommy.com

UNNAMEABLE BOOKS

USED BOOKS

The shop is packed to the rafters with new and used contemporary fiction, poetry, philosophy, and biographies. Expect to spend time browsing.
600 Vanderbilt Ave. (St. Marks Ave.) • 718-789-1534 • unnameablebooks.blogspot.com

Park Slope / Gowanus

Leafy Park Slope is a bourgeois-bohemian utopia, where the owners of tony real estate also work at the local food co-op, which encapsulates the neighborhood's earnestness. The picturesque blocks closest to Prospect Park largely make up a historic district. And Fifth Avenue is a center of fashion-forward commerce. Then westward toward Third Avenue, Gowanus is slowly changing from an industrial no-man's-land

into a destination for creative restaurants and warehouse arts spaces. Locals are waiting for the polluted Gowanus Canal to be cleaned up, which could infuse this part of Brooklyn with a little hint of Venice.

A. CHENG

WOMEN'S

Owner Alice Cheng focuses on a selection of comfortable, timeless, yet distinctive daywear and accessories from Sessùn, Humanoid, Orly Genger, and her own label A. Cheng.

466 Bergen St. (Flatbush and 5th Aves.) • 718-783-2826 • achengshop.com

BABELAND

GIFTS / SEX TOYS

When you feel good, you look good too, so if finding that delightful dillydo does the trick, why not? This shop is owned by women, and their hearts are in the right place.

462 Bergen St. (Flatbush and 5th Aves.) • 718-638-3820 • babeland.com

BEACON'S CLOSET

RESALE / VINTAGE

See Greenpoint.

92 5th Ave. (Warren St.) • 718-230-1630 • beaconscloset.com

BHOOMKI

ECO / WOMEN'S

At Bhoomki, all garments and accessories are vetted to be conscious of one of these ethical/ social/ecological tenets: made in the U.S., organic, fair-trade, artisan, repurposed, or made by women (and clever hangtags tick off which apply). Find the house line, which uses primarily Indian handmade fabrics, as well as Feral Childe, Coclico, and others. (Bhoomki Home nearby extends the concept to furnishings.)

158 5th Ave. (Degraw and Douglass Sts.) • 718-857-5245 • bhoomki.com

BHOOMKI HOME—237 5th Ave. (Carroll and President Sts.) • 718-230-4663 • bhoomki.com/home

BIRD

WOMEN'S

See Williamsburg.

316 5th Ave. (2nd and 3rd Sts.) • 718-768-4940 • shopbird.com

BROOKLYN SUPERHERO SUPPLY CO.

GIFTS

Quirky and styled to the nth degree, this wackadoodle novelty shop is filled with all the essentials you never knew you needed to fight villains (capes, X-ray powder, grappling hooks). Plus, the store is actually a front for author Dave Eggers' 826 NYC literacy foundation, and all purchases help support this herculean effort.

372 5th Ave. (5th and 6th Sts.) • 718-499-9884 • superherosupplies.com

CAFÉ REGULAR DU NORD

EAT / CAFÉ

On a Park Slope side street, Café Regular du Nord recalls the romantic atmosphere of old Vienna or Amsterdam in a very tiny space. In warmer weather, additional terrace seating makes it all the more delightful. Café Regular is a sister locale.

158 Berkeley Pl. (6th and 7th Aves.) • 718-783-0673 • caferegular.com

CAFÉ REGULAR—318 11th St. (5th Ave.) • 718-768-4170

COMMUNITY BOOKSTORE

BOOKS

Aptly named, Community carries plenty of local authors, independent titles, and a smart selection of graphic novels and children's picture books. The homey atmosphere encourages browsing for your next read and a knowledgeable staff can point you to specific titles or the peaceful patio in back.

143 7th Ave. (Garfield Pl. and Carroll St.) • 718-783-3075 • communitybookstore.net

LITTLENECK

EAT

Littleneck capitalizes on the unfussy, down-home aesthetic that does so well in Brooklyn restaurants. The food is based on a New England seafood shack menu, and even New Englanders rave about the fried clam roll, lobster roll, and steamed mussels. The Brooklyn touch adds a cocktail menu, freshly made donuts for dessert, and brunch, where poutine is also served.

288 3rd Ave. (Carroll and President Sts.) • 718-522-1921 • littleneckbrooklyn.com

LOTTA JANSDOTTER

ACCESSORIES / FABRIC / APPT ONLY

Swedish-born designer Lotta Jansdotter brings the Scandinavian aesthetic to her small, by-appointment studio/ shop. Find her own fabric by the yard, tote bags, and sweet little things like notebooks to throw inside them.

131 8th St. (2nd and 3rd Aves.) • 718-755-9945 • jansdotter.com

Great Brooklyn Reads

The fascination with writerly Brooklyn keeps several independent bookstores thriving. Thirty-five-year-old BookCourt in Cobble Hill gave their staff selects for notable Brooklyn-based books, both old and new.

The Colossus of New York (Colson Whitehead, 2003) A Manhattanite turned Brooklynite, Whitehead takes this stance on the whole Brooklyn-writer thing: "Get over it." But his lyrical essays on New York City (including Brooklyn) are a must nonetheless.

Dept. of Speculation (Jenny Offill, 2014) Offill's heartbreaking collage of prose tells of a deteriorating marriage.

The Great Bridge: The Epic Story of the Building of the Brooklyn Bridge (David McCullough, 1972) Historian McCullough's account is unparalleled on the subject.

Last Exit to Brooklyn (Hubert Selby, Jr., 1964) Selby's dark, twisted, and rough-edged Brooklyn still exists in some corners of the borough.

Literary Brooklyn: The Writers of Brooklyn and the Story of American City Life (Evan Hughes, 2011) Read about famous Brooklyn writers and the people and places that helped form them.

The Love Affairs of Nathaniel P. (Adelle Waldman, 2013) Her debut novel perfectly captures Brooklyn's contemporary literary scene, making every male author want to cower just a little farther into the corner at cocktail parties.

Marine Park (Mark Chiusano, 2014) This debut short-story collection explores life in one of the borough's less-well-known neighborhoods.

A Meaningful Life (L. J. Davis, 1971) The sardonic-toned tale of a man looking for redemption through renovating a dilapidated mansion in then-crime-ridden Clinton Hill.

Motherless Brooklyn (Jonathan Lethem, 1999) and The Fortress of Solitude (2003) Literary devotion runs deep for Lethem's gritty, lo-fi, fictional Brooklyn worlds from circa 1970.

Other People We Married (Emma Straub, 2011) Straub's sharp debut short-story collection ordained her as the belle of Brooklyn's literary ball.

Panic in a Suitcase (Yelena Akhtiorskaya, 2014) Critics swooned for Akhtiorskaya's writing in her complicated, beautiful portrait of post-Soviet immigrant life in Brighton Beach.

Prospect Park West (Amy Sohn, 2009) Love it or hate it, Sohn's cynical version of Park Slope (where she also lives) centers on a group of mothers who vie for sex, real estate, and their own self-esteem.

Sunset Park (Paul Auster, 2010) The prolific Auster, one of the borough's most celebrated authors, gives us his great Brooklyn novel.

A Tree Grows in Brooklyn (Betty Smith, 1943) The iconic American story of the struggle for a better life in early twentieth-century Williamsburg.

Visitation Street (Ivy Pochoda, 2013) This literary noir mystery, set in an August heat wave in Red Hook, will keep you turning pages late into the night.

POPPY

WOMEN'S

After a decade in Manhattan's Nolita, owner Leslie McKeown brought Poppy to her home neighborhood of Park Slope, where her pretty selection of dresses and separates by Lauren Moffatt, Tucker by Gaby Basora, Otis & Maclain, Ella Moss, and Mother Denim fit right in.

217 5th Ave. (President and Union Sts.) • 347-599-1793 • poppy.myshopify.com

POWERHOUSE ON 8TH

BOOKS

See *PowerHouse Arena* in Brooklyn Heights / Dumbo / Vinegar Hill.

1111 8th Ave. (11th and 12th Sts.) • 718-801-8375 • powerhouseon8th.com

THE ROYAL PALMS SHUFFLEBOARD CLUB

SHUFFLEBOARD

Shuffleboard was plucked from the purview of retirees and transformed into a Gowanus nightlife scene. Housed in a former factory, this venue's sprawling courts, bar, and visiting food trucks parked outside make an uncanny mix for a good time.

514 Union St. (3rd Ave. and Nevins St.) • 347-223-4410 • royalpalmsshuffle.com

RUNNER & STONE

EAT

Peter Endriss was formerly the head baker at Per Se, which is, arguably, one of the most exacting kitchens in Manhattan. At the modernist dining room of Runner & Stone, which is open all day, co-owner Endriss has brought his life-changing baguettes, croissants, and other pastries to Gowanus. It's worth a detour, if only just for breakfast.

285 3rd Ave. (Carroll and President Sts.) • 718-576-3360 • runnerandstone.com

THREES BREWING

DRINK / EAT

An eight-thousand-square-foot brewery decked out in sophisticated Scandinavian modern decor. Guest top chefs from the borough provide a rotating menu.

333 Douglass St. (3rd and 4th Aves.) • 718-522-2110 • threesbrewing.com

V CURATED

WOMEN'S / MEN'S

A boutique that is primarily a retail venue for Vallarino, the owner's line of hand-dyed and hand-painted garments with modern silhouettes, but also set up as a cooperative for other designers (including Arkins, Kao Pao Shu, and Lemniscata) to sell their wares.

456 Bergen St. (Flatbush and 5th Aves.) • 347-987-4226 • www. vcurated.com

BoCoCa (Boerum Hill, Cobble Hill, Carroll Gardens)/ Red Hook

Idyllic brownstone Brooklyn is stunning throughout the adjoining BoCoCa neighborhoods. Smith Street has become known as the borough's restaurant row. In Red Hook, Van Brunt Street is the main thoroughfare where, toward the water, you can look straight at the Statue of Liberty. While South Brooklyn was long dominated by small and family-run businesses, international retailers including Barneys, Steven Alan, and Rag & Bone are now relative newcomers to the area. And yet, a strong local spirit perseveres.

BATTERSBY

EAT

Battersby opened in 2011 to critics' raves, and the culinary elite came from Manhattan to get their forks on the cooking of creative chefs Walker Stern and Joe Ogrodnek. Thankfully, the chefs opened a more spacious sister restaurant, Dover, a few blocks away to accommodate hungry fans.

255 Smith St. (Degraw and Douglass Sts.) • 718-852-8321 • battersbybrooklyn.com

DOVER—412 Court St. (1st and 2nd Pls.) • 347-987-3545 • doverbrooklyn.com

BIRD

WOMEN'S

See Williamsburg.

220 Smith St. (Butler St.) • 718-797-3774 • shopbird.com

BOOKCOURT

BOOKS

Even with big Barnes & Noble up the street, the family-owned BookCourt survives while most of the city's independent booksellers perish. You can peruse titles in the large, bright reading room; go to regular author events; and get knowledgeable help from the literati staff (many of whom are also writers).

163 Court St. (Dean and Pacific Sts.) • 718-875-3677 • bookcourt.com

THE BROOKLYN INN

DRINK

This Boerum Hill corner saloon with a dark-wood nineteenth-century bar, old-school jukebox, and pool table in the back services a predominantly local clientele.

148 Hoyt St. (Bergen St.) • 718-522-2525

BURLAP

WOMEN'S / MEN'S / HOME

An interesting, out-of-the-way boutique feels like a real find, and Burlap is just such a place. Located on lovely Henry Street, this shop features a compelling range of items from brands such as Citizens of Humanity, Project Alabama, and Coclico.

385 Henry St. (Warren St. and Verandah Pl.) • 718-596-8370

CACAO PRIETO / BOTANICA

VISIT / EAT / DRINK

The artisanal rage in Brooklyn has been good to chocolate and whiskey lovers alike with small-scale producers bringing a fine hand to both. The Cacao Prieto factory in Red Hook makes chocolate bars, rums, and liqueurs from owner Daniel Prieto Preston's organic cacao farm in the Dominican Republic. You can tour the factory, stop in the shop, or imbibe at the Botanica cocktail bar.

218 Conover St. (Coffey St.) • 347-225-0130 • cacaoprieto.com

DIANE T.

WOMEN'S

This Cobble Hill boutique stocks an edited selection of sophisticated fashion pieces from such designers as Rebecca Taylor, Diane von Furstenberg, Cacharel, and Vanessa Bruno.

174 Court St. (Congress and Amity Sts.) • 718-923-5777 • dianetbrooklyn.com

ERIE BASIN

JEWELRY / ANTIQUES

The selection of eighteenth- to twentieth-century jewelry here is handsome, indeed. In addition to antique diamond engagement rings, collector/owner Russell Whitmore sells his own fine jewelry line, EB, created mostly with gemstones he has found over the years. There are also more moderately priced objects of desire, including art and furniture, at the shop.

388 Van Brunt St. (Dikeman St.) • 718-554-6147 • eriebasin.com

EVA GENTRY CONSIGNMENT

RESALE

The thrill of scoring an Isabel Marant jacket or Céline trousers that you can afford never gets old. This highly selective consignment shop knocks off more than fifty percent of the retail price on most garments and accessories, and only carries the best, including Chanel, Prada, Gucci, and YSL.

371 Atlantic Ave. (Bond and Hoyt Sts.) • 718-522-3522 • evagentryconsignment.com

THE GOOD FORK

EAT

Devotees rave about Korean American chef Sohui Kim's delicate, savory pork-and-chive dumplings and Korean-style steak and eggs with kimchi rice. Kim's husband built the elegant wood-paneled dining room and also works the front of the house, which adds to the mom-and-pop vibe of the restaurant.

391 Van Brunt St. (Van Dyke and Coffey Sts.) • 718-643-6636 • goodfork.com

JAMES LEONARD OPTICIANS

EYEWEAR

Brooklyn gals know how to wear a statement pair of eyeglasses. Get your own most Brooklyn of accessories at this family-run shop, which carries Dita, Cutler and Gross, Salt, and Oliver Goldsmith.

309 Smith St. (President and Union Sts.) • 718-222-8300 • jamesleonardopticians.com

KAIGHT

ECO / WOMEN'S

The eco-minded boutique Kaight sources collections that use sustainable textiles, meaning they are organic or repurposed and minimize waste generated during production. While the rotation in-store changes regularly, you can always find Big Star jeans and PACT underwear.

382 Atlantic Ave. (Bond and Hoyt Sts.) • 718-858-4737 • kaightshop.com

LUCALI

EAT

Self-taught pizzaiolo Mark Iacono creates pizza pies touched by angels: so light is the crust, and so heavenly the flavor. Just be prepared to wait—the candlelit dining room takes no reservations and has two seatings per night.

575 Henry St. (1st Pl. and Carroll St.) • 718-858-4086 • lucali.com

Essential Brooklyn Movies

If you cannot get to Brooklyn, you can still temporarily visit by getting lost in the borough on-screen. Film critic Aaron Hillis (named one of the most influential people in Brooklyn culture by *Brooklyn Magazine*) owns Video Free Brooklyn in Cobble Hill (videofreebrooklyn.com) and gave us his list of the best King's County flicks.

Brooklyn Castle (2012) An energizing documentary about junior high schoolers challenging adversity through competitive chess.

The Comedy (2012) An aging Williamsburg hipster's entitlement is put forth for critique in this thorny, transgressive drama.

Dave Chapelle's Block Party (2005) Kanye West, Mos Def, and the reunited Fugees rock the block in Clinton Hill.

Do the Right Thing (1989) Spike Lee's fight-the-power masterpiece simmers with Bed-Stuy racial tensions on the hottest day of summer.

Dog Day Afternoon (1975) Al Pacino robs a Gravesend bank to pay for his lover's sex change. Attica! Attica!

The French Connection (1971) Gene Hackman speeds through Bensonhurst in the greatest car chase ever filmed.

Goodfellas (1990) Scorsese's most quotable gangster flick: "Now go home and get your $%#*in' shinebox."

Hey Good Lookin' (1982) Ralph Bakshi's animated cult classic is an outrageous look at greasers in 1950s Brooklyn.

It Happened in Brooklyn (1947) An underrated MGM musical featuring Frank Sinatra and Jimmy Durante imitating each other in song.

The Landlord (1970) Beau Bridges buys a brownstone and learns humbling truths about ghetto life in director Hal Ashby's funny-sad debut.

Last Exit to Brooklyn (1989) Jennifer Jason Leigh headlines a haunting adaptation of Hubert Selby, Jr.'s controversial Red Hook bummer.

Little Fugitive (1953) A young boy runs away to Coney Island and influences the French New Wave through poetic naturalism.

Moonstruck (1987) Sicilian-American widow Cher romances Nicolas Cage under her family's roof in a madcap Oscar-winning comedy.

Mother of George (2013) A culturally vibrant Sundance favorite about the crisis of a married Nigerian couple living in Brooklyn.

Newlyweds (2013) In gentrified Bed-Stuy, a young repo man must decide between his girlfriend and marijuana in this soulful stoner dramedy.

Obvious Child (2014) A terrifically honest, painfully funny comedy about a stand-up comic (Jenny Slate) getting an abortion.

Quiet City (2007) Aaron Katz's acclaimed indie meet-cute film is romantically photographed to make Brooklyn seem empty.

Saturday Night Fever (1977) Well, you can tell by the way John Travolta walks, he's a Bay Ridge man. No time to talk!

The Sentinel (1976) Cristina Raines meets a blind priest guarding the gateway to hell in her Brooklyn Heights brownstone.

Shortbus (2006) Freak flags fly high and proud for this disarmingly explicit party of a drama, centered on a progressive-minded sex party in Dumbo.

Smoke (1995) William Hurt frequents Harvey Keitel's Brooklyn cigar shop in this terrific ensemble drama, written by novelist Paul Auster.

Sophie's Choice (1982) Brooklyn, schmooklyn. It's all about secretive Polish refugee Meryl Streep, here winning her first Oscar for Best Actress.

The Squid and the Whale (2005) Divorce, Park Slope–style. Indie darling Noah Baumbach dramatizes his childhood in "the filet of the neighborhood."

The Super Cops (1974) Buddy-cop flicks don't get more irrepressibly gonzo than this Brooklyn cult fave from Gordon Parks, the director of *Shaft*.

A Tree Grows in Brooklyn (1945) Elia Kazan's sentimental classic follows the toils of an Irish American family in 1912 Williamsburg.

Two Lovers (2008) James Gray's masterfully nuanced drama ensnares Joaquin Phoenix and Gwyneth Paltrow in a Brighton Beach love triangle.

MEG

WOMEN'S

We love the clothing line and shops called Meg for the comfortable, minimal, modern separates that fit many body types, including women with curves. The affable Meg designer, Meghan Kinney, greets her customers with "Hey, babe," and will pull out a piece for you, and then, if necessary, pin and alter it to suit you perfectly.

358 Atlantic Ave. (Bond and Hoyt Sts.) • 718-522-3585 • megshops.com

NIGHTINGALE 9

EAT

Chef Rob Newton and his partner, Kerry Diamond, showcase the bright flavors of Vietnamese cuisine in their third Carroll Gardens restaurant on Smith Street. Nightingale 9 serves classics like beef pho made with grass-fed local beef, which adds to the price point but is worth it. Down the street, the Newton-Diamond team serves fried chicken and okra chips at their Southern place, Wilma Jean, while their café, Smith Canteen, maintains a constant buzz.

329 Smith St. (President St.) • 347-689-4699 • nightingale9.com

OLIVE'S VERY VINTAGE

VINTAGE

Stylist and collector Jen McCulloch chooses vintage pieces with timeless appeal and tailors her shop's seasonal offerings according to trends. The collection might include Bonnie Cashin, Norma Kamali, Geoffrey Beene, and Oleg Cassini, among other titans of design.

434 Court St. (2nd and 3rd Pls.) • 718-243-9094 • olivesveryvintage.com

RED HOOK LOBSTER POUND

EAT

With so much excellent food happening in Brooklyn, we are often susceptible to cravings. The Red Hook Lobster Pound is up there for its lobster BLT or even the straight-up lobster roll. These are best paired with a hot day and a bike ride to get there, which rounds out the Red Hook experience.

284 Van Brunt St. (Pioneer and Verona Sts.) • 718-858-7650 • redhooklobster.com

REFINERY

ACCESSORIES

The small Smith Street shop first opened in 1997 with simple-shaped handbags crafted from vintage fabrics. Refinery bags have endured, and the shop now

Debbie Hardy at the Brooklyn Flea in Fort Greene.

also sells Sven clogs, which can be custom-made in many colors, as well as Indian- and African-made wax-print cotton dresses, scarves, and delicate jewelry. 248 Smith St. (Degraw and Douglass Sts.) • 718-643-7861

RUCOLA

EAT

Everything here is perfectly rustic: the farm-to-table Northern Italian menu; the dimly lit, distressed wood interior; and the scruffy bearded waiters in plaid shirts. Go at the right time of year to taste the marvels that chef Joe Pasqualetto makes from seasonal asparagus, truffles, or ramps. 190 Dean St. (Bond St.) • 718-576-3209 • rucolabrooklyn.com

SHEN

BEAUTY

The intersection of beauty and wellness is a specialty at the apothecary-like beauty boutique Shen. Owner Jessica Richards swears by products such as face oil, which is said to bring out a supple luminosity in the skin. Practically everything here is made from natural or organic ingredients. Try the Aurelia Cell Repair Night Oil or anything from By Terry and RMS. 315 Court St. (Sackett and Degraw Sts.) • 718-576-2679 • shen-beauty.com

SMITH CANTEEN

EAT

See *Nightingale 9* in BoCoCa. 343 Smith St. (Carroll St.) • 347-294-0292 • smithcanteen.com

SOULA SHOES

SHOES

Moderately priced, stylishly wearable, and mostly casual shoes (Chie Mihara, Corso Como, Puma, Clarks, Paul Smith)—Soula Shoes knows exactly what Brooklynites want. 185 Smith St. (Warren St.) • 718-834-8423 • soulashoes.com

SUNNY'S BAR

DRINK

Epic dive bar located on a cobblestoned end-of-the-world kind of street on the Red Hook waterfront. Bluegrass jams happen on Saturday nights. 253 Conover St. (Reed and Beard Sts.) • 718-625-8211 • sunnysredhook.com

WILMA JEAN

EAT

See *Nightingale 9* in BoCoCa. 345 Smith St. (Carroll St.) • 718-422-0444 • wilmajean345.com

Fort Greene / Clinton Hill

A quick subway ride from Manhattan, Fort Greene has long drawn visitors for its stunning architecture, eclectic and excellent restaurants, the Brooklyn Flea, and the Brooklyn Academy of Music (BAM), which is not an academy but rather an arts space for cutting-edge performances, including dance, theater, music, and indie films. The picturesque blocks morph into neighboring Clinton

Hill, home to the arts school Pratt Institute.

BAM CULTURAL CENTER

PERFORMANCES

Innovative, boundary-pushing performances continue to appear at all the BAM venues: Brooklyn Academy of Music, BRIC House, The Polansky Shakespeare Center, Mark Morris Dance Center, and MoCADO. Brooklyn Academy of Music, 30 Lafayette Ave. (Saint Felix St. and Ashland Pl.) • 718-636-4100 • bam.org

BROOKLYN FLEA

VARIETY / WOMEN'S / MEN'S / HOME / EAT

The Brooklyn Flea markets in Fort Greene and Williamsburg, and especially the all-food Smorgasburg, capture the entrepreneurial, artisanal Brooklyn spirit. The vendors sell all sorts of vintage and handmade products and, of course, it's the ideal place to people-watch and nosh. 176 Lafayette Ave. (Vanderbilt and Clermont Aves.) • brooklynflea.com

CLOTH

WOMEN'S

Located on the garden level of her family's brownstone, Zoë van de Wiele's shop carries casual clothing that has just that bit of something to make it special (but not too pricey)—an organic cotton T-shirt with a shapely rolled hem from American Vintage, a tunic-length mannish cardigan by Stewart & Brown—along with Utility Canvas totes and Tretorn sneaks. 138 Fort Greene Pl. (Hanson Pl.) • 718-403-0223 • clothclothing.com

FRENCH GARMENT CLEANERS CO.

WOMEN'S / MEN'S / GIFTS

A clever change of use for a former dry cleaner (the 1960s neon sign is a landmark), this boutique features Rachel Comey, Engineered Garments, Nomia, and Ulla Johnson, among others. 85 Lafayette Ave. (S. Portland Ave. and S. Elliott Pl.) • 718-797-0011 • frenchgarmentcleaners.com

GREENLIGHT BOOKSTORE

BOOKS

This community-funded independent bookstore has a devoted following, especially for their kids' book club, but their signed first-editions club of top-notch contemporary titles has attracted a national audience. 686 Fulton St. (S. Portland Ave.) • 718-246-0200 • greenlightbookstore.com

JILL LINDSEY

WOMEN'S / GIFTS / CAFÉ / DRINK / CLASSES

Billed as a mini department store, designer Jill Lindsey's emporium sells her own clothing line and a changing roster of other indie designer favorites as well as accessories, apothecary products, and select home goods. A café/lounge, backyard, events, and workshops on such things as wreathmaking create an experience that has appeal beyond shopping. 370 Myrtle Ave. (Clermont Ave. and Adelphi St.) • 347-987-4538 • jilllindsey.com

LOCANDA VINI & OLII

EAT

A nineteenth-century pharmacy that remains true to the historic architecture of Clinton Hill was converted into this beloved Tuscan restaurant with Florentine chef Michele Baldacci in the kitchen. 129 Gates Ave. (Cambridge Pl.) • 718-622-9202 • locandany.com

MADIBA

EAT

A Fort Greene institution, this South African restaurant represents with flea-market decor and the country's rainbow cuisine, which takes a bit of spice and influence from Africa, Malaysia, and Europe. Ostrich carpaccio, anyone? 195 Dekalb Ave. (Adelphi St. and Carlton Ave.) • 718-855-9190 • madibarestaurant.com

O.N.A

WOMEN'S / SHOES / ACCESSORIES

This railroad car–thin space carries moderately priced items, including Ilana Kohn patterned rompers and dresses for summer, Olive & Oak chunky knits for winter, and Charlotte Stone metallic cork sandals and wooden clog boots. 593 Vanderbilt Ave. (Bergen and Dean Sts.) • 718-783-0630 • onanyc.com

ROMAN'S

EAT

See *Marlow & Sons* in Williamsburg. 243 Dekalb Ave. (Vanderbilt and Claremont Aves.) • 718-622-5300 • romansnyc.com

THISTLE & CLOVER

WOMEN'S / JEWELRY

The homely gray storefront belies the chirpy finds inside—Ace & Jig, Lauren Moffatt, Dusen Dusen, and quite a delicious selection of jewelry. 221 Dekalb Ave. (Clermont Ave. and Adelphi St.) • 718-855-5577 • thistleclover.com

Brooklyn Heights/ Dumbo/ Vinegar Hill

The genteel streets of Brooklyn Heights are packed with multimillion-dollar townhouses. A row of these hangs over the Brooklyn Promenade, which looks onto beautiful Brooklyn Bridge Park and across the river to looming downtown Manhattan. Adjacent Dumbo offers upscale loft dwellings and shopping to match, though it's also a hub of caffeinated tech employees and quality cafés to keep them going. Continuing along the waterfront you'll find the mostly quiet, cobblestoned streets of scenic Vinegar Hill.

BROOKLYN BRIDGE PARK

VISIT

Highlights of this eighty-five-acre cultural greenway along the historic Dumbo waterfront include a beautifully restored 1922 carousel, ongoing art

exhibits, Smorgasburg (see Williamsburg) on Sundays in the summer, and the view of Manhattan.

Water St. (Old Fulton St.) • 718-222-9939 • brooklynbridgepark.org

POWERHOUSE ARENA

BOOKS

More than just a bookstore (and home to the art book publisher by the same name), this five-thousand-square-foot space holds exhibits, performances, and other events celebrating art, photography, design, fashion—the full gamut of culture. The South Slope branch is smaller but of the same spirit.

37 Main St. (Water St.) • 718-666-3049 • powerhousearena.com

TRUNK

WOMEN'S / JEWELRY

Brooklyn-based Aimee G, Radka Design, and Samoy Lenko set up this boutique to sell their wares along with other local designers and artists. Many of the garments feature interesting construction, luxury fabrics, and flattering neutral colors.

68 Jay St. (Front and Water Sts.) • 718-522-6488 • trunkbrooklyn.com

Sisters Simi Polonsky (left) and Chaya Chanin head to a meeting in Dumbo.

VINEGAR HILL HOUSE

EAT

The recipe for a successful Brooklyn destination restaurant calls for one somewhat dodgy and ungentrified neighborhood, local-farm ingredients, and a rustic design aesthetic. Vinegar Hill House really couldn't do it any better.

72 Hudson Ave. (Front and Water Sts.) • 718-522-1018 • vinegarhillhouse.com

ZOË

WOMEN'S / ACCESSORIES

Easily fitting into the new luxury environs that Dumbo's warehouse buildings have become, Zoë carries a pristine selection of well-known designers (Stella McCartney, Proenza Schouler), along with popular denim lines like Rag & Bone, Current/Elliot, and J Brand.

68 Washington St. (York and Front Sts.) • 718-237-4002 • shopzoeonline.com

Thank-Yous

With our deepest thanks, we'd like to acknowledge the help and talents from several people:

All the incredible women from our pages whose style and character are so inspiring. For going above and beyond, shout-outs go to: Jessica Richards, April Hughes, Marina Burini, Kate Huling, Hilary Robertson, Jennifer Mankins, Marina Muñoz, Ulla Johnson, Debbie Hardy, Karyn Starr, Titania Inglis, Mary Alice Stephenson, Aurora James, Taylor Patterson, Erica Rubinstein, Kathleen Hackett, and Ingrid Carozzi.

Our editor, Laura Dozier, for her sheer patience with us along the way. Michael Jacobs, for championing the project.

For artistry with beauty we couldn't have done without Rebecca Alexander, first and foremost, as well as Julia Joseph, Jessica Kelleher, Jill Freeman, Nicole Bryl, Flynn Marie, and Liz Marz.

For rolling up their sleeves and getting in there: Kristen Amato, Kate Gash, Samantha Perelson, Aaron Hillis, Andrew Unger and the BookCourt literati, Mark Dommu, Julie Bessler, Brooke Goldberg, Veronica Höglund, and Chris Tyler.

Andrew Udin for sage counsel.

Special thanks to those behind-the-scenes folks at Abrams who keep everything moving: Sally Knapp and Emily Albarillo (and their team of copyeditors and proofreaders), Denise LaCongo, Kristina Tully, Paul Colarusso, Jules Horbachevsky, Lori Zajkowski, John Gall, Karrie Witkin, Chris Raymond, and Danny Maloney.

For advice, support, and follow-through: Gene Palmer, Daniel Nesi, Newbee Nesi, Polly Nesi, Diego and Paolo and Tonio and Vasco Sierra, Albert and Elizabeth Watson, Timothy Bradlee, Kim Shunk Schiavone, Zoe Potkin, Richard and Sissy Albertine, Susan Cordaro and Sean Desmond, André Aciman and the excellent editors and writers at the CUNY Writers' Institute, Shelly Sacharow and Matt Moore, Nina and Michele Sacharow, Tania Bedford, John Dahl, John Seibert, Andrea Danese, Chip Krezell, and Magali Veillon.

Dorsey and Ron Ewing, Evan and Theo Cohen, and Oona Nesi Bradlee—for everything.

Beauty and the bridge:
GLAM4GOOD founder Mary
Alice Stephenson in an
Altuzarra moto jacket, Naeem
Khan skirt, and Christian
Louboutin ankle boots.

EDITOR: Laura Dozier
PRODUCTION MANAGER: Denise LaCongo

LIBRARY OF CONGRESS CONTROL NUMBER: 2014959314
ISBN: 978-1-4197-1795-6

PRINTED AND BOUND IN THE UNITED STATES
10 9 8 7 6 5 4 3 2 1

ABRAMS IMAGE BOOKS are available at special discounts when purchased in
quantity for premiums and promotions as well as fundraising or educational
use. Special editions can also be created to specification. For details, contact
specialsales@abramsbooks.com or the address below.

ABRAMS

THE ART OF BOOKS SINCE 1949

115 West 18th Street
New York, NY 10011
www.abramsbooks.com